K·I·S·S

DK

The Only Guides You'll Ever Need!

THIS SERIES IS YOUR TRUSTED GUIDE through all of life's stages and situations. Want to learn how to surf the Internet or care for your new dog? Or maybe you'd like to become a wine connoisseur or an expert gardener? The solution is simple: just pick up a K.I.S.S. Guide and turn to the first page.

Expert authors will walk you through the subject from start to finish, using simple blocks of knowledge to build your skills one step at a time. Build upon these learning blocks and by the end of the book, you'll be an expert yourself! Or, if you are familiar with the topic but want to learn more, it's easy to dive in and pick up where you left off.

The K.I.S.S. Guides deliver what they promise: simple access to all the information you'll need on one subject. Other titles you might want to check out include: Dreams, Caring for Your Horse, Planning a Wedding, and many more to come.

GUIDE TO

Digital Photography

TOM ANG

Foreword by **Herbert Keppler**
Publishing Director, *Popular Photography & Imaging*

DK Publishing

LONDON, NEW YORK,
MELBOURNE, MUNICH, and DELHI

DK Publishing Inc.
Editor Anja Schmidt
Project Director Sharon Lucas
Publisher Chuck Lang

Dorling Kindersley Limited
Project Editor Paula Regan
Project Art Editor Martin Dieguez
Managing Editor Julie Oughton
Managing Art Editor Heather McCarry
Production Rita Sinha
DTP Designer Mike Grigoletti

Produced by
Sands Publishing Solutions
4 Jenner Way, Eccles, Aylesford, Kent ME20 7SQ
Project Editors David & Sylvia Tombesi-Walton
Project Art Editor Simon Murrell

First American Edition, 2004
00 01 02 03 04 05 10 9 8 7 6 5 4 3 2 1

Published in the United States by
DK Publishing, Inc.
375 Hudson Street
New York, NY 10014

Library of Congress Cataloging-in-Publication Data

Ang, Tom.
 KISS guide to digital photography / Tom Ang.
 p. cm.
 ISBN 0-7894-9696-8 (alk. paper)
 1. Photography--Digital techniques--Handbooks, manuals, etc. 2. Image
processing--Digital techniques--Handbooks, manuals, etc. I. Title.
 TR267.A54 2004
 775--dc22

 2003055522

Color reproduction by Colourscan, Singapore
Printed and bound by MOHN Media and Mohndruck GmbH, Germany

Discover more at
www.dk.com

Contents

Foreword

WHEN ASKED BY TOM to write a foreword to his book, I approached the task warily. While I have spent a lifetime with film cameras and all the paraphernalia needed to develop, print, and enlarge pictures, I am nearly a digital dinosaur. Was I the best person to write a foreword to a digital guide? Wouldn't Tom be better off with a digital expert? I was immediately told that the K.I.S.S. Guide series was meant for beginners, so it actually made more sense for me to write the foreword that an expert.

Being only of late the owner of a digital camera and still considering myself a novice PC owner and user, I naturally had already scoured the digital bookshelves to help me along. I'm afraid many have helped me short.

Bookstores are fast filling with tomes all purporting to teach you everything you need to know about digital photography. But it's sad how many miss the mark with many words but poor or virtually no illustrations. Few are easy reading, and almost none of the authors remember that the purpose of digital photography is to have fun while making great pictures. Would Tom Ang's K.I.S.S. Guide to Digital Photography *be any better?*

Well, like the commercial for that famous spaghetti sauce, "It's all in there." Most important, it's an enjoyable read from beginning to end and is handsomely illustrated with interesting, instructive photos.

Is it easy going? Very much so. Great for dinosaurs. You'll find the book is cleverly arranged so you can tentatively wet your digital feet getting to know your digital camera and which buttons do what. You'll even learn how to make a hood for your monitor so you can see the screen in bright sunlight!

Almost imperceptibly you ascend the stairs to more sophisticated digital steps such as sharpening pictures, caring for your scanner, plus getting tonal and color perfection. By the end, you'll be manipulating images, stitching pictures together for magnificent broad views, making photomosaics, and producing montages, as well as mixing pictures and text.

But Tom hasn't ignored the many would-be digital photographers with no knowledge of shutter speeds and apertures. Everything you need to know about setting your camera is here – and neat stuff about good and bad composition – complete with pictures.

Three cheers, too, for the fascinating page layout complete with nifty cartoon creatures that pop up often to emphasize important or technical points, warn you what not to do, and give you inside-scoop suggestions. Meanwhile, trivia boxes provide amusing information throughout.

Would it be appropriate to say that you'll have a great romp through this guide while learning? Take it from an old dinosaur – you will.

HERBERT KEPPLER

Introduction

DIGITAL PHOTOGRAPHY takes you to the frontier of a wonderful new land. It opens up endless opportunity, boundless and harmless fun, a chance to be truly creative, and – best of all – a way to make a small contribution to peace, to the well-being of society. It can bring together the feelings and emotional parts of yourself with the technical and physical: a perfect blend of the objective with the subjective, of left brain with right.

Am I exaggerating? Not at all. What else allows you infinite combinations of visual effects, yet you use up nothing but a little electricity to run the computer and monitor? What else allows you to experiment endlessly in whatever way you wish for as long as you can stay awake, all the while barely making a dent on the earth's resources? And digital photography gives you the power to reach others around the world with your images and ideas for less than the cost of a telephone call.

What's more, you need not lose out if you wish to work with film or if you have a legacy collection of photographs. With a scanner, you can take all your film with you into the digital wonderland – it will breathe new life and opportunity into your photo collection.

In this book, we open the world of digital photography to you. It is the future of photography, but you can enjoy it now. In that way, even the most modest worker is actually contributing to the development of the medium. You might not feel it, but let me assure you: you're on the cutting edge of today's artistry.

If you are not confident about your photography, worry not. If you just want to have some fun and learn a few simple effects, then this is the book for you. But if you want to take it further, to build a foundation for photography that is more rewarding and of better quality, then this book will give you that basis, too.

In fact, we assume no prior knowledge of either computing or photography, and we take you step by step through every major topic. So, switch on your digital camera and computer, turn the pages, and open a new chapter in your creative activities.

It is not only an honor to have the foreword written by Herbert Keppler, it nicely completes a circle. Mr Keppler's work was an inspiration to me in my early days of photography – when zoom lenses were rare and automatic flash was yet to be invented. His common sense, deep knowledge, and, above all, his huge love and enthusiasm for photography were my guides and encouragement. I hope this book passes on that tradition – to inform and inspire your photography.

TOM ANG

What's Inside?

THE INFORMATION in the K.I.S.S. Guide to Digital Photography *is arranged from the simple to the more advanced, making it most effective if you start at the beginning and slowly work your way through to the more involved chapters.*

Part One

Digital photography is the meeting point of technology and artistry, bringing together fun and powerful ways of communicating. Here we lay the foundations for maximum enjoyment, trouble-free operation, and limitless creative output in digital photography.

Part Two

Enjoying your photography is like building a rewarding relationship: you get out as much as you put in. By making your photos work for you, your satisfaction will increase. Which means you have to do some work too!

Part Three

Your old photographs can also play a part in the digital revolution. Just scan them in and, for all the computer knows, they are digital files like those from a digital camera. In this part, we learn that the more carefully you scan, the better your results will be.

Part Four

Digital photography gives you unprecedented control over the quality of your images as well as the content. You're not quite Mistress or Master of the Universe but certainly of your image. In this part, we learn how to tweak and finesse the image.

Part Five

Explore the boundless power of image manipulation – it's all good, clean, utterly absorbing fun. Better still, you can try out hundreds, if not thousands, of different effects without wasting a single sheet of paper or drop of ink.

Part Six

Digital photography puts all the creative power into your hands. You really can control much of the process – which is itself a big part of both the challenge and the enjoyment. In this part, we learn how to control that power, to make your pictures shine.

The Extras

THROUGHOUT THE BOOK, you will notice a number of boxes and symbols. They are there to emphasize certain points I want you to pay special attention to, because they are important to your understanding and improvement. You'll find:

Very Important Point

This symbol points out a topic I believe deserves careful attention. You really need to know this information before continuing.

Complete No-No

This is a warning, something I want to advise you not to do or to be aware of.

Getting Technical

When the information is about to get a bit technical, I'll let you know so that you can read carefully.

Inside Scoop

These are special suggestions that come from my own personal experience. I want to share them with you because they helped me when I was starting out.

You'll also find some little boxes that include information I think is important, useful, or just plain fun.

Trivia...

These are simply fun facts that will give you an extra appreciation and understanding of digital photography.

DEFINITION

*Here I'll **define** words and terms for you in an easy-to-understand style. You'll also find a glossary at the back of the book packed with digital-photography lingo.*

INTERNET

www.dk.com

I think the Internet is a great resource for digital photographers, so I've scouted out some websites that will add to your enjoyment and understanding of the subject.

PART ONE

How to Get Started

DIGITAL PHOTOGRAPHY is the meeting point of technology and artistry, bringing together fun and powerful ways of communicating. Here we lay the foundations for maximum enjoyment, trouble-free operation, and limitless creative output in digital photography.

Getting Switched On

AFRAID TO SWITCH ON YOUR CAMERA? Terrified of making your computer crash? Don't worry. We will start from the utter basics in this chapter and won't assume you are a technically proficient person. The simple secret to starting digital photography is to follow instructions carefully and methodically – everything counts, from putting batteries in the right way, to connecting cables in the right order. In this chapter we give you background information to help you understand the instructions. But first there's an overview – a map, if you like – of the whole process, so you can see how it all works together.

In this chapter...

✓ **Where digital photography fits in**

✓ **Getting to know your camera**

✓ **Me boss, you camera**

✓ **Further features**

LET'S TAKE IT EASY AND NOT GO STRAIGHT IN AT THE DEEP END

Where digital photography fits in

*THE MOST MOMENTOUS DEVELOPMENT in photography since its birth is the invention of **digital photography**. This revolution occurred when traditional film and processing were replaced by the electronic photosensor with digital memory and computer data processing. This has left the camera part essentially the same as in film-based photography – a light-proof box carrying the controls and lining up the lens to the sensor – meaning that seeing, taking, making, and creating a photograph is pretty much the same as ever.*

DEFINITION

Digital photography *is a type of photography in which any stage involves or uses a digital image.*

What has altered, almost beyond recognition in less than half a decade of tumultuous change, is what you do after you have captured the image. In the meantime, however, film-based or classical photography has not been left behind; on the contrary, it has received a tremendous boost (see opposite).

DEFINITION

*A **memory card** is an electronic chip inside a slim plastic casing; it stores information such as image data. Memory cards are often nicknamed "digital film." There are many kinds and standards (see p.40).*
*A **digital image** is any picture or graphic in digital form. It could be created directly by drawing, but could also be caught in a camera or scanner.*

Digital convenience

More and more people are discovering the advantages of digital photography, the greatest of which is its unparalleled convenience. Even when you take into account the investments needed to gear up and get up to speed with the computing side, digital photography is overwhelmingly more convenient than film-based photography.

Besides, you do not need your own computer to enjoy the benefits of digital photography. Increasingly, photo stores and larger shopping malls are offering printer facilities, where you simply insert your **memory card** or a CD of your images, press a few buttons, and, seconds later, brilliant color prints will be dropping into your hands. In addition, the virtual nature of the **digital image** means you can send it easily via a cell phone, the Internet, or an office network.

DEFINITION

*To **scan** is to use a machine to make a digital copy of your original photograph.*

Many of you will have lots of photographs taken with normal film – holiday and family shots of years gone by (your "legacy" material). Once you **scan** these, you turn the image into a digital form and gain all the advantages of going digital.

PHOTOGRAPHIC PATHWAYS CHART

Something magical happens when you combine film-based photography with the pathways through digital photography, and a whole new world opens up to you. The only limit is your imagination. By increasing your options, total photography can inspire as it empowers. Today's photography can give you the best of both worlds.

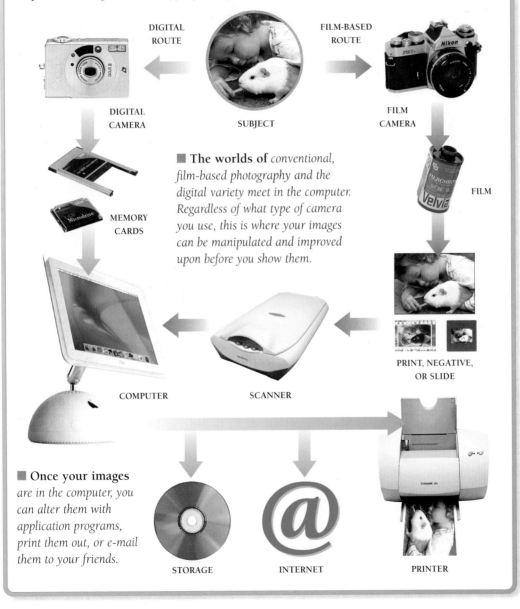

DIGITAL
ROUTE

FILM-BASED
ROUTE

DIGITAL
CAMERA

SUBJECT

FILM
CAMERA

■ **The worlds of** *conventional, film-based photography and the digital variety meet in the computer. Regardless of what type of camera you use, this is where your images can be manipulated and improved upon before you show them.*

MEMORY
CARDS

FILM

PRINT, NEGATIVE,
OR SLIDE

COMPUTER

SCANNER

■ **Once your images** *are in the computer, you can alter them with application programs, print them out, or e-mail them to your friends.*

STORAGE

INTERNET

PRINTER

Getting to know your camera

A MODERN DIGITAL CAMERA looks like a space-age gadget crammed with tremendous abilities. It can be an intimidating machine, bristling with buttons and switches. If you are new to electronic equipment or cameras, there is no need to feel intimidated when you first pick up a digital camera and don't know what to do with it.

■ **It may look like** *a film-based camera, but this is a complex mix of optics and electronics that can easily deliver excellent images.*

Despite all the manufacturers' claims, there is nothing intrinsically obvious about using a digital camera. After experiencing different models, you will start to understand the special language of signs and button-pressing sequences. But right now, just being able to turn the thing on is actually quite an achievement. Congratulate yourself if you've managed that!

■ **Buttons and switches** *on a digital camera give the user access to a wide range of settings, with displays on the LCD monitor.*

Digital-camera features

A digital camera contains some features that you will not find on a conventional camera and some that you will. Here is a selection of some of the most important features.

- ● **Viewfinder** The direct-vision type of viewfinder views the subject as if through a telescope. The electronic viewfinder is a display that you view through an eyepiece.
- ● **Display panel** This shows the images you've captured as well as displaying *menu* options.
- ● **Autofocus zoom lens** The image-capturing optic may be adjustable from moderately wide-angle to magnified, telephoto views. The control is usually a separate double switch or a ring around the lens.

DEFINITION

*A **menu** is a list of options offered by the camera. You must select one to set the camera to that option.*

● **Control buttons or dials**
These allow you to set
options as well as operating
modes such as flash, image
quality, and close-up working.

● **Power on/off** Turn this on
to start the camera working.
This may take some time
if the lens needs to be
extended, covers pushed out
of the way, and so on. After
a time, the camera will turn
itself off if it is not used.

● **Flash** This window spreads
out light from the electronic flash.
On some cameras, the flash pops up
like a car headlight when needed.

● **Hot shoe** Where fitted, this lets you fit an external
electronic flash for more power and versatility.

● **Connectors** Usually kept under a cover, sockets allow
connection to a computer, domestic TV, and mains power supply.

● **Memory-card slot** Slip a memory card in here, first ensuring it
is compatible with the camera.

● **Battery cover** Always use the recommended type. Never mix
types of battery – for example, NiMH with NiCd – if the camera
takes several batteries.

● **LCD (liquid crystal display)** This shows images as you capture
them, allows you to review them, and displays preference settings.

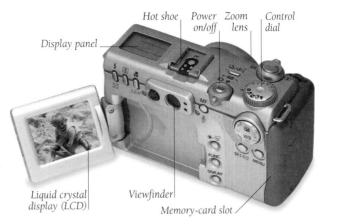

Display panel — Hot shoe Power Zoom Control
on/off lens dial

*Liquid crystal
display (LCD)* *Viewfinder*
Memory-card slot

■ **A swinging LCD screen** *is useful for taking shots
at awkward angles. Even self-portraits are made easy.*

Trivia...

*The most common reason for
new digital-camera users
calling a helpline to report a
camera "dead on arrival" is
failure to put the batteries in
the right way. The second
most common reason: failure
to read the instructions.*

ELECTRONIC VIEWFINDERS

Some digital cameras provide what seems to be an **SLR** viewfinder,
but in fact you view the image on an LCD screen magnified by
the eyepiece. This avoids the complicated mechanics and weight
of a true SLR design. The big disadvantage is that the LCD screen's
refresh rate – the speed at which it can construct or reconstruct
an image – is too slow to respond well to movement, either of the
camera or the subject. Modern electronic viewfinders can deliver
excellent images – look out for the ferroelectric LCD type.

DEFINITION

*An **SLR** (single-lens reflex)
camera uses the same lens for
viewing as for taking the
picture. For focusing and
framing, you view the image
on a focusing screen; the
image you see on the screen is
how your photo will turn out.*

Me boss, you camera

EVEN BEFORE YOU LEARN how to use the camera, you need to learn how to use the buttons. If you don't press them in the right order or combination, the camera will stubbornly ignore you. Don't be afraid of it: show it who's the boss.

Fortunately, the factory settings – the camera as it comes out of the box – will get you a long way. After putting in the batteries, you may need to put in the memory card before the camera will work. Again, follow the instructions. Many cameras offer a "Quick-Start" sheet, so you can plough through the full details at your leisure.

■ **Look out** *for cameras that have a hot shoe for fitting an extra flash unit.*

GETTING TO KNOW BUTTONS AND SWITCHES

Digital cameras have several buttons; most will be one of the following types:

- **Power on/off** Find this first. Nothing will work unless the camera is turned on. It is usually marked with a red dot, a power-on sign (a circle with vertical line), the outline of a camera, or a similar symbol.
- **Press and hold** On/off buttons may be this type. A quick jab will have no effect – you have to hold it down for one or two seconds before the camera responds.
- **Switch** Some operations require the use of a switch. You may have to press a button to unlock the switch before you can swing or turn it.
- **Shutter button** This is the all-important lynchpin of photography – you should find it comfortable to use.
- **Press once** Most buttons are of this type, but they will work only once the camera is turned on.
- **Press more than once** Repeated pressing of the same button brings up different choices. To make a selection, you may need to press another button, often called "OK."
- **Hold down one button, press another** This operation is usually reserved for less frequently used selections.
- **Navigation button** This is usually in the form of a four-pointed button that allows you to select menu items above, below, left, and right of a given item.
- **Dials** Turn these, usually to set different operating modes or to switch on the camera. You may need to hold down a small button in order to turn the dial.

Getting to know you

It is not too fanciful to think of you and your camera as working as a team. For not only do you have to learn how to use the camera to its best advantage, the camera has to learn how you like to work. Do you want to use the flash whenever it is dark, or never? Do you want the camera to adjust color balance automatically? Which quality setting do you prefer? Through setting the camera preferences, the camera is effectively getting to know you and your pattern of work.

■ **Once you have** *discovered all that your camera can offer, you will start working with it, not against it.*

Preferences

Preferences are settings you make in the early days of owning a camera and change only occasionally, as your needs change. For example, to start with, you may choose a low quality setting. This enables the camera to work rapidly, allows more images on to your memory card, and places a lighter load on your computer. Then, as you gain in confidence and need higher quality, you can change the preferences to top quality settings. Cameras usually come out of their boxes with *default* or factory settings.

> **DEFINITION**
>
> **Default** *settings are what a camera or software offers you in the absence of other instructions.*

Default settings are often the best to start with, since they are designed to automate as many functions as possible and to make things easy for you.

> **DEFINITION**
>
> **Navigate** *means to move through menus until you find and select the control option you are looking for.*

To change preferences, you must *navigate* through menus, pushing buttons to reach other menus, then push more buttons to make your selection. The more features the camera has, the more menus you have to figure out. Work patiently and follow the instruction book. If you make an error, it is usually possible to return to the factory settings and start again.

Some cameras provide a dummies', or idiot-proof, setting, often symbolized by a green dot or square. This disables many options so that you cannot choose them until you deselect the idiot-proof setting.

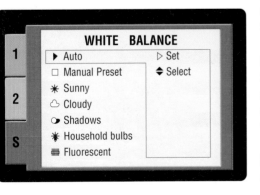

■ **This is an example** *of a typical menu screen that you might find on your camera.*

WHITE BALANCE

1

▶ Auto ▷ Set
☐ Manual Preset ⬍ Select

2

☀ Sunny
☁ Cloudy
☁ Shadows

S

☀ Household bulbs
▦ Fluorescent

USEFUL PREFERENCE SETTINGS

These are some of the preferences that will help prolong your camera battery's life.

- Turn off the image display review. You don't always need to check what you've just shot. Turning off the preview saves power and time. You can always check the shot by pressing the button for image review.
- Turn off the automatic flash. Take charge of your flash from the start. You will make yourself unpopular if your flash pops when you do not want it to, such as during stage performances. You can always turn it on when you know you need it.
- Turn the quality setting to middle or low quality while learning to use the camera.
- Set lower image quality if you don't need to make big prints or if you want to send pictures on the Internet.

Don't be surprised if your batteries go flat in the first few days of owning your camera – you are simply working it much harder than normal. Trying out all the features when learning about the camera places a heavier load on the batteries than usual photography will.

High speed, lots of noise

The majority of digital cameras offer a speed setting. This is rather similar to the film-speed setting of classical cameras, but here it changes the sensitivity of the photosensor. A high-speed setting, such as ISO 1600, allows you to work in dark conditions, with smaller apertures or shorter shutter times. But there's a downside: the image will be noisier, with poor retention of detail and lower quality color. A setting of ISO 100 or 200 gives the best image quality, but shutter and aperture settings aren't very favorable except in good light.

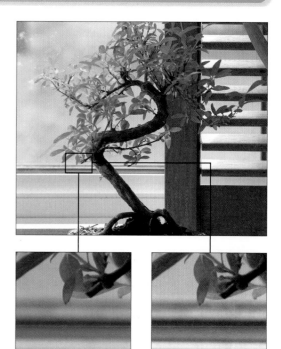

■ **Close-ups of the same scene** *shot at different speed settings (ISO 100, left; ISO 1600, right) show there is more image noise with the higher sensitivity or speed setting (ISO 1600). Noise shows up as details that do not belong, so interfering with fine detail, as well as reducing color purity.*

Further features

A FURTHER LAYER OF FEATURES may be built into your digital camera. One of the big parts of the genius of the digital camera is the flexibility that working digitally brings. This means that many features are simply a reprocessing of, or a different way of assimilating, the data that comes off the photosensor.

Video clips

Your digital camera may be able to make short video recordings at various speeds up to 30 fps (frames per second). This may be easy to access in your camera or hidden deep in the menus. Beware that you may not be able to use some functions, such as autofocus or zoom, during filming. Furthermore, even a short clip produces a huge amount of data, which means your memory card will fill up more quickly. The length of the clip may be determined by the capacity of the memory card. Note that you may need special software to play the video. It is, unfortunately, outside the scope of this book to delve into the world of digital video.

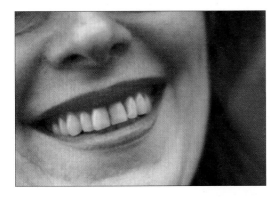

The frame rate for NTSC video (the US standard) is 30 fps; for PAL/ SECAM (the European standards) it is 25 fps. Some digital cameras record at only 18 fps or slower.

Black-and-white

For exactly the same reasons that photographers like to shoot with black-and-white film, you can shoot black-and-white in your digital camera – and without changing memory cards. Black-and-white removes the distractions given by too many colors, thereby encouraging the viewer to concentrate on shape, form, and texture. Black-and-white is ideal for portraiture. Furthermore, if you shoot in black-and-white digitally, you can cram three times as many pictures on to the memory card than if you work in color. Some cameras offer a sepia (brownish) tone mode; there is little point in this since it produces as much data as a color file. You can create sepia-toned images easily enough later (see pp.216–17).

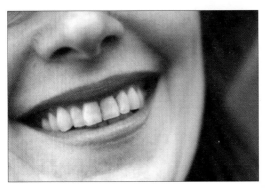

■ **It is easier** *to appreciate the sunny smile in the black-and-white image than in the color.*

Voice memos

Many digital cameras allow you to add a voice memo to a picture: after taking the picture, you press a button and speak into a microphone on the camera for a few seconds. The sound recording is placed with the image file so, with the right software, you can replay the recording. Naturally, this is really useful for anyone who has to make many reference shots, since it saves having to write in a notebook all the time.

Audio files are not large – about 30 seconds of monaural (not stereo) sound produces around 240 KB (kilobytes) of data.

Camera software

Some cameras, generally the sophisticated **prosumer** models, offer yet another layer of features, but these are contained within the software program supplied with the camera to be

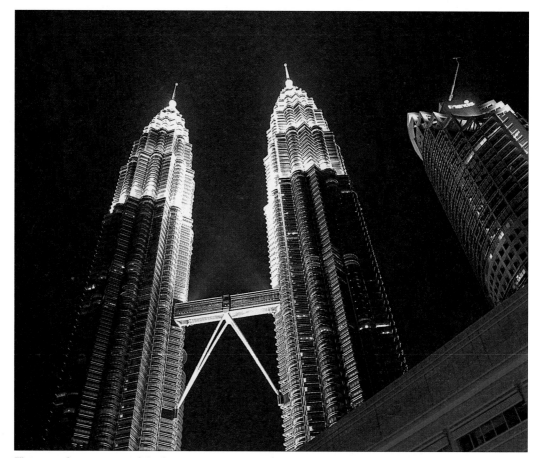

■ **An unsharp image** *of the fantastic Petronas Towers in Kuala Lumpur, Malaysia, would be very unsatisfying. You need camera, lens, and software working together to achieve high sharpness.*

DEFINITION

Sharpness *is a subjective judgment of how clearly details can be seen in an image (see p.161).*

installed on your computer. These additional features may include the ability to set up automatic image editing, such as improving on color richness and **sharpness**. You may also be able to set the camera to record in the highest quality as well as control other functions – such as the way the image files are named, for example.

A simple summary

✓ You do not need to own a computer to enjoy the benefits of digital photography. Color prints can be made from your memory card at many photo stores and shopping malls.

✓ A computer allows you to manipulate your images, improving on them before sharing them with the world.

✓ Make sure you put the batteries in your camera the right way – check your instruction manual if in doubt.

✓ Some digital cameras offer an electronic SLR-type viewfinder. However, this does not respond well to movement.

✓ Do not be intimidated by all the buttons and switches on your

digital camera. The factory settings will be fine to start with.

✓ Some preference settings will help prolong your battery's life.

✓ Opt for lower picture quality if you are not going to make large prints or if you intend to send your images via e-mail.

✓ Experimenting with all the features on your new camera will quickly discharge your batteries.

✓ Some digital cameras allow you to attach voice memos to your pictures. You may also be able to make short video recordings.

✓ Black-and-white pictures can be made on the same memory card as color pictures – unlike in film-based cameras.

Chapter 2

How It All Works

Y OU DO NOT HAVE TO UNDERSTAND how digital photography works in order to enjoy it. Equipment and software manufacturers have taken great pains to make the entire process as easy as possible, but it is complicated, so the greater your understanding, the easier you'll find it to solve problems – and the more you'll enjoy digital photography.

In this chapter...

✓ What goes on in your digital camera

✓ A day in the life of a digital image

✓ Setting up a workspace

PHOTOGRAPHY IS ABOUT ELEMENTS COMING TOGETHER – SUBJECT, LIGHT, TECHNOLOGY, SKILL, AND PATIENCE

What goes on in your digital camera

YOUR DIGITAL CAMERA superbly combines miniaturization, high-precision optics, and high-speed computing. In fact, modern digital cameras carry more computing power in their compact bodies than was used to put a man on the Moon.

Your digital camera is also a model of precision manufacturing. The need for precision is set by the tiny sensor and the even tinier photosensors. Most sensor chips are smaller than a postage stamp, yet they carry over 3 million photo cells. The lens must place an image on these cells square on to the sensor. If not, image quality will be seriously impaired.

Working the sensor

The photosensor of a digital camera acts like film in a conventional camera: it responds to light in a measurable way. But film can be used only once, while the sensor can be used millions of times because light does not normally cause any permanent change to it.

EXTRACTING COLOR

In order to record true colors as we see them, digital-camera sensors are covered with a matrix of squares – one for each pixel – colored red, green, and blue. This extracts color information by looking at the separate pixels and making complicated calculations – a process with the quaint name of "demosaicking," or color interpolation.

■ **Filters pass most** *of their own colors but also some others – for example, blue passes mostly blue as well as some green.*

■ **The filter array** *is cemented to a layer of photosensors so that each filter is centered over a sensor.*

■ **To create an image,** *the camera's software analyzes three grids of color information to work out the intermediate color values. This process is called color interpolation.*

On the contrary, a photosensor is constantly responding to light that falls on it. As with film, there are, of course, limits to what a sensor can do and how much light it needs in order to work. With experience, you will discover the limits of your sensor's capabilities.

All computer chips are sensitive to light, which is why they are covered with a black top. Those used in digital cameras are designed to measure the light and send signals to another computer chip, which processes the information, so the light-sensitive surface is left open.

Working the shutter

A few digital cameras use a traditional shutter – a mechanical blind that shuts out light – but the majority tend to use an electronic type of shutter. In these electronic shutters, the sensors are timed for exposure to light (as if the shutter were open), then they are made insensitive to light by sending all the collected light (now as electrical charge) under the covered part of the sensor.

■ **For all the marvelous technology,** *there are limits to what digital cameras can do – for example, a big difference between light and dark cannot be fully captured. Here we either lose the hill in darkness to record the sky, or we get the hill right – but then the sky becomes a featureless white.*

In bright light, an electronic shutter can open for just a brief time, while in darker conditions it stays open for longer in order to collect more light.

In practice, what matters is the responsiveness of the shutter to the shutter button: choose one that responds very swiftly to the press of the shutter button.

One difference between film and photosensors is that longer exposures cause "noise" – that is, pixels that do not correspond to details in the subject. This looks like the graininess of fast, high-sensitivity films.

Working the aperture

The lens aperture is a measure of the relative size of the hole in the lens, which controls how much light is transmitted through the lens: a large aperture allows lots of light through; a small one restricts the light. Aperture controls the **depth of field** of the image for the lens and focused distance: for landscapes, for which you want great depth of field, you set a small aperture. For portraiture, where you might want minimal depth of field, you set a large or wide-open aperture (see also pp.103–4).

> **DEFINITION**
>
> **Depth of field** *is the space in front of, and behind, the plane of best focus within which objects appear acceptably sharp.*

REUSING MEMORY

While classic photography registers and records the image in the same place (the film), digital cameras register the image in one place (the sensor) and record it somewhere else (the memory card). This means that the sensor can be used over and over again, as indeed can memory cards. This is one of the brilliant advantages of digital photography, since, with careful use, memory cards can be used to record thousands of images – offering enormous savings over film and processing in the long run.

SUBJECT

IMAGE CAPTURE

1 Film/sensor imaging

The lens projects an upside-down, reversed image on to the focal plane. For viewing, the digital camera's software automatically displays the image correctly.

A day in the life of a digital image

DIGITAL IMAGES start as light rays coming off the subject of your picture, whether it's a friend, a building, or a landscape. Some of the light is reflected from the subject, but some of it – from a lamp or the sun, for example – may be produced by it.

> **DEFINITION**
>
> **Pixels** – *short for picture elements – are the building blocks of the image. Usually square in shape, they are virtual, having no size until they are printed or displayed.*

All this light is gathered and focused by the camera lens on to the photosensor of your camera. There, your digital image is born: the image is split up into an array or grid of **pixels**, and for each pixel, the light is turned into an electronic signal. This signal is read and turned into information, or image data, and this data is stored in the memory cards.

> ## Trivia...
>
> *Early in 2003, a tobacconist in Rome snapped a suspicious pair of characters outside his shop on his cell-phone camera. He text-messaged the picture to the police, who recognized the pair as wanted for a series of robberies. Minutes later, the men were arrested – perhaps the first time a picture text message has been used to catch criminals.*

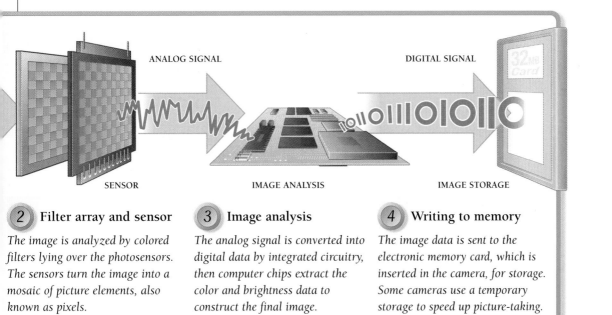

ANALOG SIGNAL

DIGITAL SIGNAL

32MB Card

SENSOR

IMAGE ANALYSIS

IMAGE STORAGE

2 **Filter array and sensor**

The image is analyzed by colored filters lying over the photosensors. The sensors turn the image into a mosaic of picture elements, also known as pixels.

3 **Image analysis**

The analog signal is converted into digital data by integrated circuitry, then computer chips extract the color and brightness data to construct the final image.

4 **Writing to memory**

The image data is sent to the electronic memory card, which is inserted in the camera, for storage. Some cameras use a temporary storage to speed up picture-taking.

The key concept

One of the most important ideas you need to understand is the relationship between the number of pixels that make up a digital image and the quality of that image. It is very simple: the more pixels you have, the better quality the image can be – but not "will be," for quality depends on many things. As a general rule, a digital camera recording 6 MP (6 megapixels, or 6 million pixels) can provide better quality images than one recording only 2 MP.

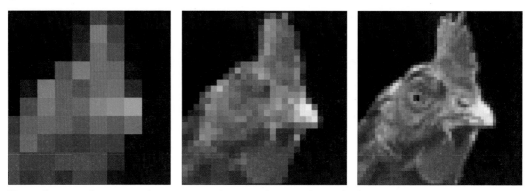

■ **Working with 100 pixels,** *you can make out only vague hints of color and shape (see above left). With ten times that amount of pixels, you can guess that it's a chicken, but details like the eyes are smudged, and the shape of the bill is distorted (above middle). You need over 3,500 pixels to show any detail – the eye and the dividing line between the top and lower part of the bill, for example (above right).*

The imaging chain

The way in which the digital information is turned into an image that you can view involves much computing, but also many subjective factors, such as how we like our colors to look.

Once the image is captured by the photosensor, it has to be stored somewhere. This is the job of the memory card. When you are ready to use it, the data must then be sent to your computer, where it is again interpreted and turned into an image you can view on the monitor.

From the monitor, you can supervise changes to the data – making the image brighter or darker, improving the colors, and removing any defects – using image-manipulation software. You then need to save these changes – you have effectively created a new image, one based on your original photograph. This image can be joined or blended with other images to create an entirely new one, a photomontage, or a composite.

Trivia...

A top-quality digital image contains more data than all the books of the medieval world put together, though not more knowledge! The entire Encyclopaedia Britannica *takes up about 700 MB – the same as only 100 pictures in this book.*

From this, you can send the data to a printer, which can then create a paper print, or hard copy, of your image. Note that the data also has to be interpreted by the printer, which needs its own range of settings. Printer settings can change the size and quality of the printed image, as well as its colors and appearance.

The image data does not have to go to a printer. It can be sent to a distant computer as a Web page, e-mailed to friends, and even sent by cell phone to another user.

INTERNET

www.webcam.com

This site will tell you all you need to know about webcams – what they are, how to use them, and where to buy them. There is a whole host of information.

This handing down of data from one machine to another, processed with various software, forms the imaging chain.

THE VERSATILITY OF DIGITAL PHOTOGRAPHY

Digital photography offers several advantages over traditional, film-based photography. The following points are just the tip of the iceberg.

- **Image capture** Anything you photograph on film can become digital, and anything digital can be output on to film or a print. Besides cameras, you can source images from a scanner, video camera, telescope, microscope, home television, film on DVD, and so on.
- **Web publishing** Photographers are joining film-makers and musicians in exploiting the Internet to reach a potentially enormous audience. You may show off your skills, you could sell prints, and you could even use your pictures to fight for environmental causes.
- **Animating still images** One of the most unexpected developments is the coming together of the still and the moving image. On one hand, many digital cameras can record video clips; on the other, animation software can turn still images into moving ones.
- **Convenience printing** In the time it takes to prepare chemicals to print in a darkroom, you could run off several prints from a desktop printer – and all in the light. And with today's affordable printers, the quality easily comes close to photographic papers. Ink-jet and pigment printers are easy to use and perfect for numerous informal and even professional printing jobs.

Setting up a workspace

DIGITAL PHOTOGRAPHY'S GREAT VERSATILITY is demonstrated by the way any room in an average house or office can be turned into a workroom. The key requirement of a workroom is comfort: you are likely to be spending long hours sitting in the same position, taking little exercise.

The room should be well ventilated, since you will want to dissipate the heat from the computer and monitor, especially during hot weather. It should not have the sun shining in, but, if it does, you should be able to darken it – for example, with a heavy curtain. Make sure it is supplied with sufficient electrical outlets for your needs. And make it lockable: you have expensive gear in there.

The working area

The desk you work on should be stable and capable of taking the heavy static weight of a large monitor without wobbling. It should also be at the correct height: seated at the desk, your forearms should be horizontal or slightly inclined down when working at the keyboard or mouse. And ensure you have enough room underneath your desk for your legs. Finally, your chair should be at the correct height for the table and should support your back and legs.

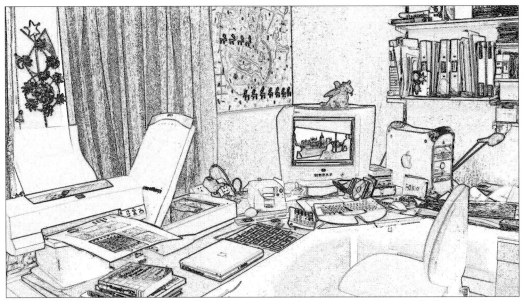

■ **The ideal desk area** *should have all your equipment within easy reach. It is usually best to position the monitor in the middle, preferably in the inside corner of an L-shaped or curved desk.*

ARRANGING THE FURNITURE

There are several points to consider when you are first setting up your digital workspace. Some are less obvious than others, so it is worthwhile mentioning them here. Bear the following in mind:

- Arrange desktop lamps so that they do not shine on to the monitor screen.
- Keep drink and food away from electrical equipment.
- Arrange the monitor so that (a) the top of the screen is approximately level with your eyes or slightly above eye-level – you should not be looking upwards or downwards at the screen; and that (b) the screen does not face a light source, such as a window or a lamp.
- You can make a hood at least 8 in deep (20 cm) from black cardboard to block unwanted light from reaching the screen and degrading the image (see p.59).
- Allow yourself a sound system for entertainment during long printing sessions or scanning runs.
- Arrange picture-editing areas – for example, a light-box – and files away from the computer and monitor.
- Locate safe storage for your data files: any magnetic-based media, such as Zip and CompactFlash, should be stored preferably at least 1 ft (30 cm) from strong magnetic fields (monitors, audio speakers, electrical motors) and away from light (such as direct sun) and heat.

Electrical arrangements

Most computer peripherals draw relatively low current at low voltages compared to domestic appliances. This is fortunate, because the peripherals for a modest workroom easily sprout a dozen power leads, all needing electrical outlets to plug into.

- If in any doubt seek advice from a qualified electrician.
- Do not be tempted to undertake electrical rewiring if you are not qualified.
- Never wire more than one appliance into a single plug.
- Never replace a blown fuse with one of a higher rating than the original.
- Never plug a device into a computer or other peripheral that is switched on unless you know for sure it is all right to do so.
- Never unplug a device that is halfway through an operation, usually indicated by a steady or pulsating light, or by the noises as it works.

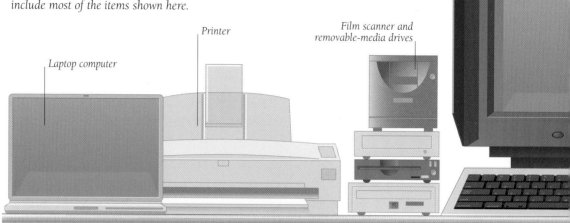

■ **The basic equipment** *that you need in a digital-photography workspace, especially if you work with prints and transparencies, should include most of the items shown here.*

Laptop computer

Printer

Film scanner and removable-media drives

Monitor with hood

Avoiding injury

It is unlikely that you will work the long hours at the high levels of stress that lead to repetitive strain injury from excessive typing or use of the mouse, but you should still take precautions.

- Work for no more than an hour at the monitor at any one time.
- After an hour's work, get up and walk around, make some coffee, and take a few minutes' break.
- After two hours' work, get up, stretch, and take a longer break: look out of the window at distant objects. Don't take a break by watching television.
- Monitor and listen to your body constantly. If something starts to ache or feel uncomfortable while at work, it is time to make adjustments or to stop what you're doing.
- Keep your equipment clean and well maintained: sticky mouse balls and dirty monitor screens or keyboards can all add to strain in more or less subtle ways.

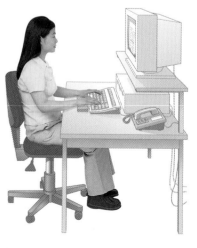

■ **Posture is very important** *when working at a computer for long hours. Be sure that your chair and desk are set at the correct heights.*

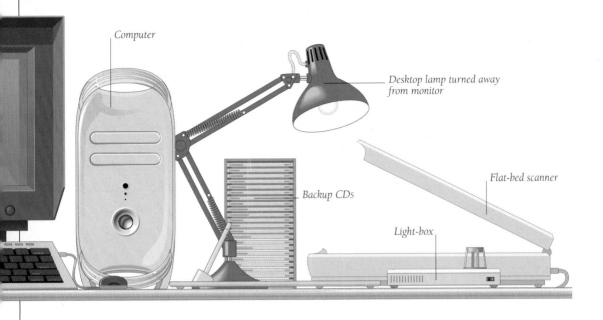

Computer

Desktop lamp turned away
from monitor

Flat-bed scanner

Backup CDs

Light-box

A simple summary

✓ A digital camera's photosensor responds to light just like film. Unlike film, though, it can be used millions of times.

✓ Most digital cameras do not use a traditional type of shutter. Instead, the sensors are timed for exposure to light.

✓ The aperture setting controls the amount of light permitted through the lens to the sensor.

✓ Memory cards can be used to record thousands of images.

✓ The passing of data between machines, processed with various software, forms the imaging chain.

✓ Digital photography is far more versatile than film-based work – from image capture to printing.

✓ Any room in an average house or office can be turned into a digital-photography workroom.

✓ Be sure that your furniture and electrics are conveniently and safely arranged.

Chapter 3
The Camera–Computer Relationship

THE DAYS OF IMPENETRABLE INSTRUCTION books in amusing varieties of English are over. If, at first, you find your camera's instruction book confusing, that is natural: modern cameras offer numerous options. So, while you can figure out so much just by playing with the controls, keep the instructions handy so that you can refer to them from time to time.

In this chapter...

✓ **Linking with the computer**

✓ **Communicating with the computer**

✓ **Viewing your images for the first time**

✓ **Troubleshooting**

SETTING UP YOUR COMPUTER NEED NOT BE A THORNY ISSUE

Linking with the computer

DIGITAL-CAMERA MANUFACTURERS *have made enormous efforts to make it easy to get pictures from your camera into the computer. However, they still have a long way to go to make it entirely painless. Apple Macintosh computers come equipped with software that recognizes digital cameras and that will start up as soon as you connect one. Other machines may need special software installed.*

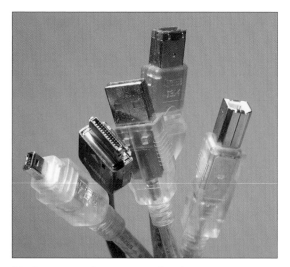

Plug-and-play is the rather hopeful notion that you simply plug your accessory (card reader or digital camera, for example) into the computer and can immediately get to work. The reality is that you usually need to install software before all the functions will work.

■ **The types of connector** *found on your camera and computer may vary with their age or, in some cases, their manufacturer.*

Connections and ports

The main method of connecting a camera to a computer is the cable or lead – fine wires in a plastic casing – with standard plugs, of which the USB (Universal Serial Bus) is the most common. Another type of connection is FireWire (also called i.Link or IEEE 1394), which is plugged into compatible or matching ports or sockets in the computer. It is safe to plug and unplug these while the computer is on, but be sure to follow the manufacturer's instructions regarding unplugging the camera. And make sure you don't unplug the camera while in the middle of transferring images.

■ **USB connectors** *have become the standard connection for both PC and Apple Mac users.*

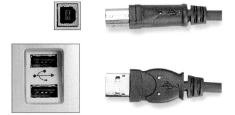

■ **When high-speed downloading** *is preferred, FireWire is the connector of choice.*

■ **Parallel ports and SCSI** *(Small Computers Systems Interface) connections are becoming less common as more and more equipment manufacturers opt to use USB and FireWire.*

■ **An adapter** *can be used if the type of connector on your camera differs from that on your computer.*

One other thing to bear in mind is that, although the connection may comply with the standard, the plug may be different – there are at least four different sizes of USB plug, for instance. So take care when replacing your cables.

Only USB and FireWire are designed to be "hot-pluggable" – there is no need to turn off the computer before connecting or disconnecting. With all others (such as serial, parallel, and SCSI) you must turn off the computer first.

HOW TO INSTALL SOFTWARE

To avoid the sort of problems that can often occur with newly installed software, follow these helpful hints:

- Read the instructions – you may have to install items in a specific order or ensure a certain file is up to date before the software will work properly.
- Turn off virus protection.
- Ensure you install via the installer or install shield program.
- If the software does not work properly, it may be easier simply to reinstall it from scratch – existing files belonging to the software will be overwritten.
- If the computer crashes when you first run the software, there may be a conflict. Try starting the software with no other software running. Check the "read me" files or contact the manufacturer via its helpline.

Beware that, at times, new software can conflict with existing programs: if you have a problem, uninstall the newest addition from the installation disc, and see if that fixes it. If not, report the problem to the software manufacturer and ask if there is a fix you can download.

Communicating with the computer

THERE ARE TWO PARTS to any communications with a computer. First, you need a suitable device to carry information that the computer can read. Then, obviously, you need a way of connecting the device to the computer, though that connection need not be visible.

A different memory

You can connect your camera directly to the computer, but that is best left for special purposes. Generally, it is most convenient to connect the memory card to the computer using a card reader or interface. You will, of course, need the right interface for your specific card type. Unfortunately, there is a growing plethora of types. Here are some of the more important ones.

- **CompactFlash (CF)** is the most widespread and often the least expensive, but it is relatively bulky compared to the latest types. It is flexible and reliable and can store large quantities, but the price rises rapidly with capacity.
- **SmartMedia** is very light and thin but fragile. Though widespread in use, its capacity is limited.
- **Memory Stick** is also light, but it is a little more robust than SmartMedia. It is slightly more expensive than CompactFlash but is just as versatile and can be built to quite large capacities.
- **Secure Digital (SD)** is a tiny card, yet it can reach large capacities. The cost is much greater than CF cards of the same capacity.
- **Multimedia (MM) cards** look very similar to Secure Digital cards and cost about the same.
- **xD cards** are very small and cost around the same as the other small cards.

COMPACTFLASH

SMARTMEDIA

MEMORY STICK

MICRODRIVE

The best-value card is actually not a card, but a tiny jewel of a hard-disk drive called the IBM Microdrive. It offers huge capacity – standard is 1 GB (gigabyte), which is over 1,000 MB. For a unit of memory, it is about half the price of any memory card.

Before you use a new memory card, you may need to format it – that is, enable it to record data. This can be done in the camera. When you first insert the card, the camera should recognize that the card needs formatting. It will also warn you that formatting will remove all data. Agree to it and, a few seconds later, you're done.

Removable media

Today's media for storing data are a far cry from the floppy disks and enormous Winchester disks of old. Now they combine incredible capacities with low cost, robustness, and ease of use. For individual use, the most cost-effective are hard-disk drives: these have huge capacities and a low price per unit of data. But you will not want to send these through the post. For exchanging files, the most widespread type is also the most useful: at the time of writing, the Zip disk, with a 100-MB nominal capacity, is almost universal.

Other ways of transferring images

Downloading your images directly from your camera may appear the easiest way, since it uses the equipment you have and you don't have to buy any extra gear. But this system is often slow, relies on sometimes-imperfect software, and if your camera has a power failure during a long download, your computer may crash.

There is a simpler way, and it's not too costly. A memory-card reader takes data off the memory card and passes it down to the computer. The majority of these need no extra software and are likely to be recognized by the computer. Simply remove the memory card from your camera and slot it into the card reader, which you have previously plugged into your computer, either directly or via a USB or FireWire cable. You don't even have to turn off the computer first.

The card then turns up as a mounted volume, just like any other removable media. Select the files you want to use and drag them into your work folder.

INTERNET

www.datarescue.com

To retrieve data from damaged memory cards, try PhotoRescue, available from this website.

■ **A memory-card reader** *is a faster alternative to using your camera when it comes to downloading your images to your computer.*

Viewing your images for the first time

IT MAY NOT BE UP THERE with your first kiss or the birth of your child, but it is a thrilling moment when you first view your images properly. Open up the folder that contains your images by double-clicking on it, then double-click on the icon of a picture – it will be displayed in moments. Depending on your camera's settings or how you transferred the image to your computer, the image will appear in a simple picture-viewer software or the browser provided by your camera or scanner manufacturer. Many of these are useful only for viewing.

It is usually best to open your images through your image-manipulation application. Start the application, then go to File › Open to look for your image.

■ **Digital photography** *can produce hundreds of images for you, but one of its great advantages over film-based photography is that they can easily be organized in an image-browsing application program.*

Moving files around

Sooner or later you will want to move your digital files from one folder to another, either to reorganize your images or to make room for more. First, select the files you want to move; you can click on each one while holding down the Shift key, so that you can move a whole lot together, or you can move the contents of the folder by moving the folder itself. You need to **click-drag** files from one location to another. Note that if both locations are on the same disk, you will move the files. But if you move a file from, for example, one hard disk to another or to a removable drive, the files will be copied – that is, duplicates will be made in the new location.

■ **The best way** *to view your images is from within your image-manipulation application.*

Deleting images

After a few sessions of untrammeled joy in making one exposure after another, you will realize that all those images you have transferred from your camera's memory card to the computer have filled up the computer's hard disk awfully quickly. The obvious solution is to **delete** or remove any images that you no longer want or need. However, consider this: a deleted image is gone forever, and methods of storing files are relatively inexpensive.

■ **Images such as this,** *from a defective file, are very rare – usually you will not be able to open them at all. Unfortunately, such errors are almost impossible to repair.*

A CD capable of holding hundreds of images may cost you less than a typical cell-phone call. Hard disks with the capacity to store thousands of images can cost less than the price of a medium-capacity memory card.

In addition, the era of digital photography means that the image you capture is now only the start of the process. Even if it is badly exposed, out of focus, and the wrong color, it may be just right as a background for a composite. It may be badly composed, but an element – a shop sign or elaborate street furniture – may be just what you need to repair another image. You don't know how useful an image will be until perhaps years later.

■ **Working on a book** *on Scotland many years ago, I almost neglected to print up a pale, shapeless shot. It had been so cold, I'd even forgotten I'd made that shot. Thirty years later, it proved to be the perfect image for the cover of another one of my books.*

Troubleshooting

UNFORTUNATELY, DIGITAL CAMERAS often go wrong, or appear to go wrong. The fact is that digital cameras are not built like tractors: it takes very little for them to stop working. On the other hand, it is usually easy to get them going again. You just need to know a few tricks.

Camera stopped working for no apparent reason

Try replacing the batteries with brand-new ones and recheck the camera. Clean any electrical contacts carefully with a dry, clean, lint-free cloth. Check that the door closing on the memory card clicks shut positively. If these measures fail to restore the camera, it is likely to have been damaged, probably with shock from being dropped or bumped.

Digital cameras are high-precision electronic devices. They are not nearly as robust as conventional cameras and are more prone to damage from vibration, shock, dampness, dust, and cold. All parts, especially any removable media, should be treated carefully – the contacts and tolerances are so fine, it takes very little to distort a part and ruin the electrical contact.

Memory card will not format

Contacts between the card and camera may be faulty or dirty. Carefully blow on the set of contacts at the end of a memory card with a puffer or can of air, then clean carefully using a clean, soft tissue. Try reinserting the card a few times – the sliding action is designed to polish the contacts. If the card still does not work and it is still under guarantee, ask for your money back.

Camera will not shoot any more images

You may have run out of memory on the memory card. Even if there appears to be space on the card, it may not be sufficient to record an image (the camera reserves hidden space for file administration). Try setting a lower resolution or lower-quality image if you do not wish to erase any of the existing images. Alternatively, see if you can discard any existing images. It is always a good idea to keep an extra card with you as a standby.

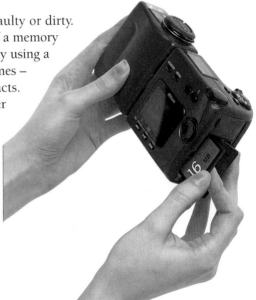

■ **The sliding action** *of inserting a memory card into your camera is specifically designed to help keep the contact points free of dust.*

Camera will not review images

If your camera will not review your images, it may be that you have tried to remove the memory card while it was working; this is usually shown by a warning light. If so, you may have damaged the file structure or the formatting on the card. The camera may then tell you that the card contains no images or that the card needs to be formatted. If that is the case, you will have lost any previously saved images. Reformat (or reinitialize) the card. Always turn off the camera before you remove the memory card. Sometimes the card needs to be inserted and reinserted a few times – this helps clean the tiny electrical contacts.

Camera won't download

Install the software that came with the camera. If the software is already installed, reinstall it and try again. Make sure that the lead that attaches the camera to the computer is connected properly and that the camera is turned on to the correct mode – usually called playback or review. If you are connecting through a USB hub, try connecting directly to the computer.

■ **This digital image** *was made with an early digital camera and displays a good deal of noise – that is, a scattering of pixels that are either too dark or too light for their neighbors, and that do not correspond to the subject's features.*

Connection works erratically

Your connecting leads may be faulty or broken. Try or buy another to check if the problem persists. Don't force in a lead that resists – the plug may be bent, and use of force will damage the plug in the computer or camera.

Download seems to take forever

Some camera software works very slowly. Try downloading a few images at a time. Quit or close down any applications you don't need. Alternatively, try downloading directly from the memory card (see p.41).

A simple summary

✔ You can connect your digital camera to your computer by cable or lead. The most common type of connector is USB, but FireWire is the best.

✔ Be aware when you are buying or replacing cables that the plug type may be available in several different sizes.

✔ Follow the manufacturer's instructions when installing camera software on your computer.

✔ If your software conflicts with other installed programs, try reinstalling it. If the problem persists, contact the software manufacturer.

✔ There are several types of memory card available. They vary in price and capacity.

✔ Downloading your images from a memory-card reader is faster and more reliable than doing so directly from your camera.

✔ Once downloaded, you can view your pictures simply by double-clicking on their icons.

✔ It is easy to organize your digital pictures with an image browser.

✔ CDs are an inexpensive way of storing your images.

✔ There is often a simple solution to any digital-camera problem.

Cameras and Gear

THE EARLIER CHAPTERS OF THIS BOOK assume that you have a digital camera to start with – they are often bundled free with computer outfits. Before long, however, you may want something offering better quality and more functions. Or you may not have a digital camera at all. This section is for you.

In this chapter...

✓ **Choosing digital equipment**

✓ **Choosing 3+ megapixels**

✓ **Zooms and zoom range**

✓ **Camera accessories**

✓ **Choosing a monitor**

✓ **Choosing the best printer**

✓ **Choosing a scanner**

✓ **Software for other jobs**

YOU DO NOT NEED COSTLY, ELABORATE EQUIPMENT TO OBTAIN IMAGES LIKE THIS GENTLE FIJI SUNSET

Choosing digital equipment

TECHNICAL AUTHORITIES AND PROFESSIONALS may advise you until they are blue in the face to select a camera by how well it fits the job you want to do. But in the end, the choice will be made as much on looks, the sound the camera makes, or simply whether you feel you trust the salesperson.

First, however, let's not assume the advantages of digital over film cameras. In some circumstances – travel in extreme conditions, for example – or for the simplest of needs – such as pictures of a toddler's birthday party – film remains the medium of choice.

DIFFERENCES BETWEEN FILM AND DIGITAL

	Film	Digital
Image structure	Silver grains or dye clouds of varying size distributed in a random pattern.	Same-sized sensor pixels arranged in a regular grid, or raster array.
Color recording	Colors in the scene separated by red-, green-, and blue-sensitive layers.	Colors in the scene separated by Bayer pattern of red, blue, and green filters.
Color reproduction	Dye clouds of cyan, magenta, and yellow.	Interpolated from color filter array.
Image amplification	Development by chemical action.	Electronic and digital processes.
Image quality	Depends on film speed, grain structure, and processing regime.	Depends on sensor resolution and interpolation methods; also compression, if used.
Storage	Image fixed by removing unexposed silver: black-and-white stable, color less so.	Image stored temporarily on memory cards or hard disks.

Basic digital cameras

A 2-MP (megapixel) camera produces acceptable to good quality ink-jet printouts up to 10 x 8 inches (25 x 20 cm) in size, so such cameras can be used for a very wide range of work, such as sales brochures, newsletters, publication to postcard size, and record-keeping for collections or asset management. All this can be obtained without the high data-storage overheads of higher resolution images.

Whether you choose an ultra-compact rangefinder type or a substantial SLR-like design with wide-ranging zoom lenses, these cameras offer built-in flash, LCD screens, zoom lens, autofocus, and auto-exposure. Other features may include the ability to make short video clips, record sound, and control over settings like the shutter time.

Check also the type of battery used: opt for Li-Ion (Lithium-Ion) or NiMH (Nickel Metal Hydride) batteries rather than NiCd (Nickel Cadmium) or Alkaline (Alkaline Manganese) batteries.

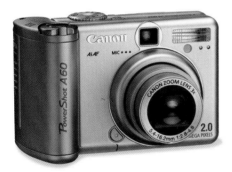

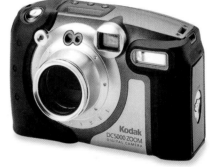

■ **The Canon PowerShot A60** *is a popular, good-value, 2-MP camera with a 3x zoom. It is neat and compact, and some report good battery life.*

■ **A large, 2-MP** *digital camera with a rugged exterior, the Kodak DC5000 is ideal for those who find tiny cameras difficult to use. It has a 2x zoom.*

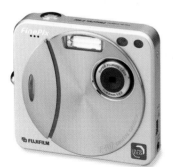

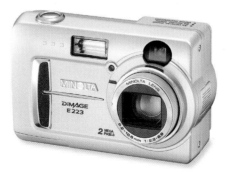

■ **Very neat, compact,** *and easy to use, the 2-MP Fuji FinePix F402 is a good starter model if you do not need a zoom lens and want something compact.*

■ **The Minolta DiMage E223** *is a 2-MP camera with a 3x zoom and a relatively fast lens – all at a good price suitable for the beginner.*

Choosing 3+ megapixels

WITH 3+ MEGAPIXEL CAMERAS, you can produce professional quality images that will make good quality ink-jet prints of A4 size or greater. For reproduction in a magazine you can enlarge to A5 safely and – with non-critical subjects or artistic treatments, such as graininess or blur – to A4 and greater.

DEFINITION

Pixel interpolation *is a mathematical process for working out new intermediate values between known ones. It is used to interpose new pixels between existing pixels.*

These cameras are also generally built to a higher quality, with better electronics and a wider range of features than cameras offering lower resolution. Not only do they cost more on the initial purchase, they are also costlier to maintain, since their larger files require more space to store and need more time to work with. Use these higher resolution cameras only if you really need the quality. Note that some cameras produce an image with more pixels than that on the camera itself: these have been added by **pixel interpolation** and may not represent any true improvement in the detail captured by the camera.

Before purchasing your camera, check that the instructions are in a printed booklet, since there is an increasing trend to supply instructions on a CD. This means that you have to start up a computer in order to read them (irritating) and print out bits you need to refer to.

Checking compatibility

When buying a camera, ensure its connection is compatible with your computer: choose USB over serial, but FireWire (also called IEEE 1394 or i.Link) is best. For batteries, opt for Li-Ion (Lithium-Ion) or NiMH (Nickel Metal Hydride) over NiCd (Nickel Cadmium).

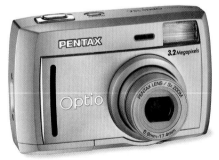

■ **The 3.2-MP Pentax** *Optio 33L has a 3x zoom in a neat package, yet takes standard CompactFlash cards. It has manual focus and reduced shutter lag.*

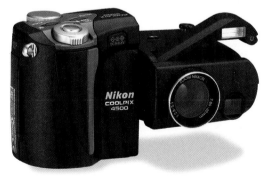

■ **The hallmark feature** *of Nikon's Coolpix 4500 is its hinged body, making it flexible for viewing. It is not, however, the easiest camera to use.*

Changing lenses

There is a growing number of SLR designs, but not all allow lens interchange. If that is important to you, check before you buy. Even if a lens fits, you may not be able to use all exposure modes if it's a recent model, and the effective focal length may not be as engraved on the lens.

Real resolution

Resolution is a measure of how well an optical system can discern or separate out fine detail to a visually useful extent – that is, with usable **contrast**. Manufacturers may make claims that their 2.5-MP sensor can produce files equivalent to a 4-MP sensor through pixel interpolation. The fact is that while an image cannot reveal more information than was captured in the first place, it is possible to process the basic information in different ways to make it look as if there is more information than there is.

DEFINITION

Contrast *measures the differences between the lights and darks in an image.*

The final arbiter of any manufacturer's quality claims is your check of the image itself. Not only should you confirm that you can see more detail and see it more clearly, don't forget to ensure that colors are true, contrast is realistic, and the file-size output is appropriate to the task in hand. Why handle a 12-MB file when all the detail you need is contained in 8 MB?

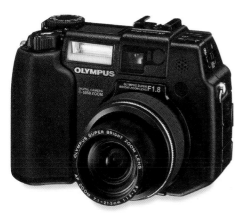

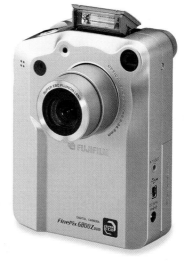

■ **The Olympus C-5050** *is a classic of its time, offering excellent image quality at 5 MP with a capable zoom and full range of photographic controls.*

■ **The uniquely stylish** *Fuji FinePix 6800 makes 3-MP images with an easy-to-use 3x zoom. This camera offers good all-round value for money.*

Zooms and zoom range

ZOOM LENSES ENABLE YOU TO CHANGE the magnification of your image without changing lenses. The optics are designed to change the field of view while keeping the image in focus. When the field of view is enlarged to take in more of the subject, the image must be reduced to fit the sensor – this is the effect of a short focal length, or wide-angle setting. When the field of view is reduced to take in less of the subject, the image must be magnified, again to fit the sensor – this is the effect of a long focal length, or telephoto ("tele") setting.

The best way to use a zoom lens is to set it to a focal length that gives you the visual effect you are aiming for, then make any small changes necessary. This approach encourages you to think ahead of the shot instead of zooming in and out of the scene in an attempt to find a setting that works well.

Zoom lenses are at their best when used as a convenient way of putting the finishing touches to the framing – to cut out or take in more of the scene. The alternative is to move away from or toward the scene.

The zoom lens on some digital cameras is stepped, so you cannot vary focal length continuously – in-between settings may not be available.

Sensor size and field of view

A camera lens projects the image as a circle of light in order for the film or sensor to capture a rectangular area centered on the image. If the rectangle extends to the edge of the circle, then it captures the full field of view. If less, then the field of view will be proportionally reduced.

■ **An easy way** *to check a lens for distortion is to photograph something with regular detail, such as a brick wall or bookcase. This shot shows the slight bowing out of the shelves, so the space between shelves is greater in the center of the image than toward the edges.*

The focal-length factor

The majority of SLR digital cameras that accept normal 35mm-format lenses use sensors that are smaller than the film format. This reduces the field of view available to the sensor. As a result, the 35efl (35mm equivalent focal length) is increased – this means that the field of view is equivalent to that of a lens with a longer focal length. For example, on the Canon 10D or Fuji S2, focal length is increased by about 50 percent compared with the 35mm format coverage. The factor by which focal length is increased – for example, 1.5x – is known as the focal-length factor.

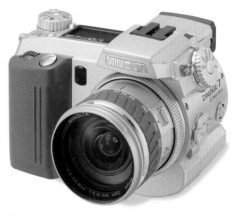

■ **The Minolta DiMage 7** *produces 5.2-MP images through its 7x zoom lens.*

Points to consider when using zoom lenses

There is a handful of issues specific to zoom-lens use of which you should be aware. The following points are among the most important:

- **Distortion** Most zoom lenses distort the image so that straight lines look slightly curved. The problem is usually at its worse at wide-angle settings.
- **Camera shake** At the very long focal lengths that some digital cameras offer – for example, 35efl of 350mm – there is a great danger that camera shake during exposure will spoil image quality. Make sure you hold the camera steadily – preferably supported on a tripod – and use a short shutter time.
- **Less maximum aperture with greater focal length** As you set longer focal lengths, the maximum aperture will become smaller and smaller. Even in bright conditions, then, it may not be possible to set a very short shutter time with long focal lengths.
- **Do not force the lens movement** Some lenses take a few seconds to zoom to their maximum or to retract, but do not be tempted to rush the action by pushing or pulling on the lens – the mechanisms are highly precise and not robust.
- **Use a lens hood** Stray light entering zoom lenses is likely to cause flare and degrade the image with lowered contrast. If you can, use the lens hood at all times. If this is not possible, beware of the effect of having a light source, such as the sun or a bright lamp, in the field of view.

Camera accessories

CERTAIN ITEMS WILL NOT ONLY MAKE a big difference to the handling of your camera, they can greatly improve the quality and reach of your photography. Unfortunately, they mean suffering extra weight and bulk. You will have to balance the gains in convenience against having more to carry.

Tripods

The need for compromise is nowhere more apparent than with tripods. The best are heavy, large, and rigid, whereas small, lightweight ones may be uselessly wobbly. Select one appropriate for the equipment you use: a rough rule is that the tripod should weigh at least as much as the heaviest item you will put on it.

For the best balance between weight and rigidity, look for tripods with carbon-fiber construction – but these are all very costly. Aluminum-alloy tripods are a good compromise – respected makes include Gitzo, Linhof, and Manfroto. If you use the tripod a great deal and need to make fine adjustments, choose a 3D head, in which each axis of movement is separately controlled by a locking arm. For out-and-about work, use a ball-and-socket head – these are more lightweight and compact than 3D heads, are excellent for quick adjustments, but are poor for precise positioning.

TRIPODS

3D TRIPOD HEAD

Very small tripods designed to be used on a table are handy for steadying small digital cameras. Shoulder stocks, which enable the camera to be braced against your shoulder, can help reduce camera shake.

Bags

Your digital-photography equipment is of the highest precision manufacture, so you must protect it. Modern padded soft bags combine good levels of protection with lightweight construction.

CAMERA BAGS

Waterproof housings

Underwater housings are essential for cameras used not just in the sea but in any water-based pursuits, such as white-water rafting and canoeing. Such housings are, of course, ideal for really dusty or wet conditions too, such as industrial sites and deserts. Users of Canon, Sony, and Olympus cameras have a choice of housings provided not only by the original manufacturer but from independent manufacturers – Aquaman and Ikelite, for example. The latter produces housings for Nikon digital cameras too.

A waterproof housing is only as good as the seals or "O" rings between the parts of the housing are clean. Keep these meticulously clear – particularly of sand particles.

WATERPROOF HOUSING

Hood for LCD screen

Bright light reduces the efficiency of LCD screens (see p.58). A hood with magnifying lens restores the screen image to its full brilliance. The hood is attached directly to the camera using elastic or Velcro® straps. The solution is neither elegant nor sturdy, but it works well enough. Some cameras, like the Leica digital camera, are equipped with proper hoods.

Digital-image storage on location

When traveling with a digital camera, it is often impractical (and never convenient) to carry a laptop computer for storing image files. One alternative is the portable hard disk with a slot for reading memory cards and controls for copying files over. Modern examples have capacities of at least 10 GB – enough to hold many thousands of images before they are full – but they are quite costly. Look out for the Archos, SmartDisk, Image Tank, Nixvue, or Mindstor.

PORTABLE HARD DISK

There is no better investment than backup for your images, so do not try to get by without. Few things will haunt you more than losing hundreds of images when you drop your memory card over the side of a boat or down a cliff. Back up NOW, while you think about it!

Choosing a monitor

THOSE OF YOU JUST STARTING OUT on digital photography are lucky. Most items of equipment are immeasurably better and far less expensive than when we "veterans" started. Monitors, humble and dull though they appear, are fantastically good and inexpensive. Your choice is only between LCD and CRT. Incidentally, all modern screens are flat. If you are offered a monitor with a very slightly curved screen, don't touch it (unless it's a Barco, a top-level monitor).

Avoid working at any monitor for more than one hour at a time: it's bad for your eyes, posture, arms, and circulation. Every hour or so, get up, walk around, stretch, look out of the window (but don't watch TV!), make some tea. Ten minutes later, you can work for another hour or so.

Liquid crystal display (LCD)

LCDs are flat panels, not very thick front-to-back, that take up little space on the desk. They are also relatively lightweight. They produce a display that does not flicker, so they are excellent for long periods of work. However, colors may be less intense than on the best CRT monitors. Also, they are a good deal more expensive than CRT monitors with the same size view. If you can afford it, LCD is preferable to a comparable-sized CRT.

LCD screens give you much less eyestrain than even the best CRT monitors, especially when you are writing or working on spreadsheets.

■ **LCD screens** *are compact, lightweight, and capable of delivering excellent quality.*

Cathode ray tube (CRT)

These monitors work by sending electrons on to a phosphorescent screen that glows with light when bombarded. They are similar to domestic TV sets and, like their homely counterparts, are large and lumbering. The models you want, with a screen size of at least 17 in (43 cm) on the diagonal, are enormous, taking up a lot of desk space, especially in the depth, and are all very heavy. Because the image is inherently unstable – it is redrawn dozens of times a second – even well-adjusted sets can cause eyestrain.

■ **CRT screens** *give good quality and are inexpensive. However, they are very bulky.*

CRT advantages

On the plus side, CRT screens can give very good colors and also very high resolutions, so that more things can be displayed on the screen (albeit at a smaller size). Better still, even very high-quality screens cost a fraction of the price of their LCD equivalents.

Modern monitors allow the user to set different resolutions, or number of pixels across the screen. Set the highest resolution that you find comfortable (you may have to restart afterward if using a Windows machine). High resolutions – 1,280 pixels or more across – offer more space to work with because the palettes are smaller.

MAKE YOUR OWN MONITOR HOOD

A three-part hood is easy to make and fix on to your monitor. It may not look very high-tech, but it will do wonders for your screen image. You need firm black or dark-gray cardboard; the amount will depend on the size of your monitor.

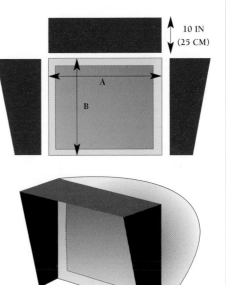

1 Measure the monitor across the top (A) and down its front face (B).

2 Measure and cut one piece of cardboard sized as long as A and about 10 in (25 cm) wide, and two more as long as B and 10 in (25 cm) wide, tapering them as shown in the diagram.

3 Place Velcro® pads on to the monitor: two on the top and at least two on each side. Remove the covering from the pads to reveal the adhesive patch.

4 Place the card in position with the deeper part of the sides at the top.

5 Tape together the joins between the horizontal and vertical cards.

Choosing the best printer

MODERN PRINTERS OFFER what can only be described as incredible value for money. They all produce excellent to remarkable print quality at low prices and are generally highly reliable and easy to use. The only downside is the cost of inks and good-quality paper, but even there, it is possible to obtain good quality at reasonable prices. Let's look at the features you should check out.

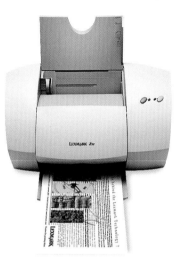

Paper handling

Some printers will automatically detect the paper size and make settings to suit, especially those that can print directly off a card reader. Others can accept a large range of papers of different weights, ranging from ordinary papers of 75 **gsm** through to heavy cards of 300 gsm or more. Some printers are fussy about the paper they accept. If you expect to print on anything unusual, such as watercolor or handmade papers, check the suitability of the printer before purchase.

■ **Even low-cost printers** *produce very acceptable image quality.*

Some larger printers will accept paper on a roll, permitting small posters to be printed. Other versions hold a small roll that allows small prints to be printed one after another on the same strip of paper. One variant that is very attractive is the printer that can print right up to the paper margin, leaving no white border.

Resolution

In general, printers offering more dots per inch can deliver better quality results. If possible, it is best to look at results when comparing printer quality, rather than reading technical specifications.

Four or more inks

Printers using six or more different colors for printing are more likely to produce photographic quality than those using only four colors – but a high-quality printer using four colors can produce better results than an inexpensive six-color printer.

Separate ink cartridges

Most desktop printers keep all the color inks in a single, integrated cartridge (the black is usually separate). This means that if you print out a lot of pictures with, for example, blue skies, you will have to change the cartridge when the cyan ink has run out even though there is still plenty of magenta and yellow left. Digital photographers prefer printers with separate ink tanks for each color.

■ **Being able to change** *your printer's colored ink tanks separately can save you money.*

Printers with card readers

Some printers have the ability to read memory-card devices and print directly off an inserted card without the need for a computer. This is a great convenience for basic proof printing if you need to check the quality of images from a shoot or if you repeatedly need to make prints to order – you can just store prepared image files on a card and print them as needed. Beware, however, that not all printers equipped with card readers can print without a computer – the printers merely have built-in card readers. If in doubt, check before purchasing.

HOW TO CHECK PRINTER OUTPUT

Today's desktop printers can outperform the quality of many digital cameras. Ensure that you print out a very high-quality image with correct color settings.

1. Look closely at areas of very dark tones in your test print. Do the dots of color appear to run together into uneven clumps or puddles? If so, the paper is unsuitable and may give a false impression of the printer's performance. Run a test on better-quality paper.

2. Check large areas of even mid-tones, such as blue skies and evenly painted walls. Are they banded (as though painted in strips with tiny gaps between) or uneven in any way? If so, reject this printer as an option.

3. Check small areas of smooth, even tone, such as the side of a face falling into shadow or the bodywork of a car. Are the changes smooth, or do they look mottled or banded? If so, reject this printer as an option.

Choosing a scanner

*FLAT-BED SCANNERS are like photocopiers: you place the original face-down on a glass plate, and a sensor under the glass runs the length of your original to make the scan. A scanner is a must if you need to **digitize** old prints whose negatives have been lost or prints from negatives that are too large for your film scanner (see opposite). If your print is large enough and good enough, even inexpensive scanners are capable of producing results that can, with a little work, be turned to publication quality.*

> **DEFINITION**
>
> *To **digitize** is to turn an analog record, such as a print, into a digital file – either using a scanner or a digital camera.*

Some flat-bed scanners can scan transparent originals but may need a transparency adapter to do so. Check that the adapter is supplied with the scanner, since separate ones can add considerably to the total cost.

Well-known manufacturers such as Epson, Umax, Microtek, Canon, and Heidelberg all offer machines that cater to the needs of a range of people, from the home-office worker, to the pre-press expert. Manufacturers like Canon, Epson, and Hewlett-Packard concentrate on machines for the consumer and can

■ **Whatever scanner you buy,** *you should be able to achieve excellent results from photographic prints quickly and simply.*

provide very good value. In general, the more you pay, the better performance you can expect – both in terms of the mechanics and the software interface.

Choosing a scanner

While modern scanners are all likely to give good service, to ensure you are content with your purchase, carry out the following when selecting a scanner:

 Watch the scanner in action – some are very slow, some make irritating noises.

 Examine the software with which you control the scanner – some are confusing and badly laid out.

 Check that the scanner's connection is suitable for your computer – the best is FireWire. USB is a low-cost (and slower) option.

 Ensure that the retailer guarantees it will return your money if the scanner does not work with your computer and software. Do not accept that it is your fault if the scanner does not work – no one should expect you to have the expertise to resolve technicalities like driver conflicts.

⑤ If you need to scan films or transparencies, check whether a transparency adapter is extra.

Flat-bed scanner for business use

Flat-bed scanners can be equipped with software known as optical character recognition (OCR) applications. These turn printed material into word-processing documents. Software is also available – for example, PageCam – that claims to be able to digitize digital photographs of printed pages.

All-in-ones

Also called multifunctional devices (MFDs), all-in-ones combine the jobs of scanning, printing, copying, and faxing in various combinations. They produce good quality but may work slowly. They are excellent choices for those short of space or having only occasional need for such work. Hewlett-Packard, Epson, Canon, and Lexmark are some of the reputable makers of all-in-ones.

■ **All-in-one machines** *save space, but you will then have all your eggs in one basket.*

Film scanners

The best way to scan film, such as 35mm transparencies, is to use a film scanner. These cost more than general-purpose flat-bed scanners but produce better results. A film-scanner represents the best balance of features and quality, and they can give excellent results at a modest cost. The main manufacturers, such as Minolta, Kodak, Nikon, Canon, and Microtek, offer film scanners that produce professional-quality results.

■ **A film scanner** *is a must if you have a legacy of 35mm shots.*

Software for other jobs

THE MODERN PHOTOGRAPHER must be multiskilled, able not only to photograph well, but also capable of handling the computer resources needed to make the most of the pictures taken. For a relatively modest outlay, anyone can produce professional-looking brochures, booklets, posters, and websites. The software that provides this publishing power includes the following.

Desktop publishing (DTP)

Desktop-publishing software enables you to design page-based products with greater ease than working with word-processing applications – however powerful the word processor. DTP applications enable you to handle pictures and type flexibly and fluidly. Microsoft Publisher (PC only), Serif Page Plus (PC only), and AppleWorks (Mac only) are inexpensive and suitable for basic publishing needs such as newsletters, short brochures, or simple books printed on ink-jet or laser printers.

Look for software that bundles lots of goodies, such as clip-art and fonts, with the actual program. This can save you a lot of money.

Clip-art and fonts

If you need a generic illustration – such as a telephone, sports item, or road sign – it can be easier to use or modify one already created. Clip-art collections are inexpensive – the problem lies in selecting from the huge choice on offer.

Fonts are collections of typefaces, from the florid to the serious, the ornamental to the high-tech. They can add a great deal to the attractiveness of your work. Fun fonts are available on the Internet.

INTERNET

www.fonts.com
www.1001freefonts.com

These sites offer free fonts for both Mac and PC users.

QUOD ERAT
Quod erat demo
Quod erat de
✳◆□✻ ✻□✷▼
Quod erat demo
Quod erat demonstrandum
quod erat demons
quod erat demon
Quod erat demonst
QUOD ERAT DEMO
Quod erat demonst

■ **Free fonts** *can be found quickly and easily on the Internet.*

Protection

It does not take long for the contents of your computer to represent a huge investment in money, time, and effort, so protect your machine from computer viruses. Windows-PC users are vulnerable

if they surf the Net or share files with other PC users since some viruses can destroy a hard disk. Mac viruses are not so destructive, but an "infection" can still cause lost time. All computer users should install virus-protection software.

Cataloging software

When you build up a collection of more than a few dozen images, you will be grateful for software that helps you keep them all organized. Packages like Extensis Portfolio or FotoWare FotoStation also make it easy to produce pages for the Web and to print out sets of pictures.

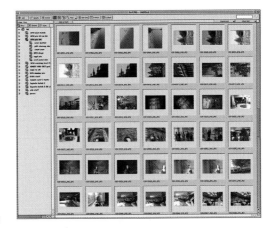

■ **Software is available** *that will help you organize your photographs, presenting each folder's contents as a series of thumbnail images.*

A simple summary

✔ For some situations, film cameras still have the edge over digital cameras.

✔ A 2-megapixel camera can be used for a wide variety of work and may be suitable for you.

✔ For high-quality images, you require 3+ megapixels.

✔ Check a camera's compatibility with your computer before buying it.

✔ Zoom lenses let you magnify a scene without changing lenses.

✔ Many accessories are available to the photographer: tripods, camera bags, and waterproof housings are among the most important.

✔ Your choice of monitor essentially comes down to LCD or CRT.

✔ Even low-cost printers can produce good-quality images.

✔ A scanner is essential for digitizing prints.

✔ Software is available to help you present your work professionally.

PART TWO

Making Photos Work

ENJOYING YOUR PHOTOGRAPHY is like building a rewarding relationship: you get out as much as you put in. By making your photos work for you, your satisfaction will increase. Which means you have to do some work too!

Chapter 5

Creating Photographs

THERE'S SOMETHING IN TALKING about taking photographs that suggests we are grabbing or removing something – almost as if photography were some sort of thievery. At its best, though, photography is a partnership or participation between yourself and the subject, regardless of whether it's a close friend or a distant landscape. Better still, you will get more out of photography the more you put in – which means *making* and not *taking* photographs.

In this chapter...

✓ **Are you taking or making?**

✓ **What to photograph and where to start**

✓ **Trying out the camera functions**

✓ **How to hold the camera and support yourself**

EVEN EVERYDAY OBJECTS CAN LOOK INTERESTING WITH A LITTLE CREATIVE THINKING

Are you taking or making?

MOST OFTEN WE TALK ABOUT "taking" *a photograph. But professionals talk about* "creating" *or* "making" *a photograph, or perhaps* "working" *a shot. The difference is instructive and vital. When you make something, you work with it; you hold it in your hand, figure out how the parts fit, and appreciate its shape and weaknesses. You look at it from all angles to make sure that you fit the bits properly and neatly. This is exactly what all careful photographers do: they create, they work, they mold – they never simply take.*

Photographers look at all the elements that make up a picture: the light, the movement, the timing, the subject, and how far away it is. They think about their camera and lenses – whether they are set up and ready or appropriate for the job. And they are never satisfied until they get it right.

■ **I loved the shape** *of this path, in New Zealand farmland, and returned twice in the hope of finding some activity on it. One perfect evening, I saw this herd of cows on their way to being milked.*

■ **To obtain this view** *of tourists on a giant sand dune in China, I climbed another dune, in full sun with air temperatures in the high 90s Fahrenheit (high 30s Celsius).*

This may sound intimidating and hard work – well, it can be hard work – but you will soon discover that the more you put into your digital photography, the more you'll get out of it. For starters, images do not wander uninvited into your camera. And if it was too easy, where would be the fun in it?

That gentle observer of Parisian street life, Robert Doisneau, taught that to be a great photographer you had to walk and walk, and then walk some more. Rushing around the way we do today does not generate great pictures.

So before you can consider how best to capture your chosen image, how to present the dynamism of a particular scene, or simply whether the landscape you want to photograph looks better by night or day, the first thing you have to do is find your subject. And that can be a challenge in itself.

Once they have learned how to use their cameras, the majority of people, including photography students, have trouble knowing what to photograph.

What to photograph and where to start

DON'T BE EMBARRASSED if the initial joys of learning how to use your camera are replaced with the gut-wrenching question, "What now?" By putting your energies into learning new technical skills, you divert energy away from the question of what to photograph. So it's not surprising if you feel like you don't know what to do next.

Let imagination do its work

Whatever your passion, there is a place in it for digital photography. Even if it appears unlikely, there will be an angle – I promise! You like to cook? Love children? Practice t'ai chi? Or you simply like to dream? A little thought will lead you to a visual spin on the subject. Photograph recipe ingredients. Concentrate on the little hands of children. Express the feelings of a t'ai chi exercise in abstract images. Reconstruct a dream.

Trivia...
The painter Georgia O'Keeffe said, "To create one's own world in any of the arts takes courage."

Think of others

Another approach is to let others decide: offer your skills to people in your neighborhood. It doesn't matter if you're not greatly skilled – merely owning a camera and computer gives you facilities that are probably needed by some group whose cause you are sympathetic to. So, instead of giving money, you could offer some time and photos.

THE SIMPLE THINGS

Try this. Make a simple list of daily, ordinary objects in your life – dinner plates, bus stops, drying clothes, for example. Do not prejudge the subject – if the idea comes to you, there is probably a good reason for it. Choose one subject and take some pictures on the theme: again, do not prejudge the results, just let the subject lead you. Be ready to be surprised. Do not think about what others will think of you. Do not worry about taking "great" pictures. Just respond to the subject – if it's not an obvious visual treat, then you might simply have to work harder to make it work visually. Don't abandon a subject just because it seems unpromising (see pp.256–7).

■ **Public restrooms** *may seem a quirky choice for a project, but all photographers have to visit them at some time or other. So why not photograph them at the same time? These buildings are as far apart as New Zealand, Kyrgyzstan, and Scotland, and they have nothing in common except function.*

Campaigners trying to save a green area from development would love to have a stream of pictures for their website. People raising money for a community center will appreciate photographic documentation of the events and efforts as a tool to strengthen their cause and commitment.

Start small

Pace yourself. Don't try to do too much too quickly to an unrealistically high standard. Aiming too high just gives you an excuse to give up early. You want to digitize all the thousands of historical pictures in your family albums? Fine, but don't try to complete the entire project in a month. You want to photograph all the spoor (footprints) of African big game? Great idea, but are you sure you have the expertise and money needed?

Do not worry about money

It is important not to concern yourself too much with finances. This is not, of course, a licence to sell your home to pay for the best kit on the planet; rather, it is a warning that overt preoccupation with costs is a project's kiss of death. It freezes enthusiasm, dampens the spark of adventure, and becomes in itself the cause of the waste of money.

DINNER TIME!

A preoccupation of any traveler is where to eat next, and this is a great part of the fun of traveling. It is also a most photogenic subject and can tell you lots about the countries you visit. In short, it's an ideal project.

■ **When you sit down** *for a meal, don't put the camera away (provided you don't offend your host). Even a simple roadside restaurant and modest meal can present a visual feast.*

■ **Sheltering in the shade,** *this chef tends a shashlik barbecue that is side-lit by the hot sun of an Uzbek afternoon. The barbecue only smokes like this for a short time during each cooking cycle.*

■ **Food photography** *can also be about the life around it. Here an impatient crowd lines up for a hot lunch, with shouted orders and questions flying as the delicious smoke stokes up clients' hunger. Wait for a telling moment, such as the exchange of cash for goods, a glance, or a gesture.*

■ **Street hawkers** *are among photography's most willing subjects. But reward them for their cooperation by buying a mouthful – it never costs very much, but can mean a lot.*

■ **A table's-eye view** *of a dim-sum meal is easily handled by a digital camera with a swivelling LCD screen. Making your pictures this way may also intrude less on your friend's enjoyment in the meal.*

The value of a project

Regardless of cost, a project in which you passionately believe has value in itself: not only does it keep you out of mischief, it integrates and substantiates a whole range of your skills with your interests. It is almost always an inexpensive way to satisfy yourself at a high level.

Allow a project its own pace and progress

You may think you're in the driving seat but, in reality, developing a project is more like riding a horse. It's based on cooperation, not coercion. It's based on working with the moods of the subject, not controlling its every move.

Thoughts and misgivings because of lack of confidence are very common. If you find yourself inhibited and afraid of looking silly, if you think "It's been done before," don't forget: you are doing this for yourself, not for anyone else. So who cares what anyone else thinks?

Trying out the camera functions

NOW THAT YOU HAVE SOME *experience with your camera and want to embark on more focused photography, it's time to ensure that the camera doesn't get in your way. For this it is worth revisiting the instruction book to consolidate your command of the controls. When you first looked at the instructions you probably thought you'd never need even half of the features – not knowing what they are for, it's easy to forget them. But there may be a certain feature that could really help you with your project.*

Yours to exploit

Don't be ashamed of exploiting your camera to the fullest. Let the snobs in photography make their own painstaking (and painful) exposure measurements while you let the camera work it out for you. Let the technophobes struggle while you hand all responsibility over to the electronics.

As you learn more, by all means take control of more of the picture-making process. But know this: the hard part of photography is in the ideas, the sheer exertion of keeping your eyes open and being alert when everyone else wants to have supper and a drink.

UNDERSTANDING CAMERA FUNCTIONS

To learn about your camera, try the following:

a Work in different lighting conditions; set the camera to each of its different exposure modes: shutter, aperture priority, and program, as well as manual mode if available.

b Deliberately over- and underexpose in different situations: bright, dark, sunny, misty.

c Deliberately throw a subject out of focus.

d Learn how quickly the shutter responds to the shutter button – some are more sluggish than others.

e Try out the various picture modes – landscape, portraits, sports, and so on – to see how the camera tries to help you with preprogrammed settings.

f Try different quality settings.

Try taking shots around the house; photograph things that normally you'd never look twice at, such as a dull shop window (see p.77). You never know what you might learn – and not just about the camera either. It is well worth your while systematically going through all the functions the camera provides. The beauty of digital photography is that you can discard all those early learning experiences without wasting any film or processing costs.

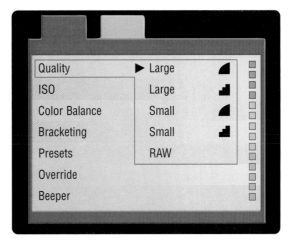

■ **Experiment with different** *quality settings: lower quality may be perfectly acceptable for your needs, and the advantage is that you'll be able to store more images on your memory card as well as obtain a faster response from the camera.*

EXPOSURE EXPERIMENTS

Simple exposure sequences can show you a great deal about the camera's ability to capture a range of low to bright light, as well as about light itself. Notice how, as exposure is increased, bright areas lose their color and shadow areas gain color.

■ **A correct exposure** *is always a compromise – you want to record the bright values without losing the dark values, and vice versa. Here, there is ample shadow detail and the sky still holds its color.*

■ **An overexposed** *rendering loses sky colors but brings out shadow details. However, the mid-tones look too light.*

■ **When underexposed,** *bright areas like the sky can look really nice and the mid-tones are rich, but we lose all shadow detail.*

■ **This unimaginative shop window** *offers a textbook example of mixed lighting and shows the limits of automatic color correction. The camera has tried to correct the red-yellow of the lights, so the sky (in the mirror) has come out a strong blue.*

■ **When I squeezed** *the shutter button, the cat was perfectly silhouetted against the window. But by the time the shutter ran, the fidgety cat had moved, unaware that it had denied itself a moment in the history of photography.*

How to hold the camera and support yourself

ONCE YOU HAVE EXPERIMENTED with your camera and can find your way around the controls, it is time to refine your command of it.

It is important to ensure that you are really comfortable with your camera. When you're at ease, your photography will flow and grow in confidence.

It is worth paying a little extra to buy your camera in a specialist store that allows you to try out a camera, rather than going for the cheap mail-order purchase.

■ **It can be difficult** *to hold the camera steady when viewing your subject through the LCD screen found on the back of most digital cameras.*

When you find a store with an assistant who is well informed, helpful, and does not push you for a sale, stick with it – the service you receive is well worth the extra you might pay. It is bad etiquette to try out a camera in a store, taking up a salesperson's time, and then buy it more cheaply on the Internet or at some large discount store. If you know of a more competitive price, at least give the store a chance to match it.

Know thy camera

To get to know a camera, you have to practice using it. A common situation is finding that you want to do some photography but, because it has been months since you last picked up the camera, you can't remember how to make the settings you need. If you're about to go on holiday, it's a good idea to refresh your memory of how the camera works before you leave.

Even though I know my digital camera pretty well, I take the instruction book with me on trips. Not only is it easier than trying to remember some obscure setting, but having the instruction book can assure me that all is working properly.

DEFINITION

Definition is *a measure of how much detail is recorded. Low definition equates with not much fine detail being visible; high definition shows fine detail clearly.*

The most common technical reason for spoilt pictures is camera shake, a nice euphemism that puts the blame on the camera when really it's the photographer's fault for moving during the exposure. As a result, the image is blurred. At times, the blur is barely noticeable, so the image just appears a little soft and lacking in **definition** or "bite." Severe camera shake appears to smear the picture across the frame.

Fidget prop

The best way to prevent camera shake is the most unpopular camera accessory ever invented: the tripod. Even a small tripod is better than nothing (see p.56). But no one likes lugging these little monsters around. The next best thing is to lean on something – a wall or a sturdy tree – when you make the shot. If there is no support available, make it out of your own body: crouch down on one knee, and support the opposite elbow on its corresponding knee or thigh.

■ **If you are using** *a long lens or your camera's zoom function, use any means of support available to you in order to steady the shot.*

Try to hold your digital camera against your face – that extra support really helps. Avoid taking shots with the camera held away from your face, usually so you can look at the LCD screen on the back. If your camera has a big lens, cradle it in your left hand, palm up (not over the side or top of the lens).

■ **When using** *an SLR-type camera, the best way to deal with its weight and bulk is to cradle the lens in your left hand.*

■ **The "body tripod"** *is a great way to steady your shot if no other support can be found.*

A simple summary

✓ Photographers tend not to "take" photographs; rather, they "create" or "make" them.

✓ It is not unusual to find yourself stuck for inspiration over what to photograph. Concentrate first on subjects that interest you or everyday objects and scenes.

✓ Be realistic when planning photographic projects.

✓ Do not burden yourself with financial concerns. Cutting costs will be detrimental to your photography.

✓ Take the time to experiment with all your camera's functions. Once you know how they work, you will be able to decide whether or not to use them.

✓ Use your camera regularly to remain familiar with its functions.

✓ The most common reason for spoilt pictures is camera shake. Support your camera properly.

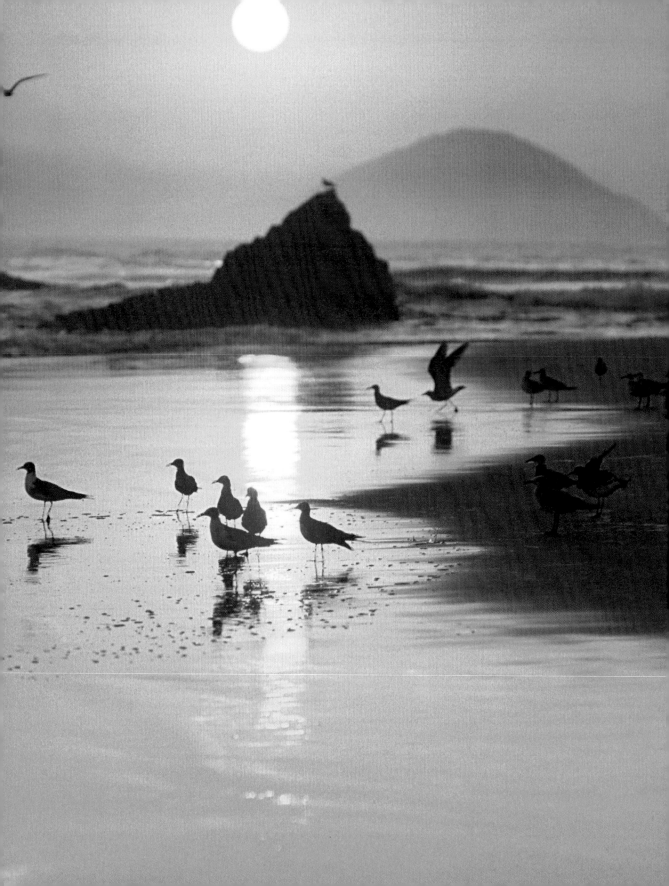

Chapter 6

The Joys of Composition

WHEN WE TALK ABOUT PHOTOGRAPHIC COMPOSITION, it is not like composition in music or even painting. Actually, it is more about disposition. In photography we generally find things as they are. Only in the studio or on certain occasions – such as arranging family members for a wedding photograph – do we have direct control over the position of each element. The art of photographic composition is to find a perspective and a precise position in which all the elements in the scene or subject come together in a visually pleasing, arresting, or challenging way.

In this chapter...

✓ **Picture compositional tricks**

✓ **Image orientation and proportion**

✓ **Changing perspective**

✓ **Working with color**

✓ **Posing people**

A GLORIOUS DAWN ON MEXICO'S PACIFIC COAST: I MANAGED JUST ONE SHOT BEFORE THE GULLS FLEW AWAY

Picture compositional tricks

PICTURE COMPOSITION is really all about your response to what you see, and how you solve the problem of making sure that viewers can share your visual experience. Successful composition in photography is about sharing your joy in the shapes and the disposition of elements in the scene. Although "rules" of composition are no guarantee of success, they do have their use: they distil the features of pictures we have found to create pleasing, effective, or communicative work.

If you are new to photography, it may help to make an image while trying to discern its structure – the lines joining main features or the overall shape – rather than concentrating on the features that are more obviously visible or on the surface. Understand the bones, and you can recreate the whole body.

■ **Without its diagonal shoreline,** *this picture would look empty and devoid of interest.*

To help me see the "bones" of a scene, I often half-close my eyes and look "through" it, trying to throw it out of focus.

One of the most common so-called rules of composition is the Rule of Thirds, in which it is stated that main items should be placed a third of the way in from one side.

The Rule of Thirds is a confusion of the Ancient Greek concept of the Golden Section, which gives geometric perfection: the ratio of the short portion to the long portion is the same as the long portion to the whole length.

■ **The numerous repetitions** *of a simple shape – the seagulls – and their regular yet irregular distribution is beguiling to the eye. Unfortunately, the top left corner of the image shows no activity.*

Keep an eye out especially for small branches and overhead wires, which, if they are captured in your photograph, can be very distracting. Although, as a digital photographer, you can remove these distractions later, it is better to avoid recording them in the first place if you can.

The only real no-no in composing your pictures is not to rely on or be restricted by rules. The best and only rule is NO rule!

■ **The windows** *of a beach-side restaurant frame the view of the shore: all you have to do is wait for someone to walk into the frame.*

■ **The rhythmic patterns** *of trees and shadows lead the eye to the figure, which, being almost part of the pattern, can easily be missed.*

■ **These parrots** *were in the corner of a stall. A centrally composed shot works well, but you should also compose a shot that takes in more of the stall.*

■ **This cat knew** *not to place herself dead-center to the chair: the slight imbalance, and her upward gaze, provide a needed tension to the composition.*

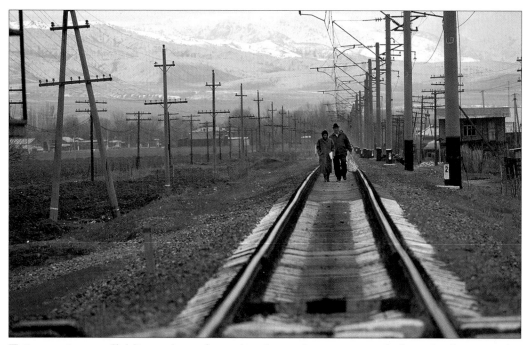

■ **Converging parallel lines** *– here, of everything from railway to wires and telegraph poles – strongly convey space. The people on the line not only offer scale but also suggest a suffocating sense of great distance.*

Image orientation and proportion

*SINCE THE USUAL PICTURE **format** is rectangular in shape, you immediately have a choice. Do you shoot so that the length lines up with the horizon (this is called landscape format), or do you shoot so that the length of the picture is upright (portrait format)?*

And don't forget there's another option: you can go square. Some cameras are natively square in format, but in digital photography you can always crop a captured image into a square shape at any time. Come to think of it, you can crop an image to exaggerate its rectangular proportions too.

Beware: cropping an image down is nothing but throwing parts of your image away to make it smaller. And you cannot get the bits back together again. Ensure that you have sufficient data for the job and that, as ever, you work on a duplicate or copy file.

Professional photographers try to shoot upright, or portrait-format, pictures as often as they can because they know these are in great demand. Also they are more likely to be used on the cover of a book or magazine, which gives more prestige and, more importantly, pays better!

■ **Landscapes do not** *have to be – and, indeed, are often better not – shot in landscape format. Here, it was tempting to work on the expanse of a river, but then I would have missed out on the reflections.*

Being selective

One of the most effective yet easiest ways to improve the impact of your pictures is to move in closer. This cuts to the chase, excludes clutter, and will concentrate your viewer's mind on what really matters. Less is more!

> ### DEFINITION
>
> **Flare** is light that is present in the image but that does not actually help show detail or colors – it is just an unwanted nuisance. It's caused by stray light bouncing around inside the lens. The **luminance range** is a term given to the difference between the brightest and darkest parts of the image.

The best way to move in close is to use your feet to take you there: simply leaning forward a little could make all the difference. But sometimes you can't move nearer, and that is when the zoom lens comes into its own. Use the zoom more as a last resort than a first solution.

Moving in can make photography easier in other ways. By cutting out unnecessary sky, you are more likely to obtain the right exposure, because the camera is not fooled by excess light, and there will be less *flare* from stray light. At the same time, the *luminance range* will be reduced, again aiding the camera and, eventually, making it easier to work on the image and to print it.

■ **My original shot** *of this scene had too much space above and below the swan because it was taken from too far away. A radical crop to letterbox shape emphasizes the pattern of reflections and the swan's relationship to it.*

■ **To some, a square format** *is the worst of both worlds – neither fish nor fowl – but for others it neatly solves the problem of which way to orient the picture. Once you experience its charms, it is hard to go back to rectangular shapes.*

87

■ **A head-on shot** *of a Maori wood carving (left) is informative enough, but it lacks impact. Also, the bright light in the background is distracting without contributing to the image in any way.*

■ **Close up,** *we get face to face with the warrior and can appreciate the detail of his moko, or pattern of tattoos. At the same time, no part of the image is wasted.*

One of the things that distinguish professional photographers from others is that they are always thinking about the end result: Will it be easy to work on? Will it print well? Does it "do" what it is supposed to? You don't have to worry as much as they do, but you will enjoy your photography more when you plan ahead.

Changing perspective

YOU CONTROL PERSPECTIVE *by changing your position, because perspective is the view that you have from where you are. Perspective is one of the easiest things to control, yet it has a powerful effect on an image. Watch professional photographers at work: you will see them constantly moving, bending right down, climbing up, getting very close to the subject, crouching down. The more mobile you are, the more dynamic your photography will be.*

How much is taken in or seen by the lens (called the "field of view") depends, not surprisingly, on the lens – and, in particular, on its effective focal length (which we'll move on to shortly). The field of view does not change with perspective.

In general, the further away your subject is, the more you have to move to change perspective visibly. What you are doing is altering the relative positions of your subjects: a tree may overlap the front of a house from one position, but when you move to one side, the tree appears to move relative to the house, so it no longer intrudes. Even with distant landscapes, small changes in position make a difference: at your full height the horizon may be unbroken, but if you crouch, suddenly trees appear and cut into the sky.

In some circumstances – such as with still lifes, interiors, and portraits – there is a small change of perspective between seeing the subject with your unaided eyes and seeing it through the camera. This is called parallax, and it is caused by the camera lens looking at the subject from a different position than you. It can make a powerful, if subtle difference to the composition.

Effective use of zoom lenses

Zoom lenses help your photography by encouraging you to vary perspective. Short focal-length settings give a wide-angle view, taking in more of the scene. You can approach close to a subject and still get a bit of the background in view. But if you stand back, you can take a lot more of the scene; this behavior is complemented by a wide angle's typically generous depth of field.

A long focal length magnifies a narrow view, allowing a closer look at something. For distant views, long focal lengths also bunch together objects that are far apart: an urban view will show buildings stacked on top of one another although they may be a block apart. Approach closer, though, and a long focal-length view will isolate the subject focused on, because everything else seems blurred due to the shallow depth of field.

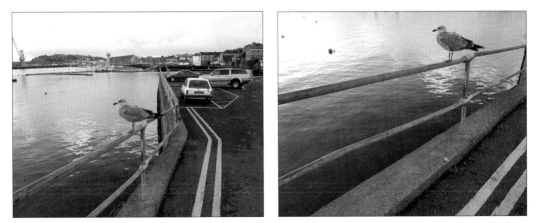

■ **Simple changes in height** *"move" the horizon in ways that can benefit your photography. In the first shot above, the horizon is visible and shows more of the scene, but this competes with the gull. By placing the horizon above the image frame (right), the gull gets prime spot – it all depends on which is more important to you. At the same time, the lines of the road help structure the composition.*

■ **Try experimenting** *with your zoom lens. One trick that often provides captivating results is to zoom during a long exposure – this streaks outlines and lights. Here the subject was a set of Christmas lights.*

Short or long focal length?

Once you become more experienced with zoom lenses, your subject will dictate the appropriate lens for the image. In the meantime, bear the following points in mind.

Advantages of a short focal length

- It takes in more background or foreground.
- Close-ups exaggerate the size of the nearest subject.
- It exaggerates the difference in distance or position of the objects in the composition.
- A greater apparent depth of field joins the subject to the background.

Advantages of a long focal length

- It compresses spatial separation.
- The apparently reduced depth of field helps separate the subject from the background.
- It magnifies the main subject at the expense of losing surroundings.

Trivia...

The great Ernst Haas was the first to observe that "the best zoom lens is your feet." It's as true now as when he said it, in the 1960s.

■ **By deliberately choosing** *as high a viewpoint as possible – I was standing on tiptoe – I could concentrate on what interested me, which was the different sets of parallel lines: in the hat, sleeves, the grass, and the distant wall. And a wide-angle view pulled it all in.*

Working with color

SUCCESSFUL COLOR PHOTOGRAPHY means you team up and work with color, rather than merely copying a scene in color. One approach is to concentrate on the color rather than the subject – in other words, to treat the subject as if it were an incidental feature. You need to learn to see colors as separate from the objects that display them.

This single change in mental focus will radically transform your photography. You can evaluate a scene not in terms of whether it's a marvelous vista but in color terms. Are the greens of the intensity or **saturation** you wish for? Is the light too contrasty to allow giving colors any depth?

> **DEFINITION**
>
> *Color **saturation** measures how rich or pure it is: highly saturated colors are very pure and appear strong.*

The more you look at colors, the greater will be your appreciation of the richness offered by vision and knowledge of how to translate that into an image. You will learn, for instance, that bright colors such as yellows and light greens are a delight to the eye but are not easily caught by the camera. Sumptuous purples and blues enrich our visual experience but often disappoint in their image.

One advantage that digital photography has over film-based work is that it is far better able to capture greens accurately. This is particularly apparent in the photography of jewelry: green gemstones always look far too dark in color film unless great pains are taken to compensate.

Working with adjacent colors

Colors that are directly to the left or right of a color on the "color wheel" are said to be analogous, or adjacent, colours – for example, light and dark green with yellow or blue, purple, and cyan. A combination of these colors is always harmonious to the eye and easy to compose since the colors work together and will bind disparate elements.

■ **The color wheel** *is a way of showing all the colors of the rainbow, with the most saturated colors on the rim and the palest colors in the center. If you start at any point, you can change hue by traveling around the wheel, but you will eventually return to the original color.*

Landscape photographers like using harmonious schemes of browns and reds, while garden photographers love greens, blues and purple, or yellow.

Monochromatics

A version of the adjacent-colors scheme is the monochromatic scheme, in which the colors are all of similar hue. Here, most colors in the image are variants of each other – very close neighbors in the color world. This offers tonal subtlety instead of color contrasts: duotone or sepia-toned effects are highly monochromatic. Views of the sea offer infinite varieties of blues, and sunsets offer a wide range of orange colors. Close-ups of flowers are often rewarding because they offer narrow, subtle color shifts.

■ **The colors in this shot** – *blues, greens, and yellows – lie in sequence, one after another on the color wheel: the result is color harmony and calmness.*

Working with contrasting colors

Strong contrasts work with colors that are not situated next to each other on the color wheel. While compositions with strong colors are often appealing when experienced, they are not particularly easy to organize into a successful image. Look for simplicity in structure or clear composition – too many elements usually lead to a disjointed, chaotic image.

The intense colors that can be captured in digital cameras are very attractive to the eye and always make an impact. However, their strength requires that you use them with care: strong colors on the page of a magazine or on a Web page will compete with any words that you want a reader to take in, but they are also likely to conflict with other images or graphic elements.

■ **A dull winter's day** *in a traffic jam is not a promising photo opportunity, but a two-second long exposure while on the move blurs the red and orange lights to contrast with the cold colors of the day. Note to readers employed in law enforcement: I wasn't driving!*

As you gain experience, you will learn that even if you can see certain colors on the monitor screen, you may not be able to reproduce them on paper. Purples, sky blue, oranges, deep reds, and brilliant greens all reproduce poorly on paper – they will look duller or darker than on screen.

If your images will be enjoyed only on a monitor – for example, on your website – you can work with images that are as highly saturated as you like.

Working with pastel colors

Pastel colors contain a large portion of white or gray and, as a result, are paler, less saturated, or less vibrant than bright colors. However, they are vital tools for the photographer. Pale colors suggest softness and calm; they are gentle where strong colors are vigorous. Pastel shades are also important as counters to strong colors. And don't forget: essential colors such as skin tones are primarily pastels. But it is harder to find pastel colors than strong ones.

■ **Almost all** *of the impact of this image relies on the color contrasts – in black-and-white, it would be a formless muddle.*

You can concentrate on pastel colors in their own right. Such images are often associated with the high-key exposure, since the presence of dark shadows tends to overwhelm the fine colors. As a digital photographer you have the advantage of being able to tone down colors deliberately to create pastel shades artificially.

■ **You don't want** *the soft lines and textures of this nude to be delivered in strong colors. Even the toned-down, digital-camera image was desaturated further to make a suitably soft image for the subject. Note that pastel tones are very hard for digital cameras to record well and for printers to print. Work at the highest quality settings to avoid problems.*

■ **The soft, faded colors** *of a shop in northern France should be preserved. Don't be tempted to strengthen or deepen them or you will lose the sense of dilapidated charm.*

Posing people

PEOPLE RESPOND TO A CAMERA in many different ways, ranging from total indifference to a startling change in personality put on just for the camera. Your job as a photographer is to decide what you want to depict and somehow coax that out of your sitter. Above all, pictures of people are about your relationship with that person.

The art of patience

The easiest strategy is to wait and see. But you have to be both very patient and extremely quick on the draw, because the gesture or expression you want will come without warning and may last no longer than the blink of an eye.

■ **Although this is not strictly** *about catching the gesture of a person, the principle is the same. It began as a normal pose – an eagle with regally folded wings – but then the bird stretched its wings and caught one on its master's hat. The wing remained there just long enough for me to get one shot.*

■ **At a Christmas party,** *there is no way you can make anyone sit still for 5 seconds – you just have to wait and see, and catch family members posing themselves.*

■ **The keeper** *of a bird sanctuary was nervous about being portrayed by herself, but once she was next to her favorite pet – this enormous eagle owl – she was a different person.*

Prepare your camera, frame up, and wait – keep talking, engage with the sitter, but do not direct. Some people freeze up if you try to direct them, but if you let them be, they can't maintain a position for long, so all you have to do is have more patience than them.

Snap a shot quite early on, or several – the beauty of digital work is that you can erase what you don't want. Your subject will hear the shutter, think it's over, and relax. Then you have them!

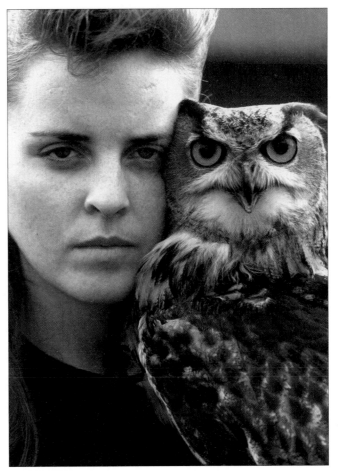

Directing people

When making more formal portraiture photographs, the main trick for directing people is to keep them relaxed: jokes, firm but friendly charm, and sometimes even gentle bullying are called for. But try to understand and sympathize with any unease. Help your sitters feel good about themselves – the usual reason for refusing to sit is because they do not think they're attractive enough or that they'll spoil your picture.

Exploit the instant-playback feature of your digital camera. Show your subjects what you're doing and how they look in the picture. Sometimes people make suggestions – for example, going to the garden or wearing a dark suit. Go along with their suggestions and work together to create a great portrait.

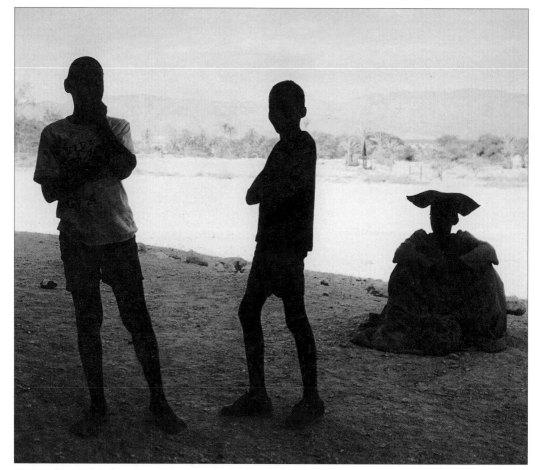

■ **People in Namibia** *are not used to seeing Chinese people in the desert, so I was an object of curiosity for them. This made it easy for me to ask them to stand apart; then I just waited for natural changes in their posture to do the work.*

A simple summary

✔ Once you understand the structure of your subject, you will be better able to create a harmonious reproduction.

✔ Be on the lookout for distracting elements in the periphery of your scene. Although they can be removed at a later stage, it is better not to include them in the first place.

✔ When composing, the best and only rule is NO rule!

✔ There are three main shapes, or formats, for your photographs: landscape, portrait, and square. But landscapes do not always have to be landscape format, nor portraits portrait!

✔ Moving closer to your subject can help remove some of the clutter from the scene.

✔ Use your zoom as a last resort rather than a first solution.

✔ Knowing what you intend to do with your image will help you make the right choices when taking the picture.

✔ Moving around your subject will give you a different perspective. Always look for the most dynamic point of view.

✔ Short focal-length settings give a wide-angle view, taking in more of the scene. A long focal length magnifies a narrow view.

✔ The color wheel presents the most saturated colors on the rim and the palest in the center.

✔ It may not always be possible to reproduce on paper the colors you see on your monitor.

✔ A photograph of a person tells of the photographer's relationship with the sitter.

✔ For candid shots, be aware that people relax once they think you have taken the photo.

✔ For portrait work, relax your subject with friendly chat.

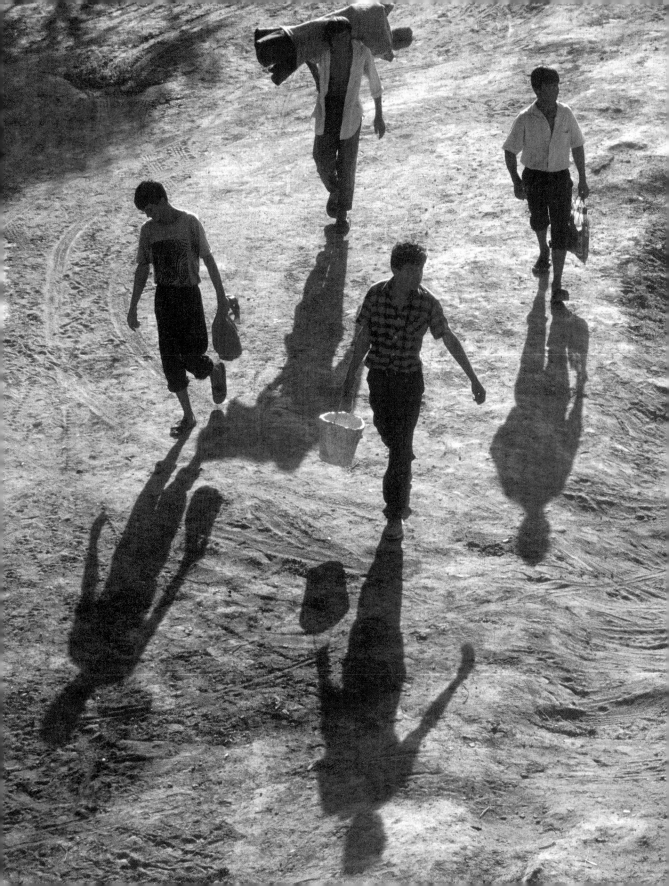

Chapter 7

Creativity through Control

ONE OF THE MAIN REASONS we enjoy photography is because it rewards the combination of creativity and technical skill. A balance between these factors is achieved by controlling the basic settings on the camera. While there are many more settings possible on digital than on conventional cameras, few of these relate directly to the creative shaping of the picture; they are more about housekeeping than image-making. And for both film and digital cameras, the controls are few and simple but devastatingly powerful: shutter, aperture, focus, and focal length.

In this chapter...

✓ Shutter control

✓ Aperture control

✓ Focal-length control

✓ Working close up

GREAT LIGHT, THE RIGHT LENS, AND GOOD LUCK FINALLY CAME TOGETHER TO MAKE A GREAT PICTURE

Shutter control

THERE IS A PLACE FOR BLURRINESS, even if the general rule is that the camera should be held steady with the minimum of subject movement to ensure that images are sharp. The effects are unpredictable and artistically unique – no other medium represents motion in quite the same way. It may offer a pleasant change from pin-sharp imagery.

Playing with movement

For example, while photography in a moving car is not recommended, it is worth experimenting with – if only to reduce the tedium of being a passenger during a long journey (see p.94). In such a situation, even a short shutter time will not be sufficient to prevent blur from motion. Alternatively, if you are static – for example, taking a rest while out for a walk – you can set a long shutter time – at least half a second – and move the camera during exposure. Another possibility is to set a long shutter time and change the zoom setting during the exposure to give the characteristic radially exploding view (see p.90).

■ **The low light** *of an African dawn meant short exposure times were impossible, so I used about a half-second shutter speed to blur these flamingoes in flight.*

Incidentally, motion-blur images will compress to very high levels without noticeable loss in quality because of their inherently lower image quality.

The shutter lag – the delay between the moment you press the shutter and the moment the image is captured – can be long enough to make the timing of sports, child, and animal photography a tricky matter. If precise timing for a shot is important to you, then it's best to check out the camera before buying.

Aperture control

DEPTH OF FIELD has already been defined on p.28. This definition misses, however, the power of depth of field to help communicate your ideas. You can use it to imply space with great economy, to suggest being inside the action, and to show separation between elements in the picture.

Control with aperture

Your chief control over depth of field is the lens aperture: as you set smaller apertures – by increasing the f/number, say, from f/2 to f/11 – depth of field increases. This increase appears much greater with short focal-length lenses (for example, 35efl [35mm equivalent focal length] of 28mm) than with long ones (35efl of 300mm). Depth of field also increases as the subject focused on moves away – conversely, up close, depth of field is very limited.

Depth of field varies according to the lack of sharpness a viewer will accept, and that depends how much detail a viewer can discern. This, in turn, depends on the final size and magnification of the image. As a small print, an image may show a great depth of field, but if that image is greatly enlarged, it is easier to see where the sharpness ends, and then depth of field will appear smaller.

■ **This picture shows** *how a shallow depth of field can be exploited. Focusing on the plants in the foreground throws the swan out of focus, which is preferable to having the plants blurred in front of a sharply focused swan.*

■ **When using a long focal-length lens,** *even objects that are close together will appear out of focus. This shot of a parrot was taken in London, using the equivalent of a 560mm lens and an aperture of f/5.6.*

Using depth of field

Deep depth of field – that is, a small aperture due to a high f/number, wide-angle lens, distant focus, or a combination of these – extending from the near edge to the far margins of the image, is often used for:

- Still lifes – for example, food, small-scale models, or technical shots;
- Landscapes – for example, wide-angle views of general topography;
- Architecture – for example, views of frontage showing the foreground to the building;
- Interiors – for example, from nearby furniture through to far windows.

Side benefits of smaller apertures tend to be reduced lens flare and improved lens performance.

Shallow depth of field – that is, a wide aperture through a small f/number, long focal-length lens, near focus, or a combination of these – in which only a small portion of the image appears sharp, is often used for:

- Portraiture – for example, to bring the viewer's attention to the eyes of the subject;
- Reducing distraction from elements that cannot be physically removed – for example, branches or a fence in front of the camera;
- Isolating the subject from its background – for example, to keep a sportsman sharp but his spectators blurred, or to focus the viewer's attention on prepared food and blur the table setting.

■ **A zoom lens** *enabled me to follow these shepherds in Tajikistan as they walked away. A large aperture reduced the depth of field to blur the background.*

Focal-length control

CHANGING FOCAL LENGTH is easy because zoom lenses are a near-universal feature of digital cameras. All you have to do is push a button to get more in view or to magnify a smaller section of the view.

Wide-angle views

A short focal length gives a wide *field of view* that allows you to approach a subject closely while still catching much of the background. If you step back a little, you can take even more of the subject into the frame.

■ **I chose a wide-angle** *view for this shot so that I could incorporate a good many of the vertical lines, which I have used to frame the small figures.*

Telephoto views

It would be sensible to refer to the opposite of wide-angle as narrow-angle, and, technically, that is correct. But in common parlance it is known as telephoto, a reference to the magnifying powers of a telescope.

Trivia...

The first widely available zoom lens, from Voigtlander, offered a modest 36–82mm range, yet weighed more than a modern professional camera. It cost a fortune but gave low-contrast results that would embarrass today's point-and-shoot cameras.

■ **To capture things** *that are very far away, a long telephoto lens is an invaluable addition to your camera kit.*

The telephoto effect

A longer focal length magnifies a narrow view of the subject: you can look closely at a person's face without being physically close. This forces longer perspectives, which pull together disparate objects: in a distant urban view, buildings that are several blocks apart appear to be right next to each other. At close distances, a narrow view tends to separate out objects that may actually be quite close together.

■ **It would be rude** *to get too near a man at prayer to concentrate on his prayer beads, so I shot from a distance with a long focal-length setting.*

DIGITAL ZOOM

Digital zoom is a computer-generated increase in apparent focal length. If you hold down the button that increases focal length, many cameras switch to digital zoom once the lens reaches the maximum. Although the focal length does not actually increase, the image continues to be magnified. In some cameras, you may have to set a separate digital-zoom function for the same result. Digital zooming works by enlarging a central portion of an image to fill the given format. It does not add more information – it may even mask existing information – but it provides an acceptable way of achieving greater image magnification. You can obtain the same effect with image-manipulation software, but this is less convenient than the camera doing it.

LONGEST ZOOM SETTING DIGITAL-ZOOM ENLARGEMENT

Working close up

TRUE CLOSE-UP PHOTOGRAPHY used to need costly specialist equipment. This has changed with digital cameras, which work at close range as if they were born to do it. Additionally, the LCD screen provides a reliable way to frame close-ups accurately without the complexities of an SLR camera.

In the past, close-up photography – making photographs at a nearer-than-normal focusing distance of around 28 in (70 cm) – was available only to keen photographers who had invested in special equipment. More recently, close-up photography has been denied to the many millions who own autofocus compact cameras because the viewfinder arrangement makes it impossible to frame close-up shots accurately. Digital cameras have changed all of this. Not only is the optical set-up conducive to close-up photography (focusing distances with the lens nearly touching the subject are not unusual), but the universal use of LCD screens that give a through-the-lens view allows all but the simplest digital cameras to focus close-up.

Close-up composition

One of the most effective ways to approach close-up photography is to assess your images in terms of design and composition. Are the elements rhythmically disposed? Do the colors work together? Will the image be effective when seen at different sizes – at postage-stamp size or as a large print? This is a very useful test that can also be applied to other kinds of images.

■ **Digital cameras** *are perfect for that favorite subject, flowers. They may record certain flower colors, like blues and greens, more accurately than film, but they are not so good with yellows.*

CLOSE-UP KEY POINTS

The main points in close-up photography are:

1. **Depth of field** is very limited, meaning that the distance within which an object appears acceptably sharp is very small. It is all but impossible to contain a subject within sharp focus, and setting a very small aperture (if it is even possible on your digital camera) does not greatly increase the depth of field, yet it greatly increases the exposure time. In practice, the best strategy is to exercise artistry in choosing which part should be sharp.

2. **Movement** in either your subject or your camera, or both, is greatly magnified. You will need to steady the camera and the subject – the slightest breeze over a flower will render it unsharp; the slightest twitch of a spider's body will blur your portrait of it. **Flash** is often used to reduce the effect of camera or subject movement.

> **DEFINITION**
>
> **Flash** *is a very brief burst – less than* $1/1,000$ *of a second in duration – of intense light. This light is added to that from the available, or ambient, light.*

3. **The working distance** – that is, the space between the front of the lens and the subject – can be important for live subjects. For birds or butterflies, you need a greater working distance so as not to disturb them; if you are photographing snakes, it will put you out of harm's way. This needs longer-than-normal focal lengths – ideally a 35efl of around 180–200mm. Besides, if you are close up with a wide-angle field of view, you may as well photograph from a greater working distance at a longer focal length. On occasions you may want to keep a good distance between yourself and the subject – a beehive, perhaps. In such cases, set the longest focal length on your zoom lens before focusing close up.

4. **Automatic flash exposure** may be inaccurate at very close working distances. At very short distances, the circuitry may be unable to respond quickly enough to prevent overexposure. To combat this, reduce flash exposure either by setting controls, if possible, or by setting the flash to manual. Alternatively, cover the flash head with translucent material, such as a handkerchief.

All this adds up to close-up photography needing more care and attention than normal photography. To get the best out of it, ensure your digital camera allows apertures to be manually set and that close-up focusing is available at the long end of the focal-length range.

Close-up portraits

If you approach, with your camera, within touching distance of someone to make a portrait, and you can see all of their face, take care not to exaggerate their features.

Any part of the face closer to you than other parts – especially the nose – can seem disproportionately large in a close-up photograph.

■ **I had to snatch** *this image very quickly – I was on a guided tour and had no chance to change my lens. As a result, I approached a little too close for the lens I was using, creating a not-very-flattering portrait!*

A simple summary

✔ Movement of the camera or subject during an exposure will result in an unsharp image – but this may not be undesirable.

✔ Shutter lag is the delay between the pressing of the shutter button and the image capture.

✔ A smaller aperture (that is, a higher f/number) increases the depth of field.

✔ A short focal length offers a wide field of view.

✔ The opposite of wide-angle is called telephoto, or tele.

✔ The through-the-lens view of the LCD screen has made digital close-up work highly accessible.

✔ Lack of movement is even more important for close-up work.

✔ For the best close-up results, set your apertures manually and check that close-up focusing is available at the long end of the focal-length range.

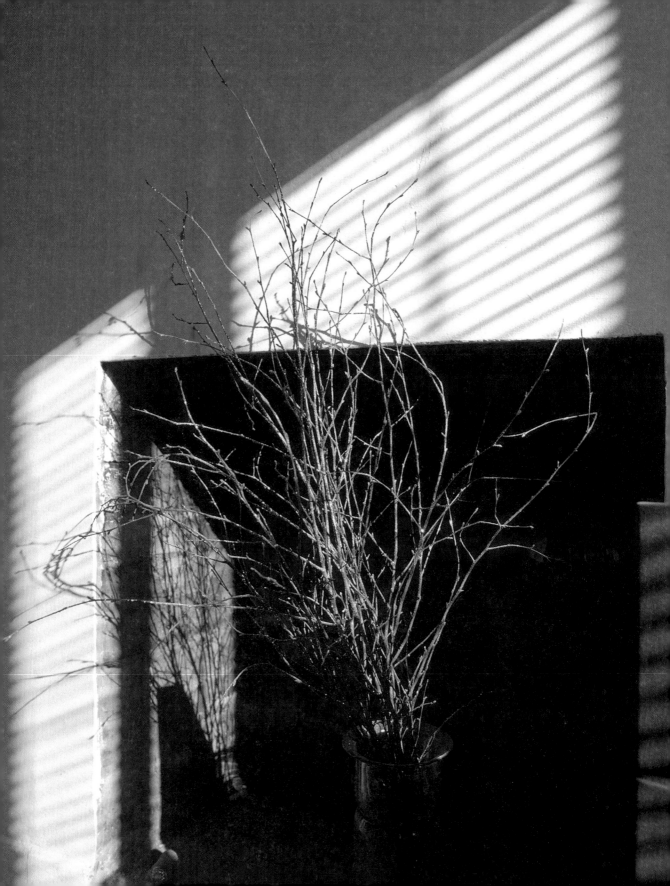

Chapter 8

Your Partnership with Light

Not for nothing does "photography" mean "writing with light." The photographer who forgets the writing bit is the one who misses out on both the challenge and the reward. Its changing moods, its silent transitions that can turn a humdrum scene to magic, its ability to sculpt and reveal shape, luster, and texture – these are constituents of the joy that is photography. Even better, then, to be able to work with light, to write with it, to create your images. The control you exert over light can be simple or elaborate – the main requirement is simply to open your eyes.

In this chapter...

✓ **Controlling camera exposure**

✓ **Creating silhouettes**

✓ **Working with backlighting**

✓ **Creating high key and low key**

✓ **Easy flash photography**

✓ **Flashy techniques**

111

FOR A FEW DAYS IN THE YEAR, THE SUN IS AT JUST THE RIGHT ANGLE TO LIGHT UP THE FIREPLACE

Controlling camera exposure

EXPOSURE CONTROL ENSURES that the optimum amount of light reaches the sensor to obtain the results you want. In digital photography, exposure control is a dynamic process in which the sensor delivers a stream of instructions to the camera controls to ensure it receives exactly the light it wants. Nonetheless, it is best to know how to control exposure accurately: you get the best from whatever system you are using, and it saves you work later.

Measuring systems

The simplest systems measure light from the entire field of view, treating all of it equally. However, many cameras use a scheme in which light is taken from the entire field of view, but more account is taken of light from the center of the image.

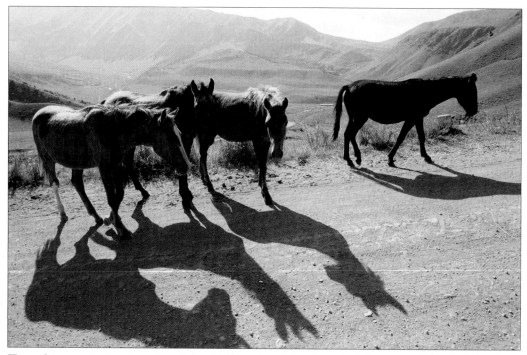

■ **Working against** *a strong hazy light with complicated shapes and subtle tones calls for the help of evaluative metering. Here, it did a perfect job of balancing the details in the dark horses while retaining the colors in the bright landscape.*

The latter system can be taken even further to ignore light from most of the image and to measure only from a central patch, which can vary from as much as 25 percent of the whole to less than 5 percent. For professional photography, this so-called selective area or spot-metering scheme is the most practical and precise.

A machine-intelligent approach is to divide the measuring area into a patchwork of zones, each of which is separately evaluated. The meter compares the results from the zones with a database of different picture-making situations and comes up with a camera setting. This system, commonly known as evaluative or matrix metering, is very good at selecting the correct exposure.

Camera settings

Once the camera has made the measurement, it must set the shutter and aperture controls. The shutter is responsible for how long the sensor is exposed to light – the exposure or shutter time. The aperture measures the relative size of the hole through which light enters the camera: a small

■ **A correct exposure** *for this cozy guest-house would make it too bright. Technically underexposed, this image preserves the atmosphere of the dining room.*

■ **Afternoon sun streams** *into this barbershop in Uzbekistan. A technically correct exposure would have made the scene a little too dark. Since I wanted to preserve the sense of light flooding into the room, I allowed some extra exposure.*

hole, or aperture, lets through less light than a large hole. In the majority of digital cameras, the camera decides which combination of shutter and aperture to use. In more advanced models, you can set one – say, for example, shutter time – and the camera will automatically choose the appropriate setting for the other.

The secret to camera exposure is to realize that there is no such thing as the single perfect exposure for a scene. Varying with your interpretation or intentions, different exposures can all be right. The only correct exposure is the one that gives the result you want.

Creating silhouettes

TO CREATE A SILHOUETTE, you expose for the background – whether it is the sky or a bright wall – so that the foreground object becomes very dark or black. Ignore the foreground – in fact, point the camera away from the foreground to ensure that it does not affect the exposure reading at all.

For silhouettes to be most effective, there should be minimal light on the silhouetted subject, otherwise it loses its shape – and the main point of a silhouette is to exploit visually its outlines or shape in contrast to the background. In this respect, a plain background, such as a blue sky, is most effective.

■ **The day was dull** *and hazy with no color in the sky at all. So, when the boy climbed into the tree, I was hoping only to record the contrast of his body against the old branches. It was a surprise to find that, by taking the exposure from the sky and underexposing a little, its blue color came through.*

■ **To get a different slant** *on a much-photographed monument, I waited for a bright morning. By exposing to obtain a nice blue sky and hiding the sun behind the column, I created this silhouette.*

Working with backlighting

THE CLASSIC BACKLIT SUBJECT is a portrait taken with a window or the sky in the background, or an airplane in the sky; but remember that figures on a bright sandy beach or a ski slope in the sun are often also strongly backlit.

The challenge for exposure control is that the strong background light dissuades the meter from setting a camera exposure to give the darker subject in the foreground enough light. You will need to override the exposure or set it manually to give more exposure to compensate. Many cameras offer a backlight button to do just that.

> **DEFINITION**
>
> **Veiling flare** *is light – like an overall mist – in the image that does not form the image. It lowers contrast.*

Dealing with flare

A further problem with photographing backlit subjects is **veiling flare**. This is aggravated by the increase in exposure needed for the subject in strongly backlit situations. It is very difficult to prevent the light that spills around the edges of the subject from blurring details while reducing the subject's contrast and color at the same time.

The use of highest-quality lenses helps reduce the effect of flare but, of course, a lens hood is of no help in this situation.

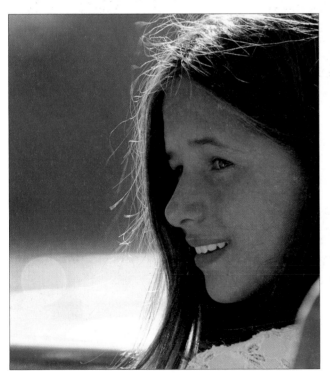

The photosensor surface is more shiny than normal film. This can cause problems because the surface reflects more light than film. This light then bounces around inside the camera and reduces image quality.

■ **In a classic backlit** *situation, the hair can be beautifully lit to create a bright halo around the head. Full exposure for the face has overexposed the background to nearly full white, but that helps frame the lovely face.*

Creating high key and low key

THE KEY TONE IN THE MAJORITY OF IMAGES lies at or near the mid-point between the darkest (or black) tones and the brightest (or white) tones. The visual effect of deliberately shifting the key tone is not merely to make an image lighter or darker overall, but also to signal a mood or feeling to the viewer.

When you choose to shift the key tone, the exposure is technically incorrect – an under- or overexposure – but it is one that you may choose from time to time. High-key images show few, if any, truly black areas, while in low-key images, white-bright areas are reduced to a minimum.

■ **It was dark** *inside this Greek monastery, and a "correct" exposure would have rendered the interior too bright, losing the atmosphere. Exposing for the priest's face and the candles led to a low-key result overall.*

High means bright

High key signals style, being full of light and airiness – the overcoming of shadows and the sense of being outdoors. Obtaining a high-key image is not solely a matter of increasing the exposure; rather, it is of ensuring that many of the tones of the image are lighter than mid-tone. You can achieve this by lighting your subject evenly from both sides, by using fill-in flash or reflectors to reduce the strength of shadows, or by positioning yourself in such a way as to minimize your view of shadows. In low-contrast situations, high key may be achieved by increasing exposure. With digital cameras, you can easily see the effect of deliberate, non-standard exposure settings immediately after taking the image.

■ **An image such as this** *will take almost any amount of overexposure, because its subject matter will always be clear, and the simple shapes depend on neither subtleties of contour nor color transitions.*

Whether working with film or digitally, I always create high- or low-key effects afterward, in the darkroom or on the computer, never on the shoot. I never know whether I might want a properly exposed shot after all.

The easiest way to expose to high key is to base your exposure reading on the shadow area – that is, point or limit the reading of your exposure meter to the shadows. You may need to approach close to a darker region, take the exposure reading, hold it in, and then recompose the image.

■ **A modern, trendy nightclub interior** *cries out for the high-key, minimalist treatment. The darker shot (left) is the original as captured, tinted orange by available light. Balancing the orange to neutral and increasing exposure returns the image to its true, bright-white self (right).*

Quick high-key results

By placing the darkest area with detail as your mid-tone, all the other tones in your image will be lighter, and you should have very little in the image that is darker than mid-tone. The result is a high-key image. This method avoids calculations and is the easiest way to work while on the move.

Beware that deliberate overexposure in a digital camera may cause electronic **artifacts** due to an overloading of the photosensors. It is probably better to capture the images with normal exposure and create the high-key effects later with image-manipulation software.

Mean and low

The mood of low-key images is somber, mysterious, and metaphorically darker, achieving a dramatic effect. Being unable to see details in the large dark areas, one can only guess and be afraid! Technically, it is easier to create low-key images than high-key, since less light, exposure, and control are required. But remember: when you output the images, your prints will have large areas of dark tone, which can easily be overloaded with ink.

Low-key flexibility

The most flexible technique for exposing low-key imaging is to concentrate the exposure reading on the brighter areas holding some detail. If you point your metering at such a region in your subject, that will be rendered as a mid-tone gray. This means that everything darker than the bright area – that is, most of the image – will be darker than mid-tone gray. Shadows with detail will therefore become completely black, lacking any detail.

With digital cameras, a deliberate underexposure can give you a noisy image. It is better to create the low-key effect after obtaining the image with normal, correct exposure.

■ **In Fiji, a stream of cool water** *is a haven from the high temperatures. The original scene was quite dark, but this shot is even darker. The overall low key holds the eye on the colorful leaf and the feet gripping the stones.*

Easy flash photography

COMMON PROBLEMS with using electronic flash include overexposed results (particularly of the foreground), as well as underexposed results (particularly of the background). Underexposure of long-distance shots is also very common. Uneven lighting, with the corners or foreground less bright than the center of the image, is another typical problem.

Distance problems

Modern electronic flash units measure exposure automatically. As a result, they are as prone to error as camera exposure meters. Also, the light produced by a flash unit falls off rapidly with distance. Overexposed flash pictures are usually caused either by taking the picture too close to the subject or where the subject is the only thing in a lot of empty space. Underexposure is caused by insufficient flash power: no small flash unit can light an object more than 33 ft (10 m) away, and even quite powerful units cannot reach more than 100 ft (30 m).

■ **Flash units** *used close up often give overexposed results. You could set underexposure deliberately or temporarily cover the flash-head with white tissue.*

■ **Using flash** *where there is glass around is tricky. The flash is thrown back at you, causing the important part of the picture to come out too dark.*

■ **Even with a flash** *mounted above the camera, the lens hood of a large lens obscured the flash so that the lower part of the image was in shadow. This problem is worse with wide-angle views, as seen here.*

Uneven lighting is caused by the flash unit being unable to cover the area seen by the lens. Another problem is that an attached lens or accessory, such as a lens hood, may block off light from a camera-mounted flash.

Avoiding red eye

Red eye makes portraits that are taken in dark conditions with flash look as though the sitter is on a horror-movie set! This phenomenon is caused by the light reflecting off the blood-red retina of the eye, because the iris of the eye – its aperture – is wide open, allowing the flash light an unobstructed path. It is at its worst if your subject looks straight at the camera, but, short of turning away from you, there's no guarantee you will avoid it even if your subjects look to one side. The correct solution is to work in quite bright, ambient (available) light conditions, so that the pupils of everyone's eyes close down somewhat.

■ **In the dark,** *a flash fired straight at someone's face reflects off the back of the eye's retina as a blood-red color.*

RED-EYE REDUCTION

Many cameras feature a "red-eye reduction" mode, which emits a brief flash or series of flashes just before the main exposure. Although the human eye responds in under a fifth of a second, it's often that fifth of a second that makes the difference between a well-timed shot and one that misses the smile or gesture. It's best to turn off red-eye reduction for anything but the most informal party shots.

Flash synchronization

The flash of light and the run of the camera shutter are two separate events, so we must ensure they happen in the right sequence and at the right time. First, the camera shutter must open sufficiently to expose the whole of the sensor, and the lens aperture must be at the right setting. Then the flash can go off. Ensuring this happens is the job of flash synchronization. With the majority of digital cameras, where the shutter is inside the lens, that presents few problems. But with SLR-type cameras there is a limit – often called the "x-synch setting" – usually between $\frac{1}{60}$ and $\frac{1}{250}$ of a second, which is the shortest shutter time that can be synchronized. Longer times present no synchronization problems.

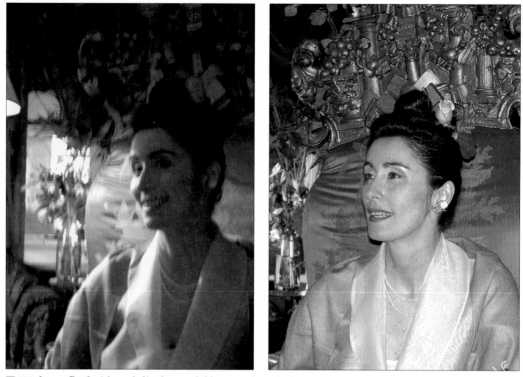

■ **Without flash** (*above left*), *the available or ambient light is very pleasant and warm, but the slightest movement from the subject (the bride) causes blur. A flash exposure, on the other hand (right), catches the sitter sharply but loses out on the atmosphere.*

Flash tips

For close-up flash photography, reduce the power of your flash, if possible – usually only on accessory flash units. When photographing distant subjects in the dark – for example, landscapes and concerts – using the flash is usually a waste of time (and, if at a concert, a nuisance); turn it off and use a long exposure, with support from a tripod or by leaning on something suitable, such as a chair or a fence. To ensure the background is not rendered black, set a sufficiently long shutter time; use the metering to guide you. Generally, it is best to give slightly less than full exposure to the background.

The best way to obtain reliable results with flash is to have as much experience as possible. With digital photography, it is easy to make exposures at different settings and in differing situations to learn their effect – all without wasting any film at all.

Some modern flashes offer a modeling light that illuminates briefly to show the effect of the light. This is a very useful check, but it can consume a good deal of power and may disturb your subject.

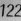

Flashy techniques

YOU ONLY NEED a little experience with the built-in flash on your digital camera before you yearn for more control and better quality lighting. If you think you may want to use flash a lot, buy a camera with a hot shoe. This is a squarish metal socket, usually on top of the camera, into which you can slide a flash unit.

Bounce flash

A direct flash shot produces rather unpleasant results. But if you have a flash with a swiveling flash head, you can turn it away from your subject and aim it, for example, at the wall. The light then reflects, or bounces, off the wall, becoming a lovely, large, diffused light source that produces a softer effect. It also reduces the rapid light fall-off that is characteristic of a small light source.

Mixed lighting

The result of balancing flash with an exposure sufficient to register the ambient light indoors generally delivers the best-looking results. The lighting is soft, but the color balance is warmed by the ambient light, while the background has a chance to appear quite natural. For this effect, you need to use the "slow-synch" mode if your camera offers it. This allows the ambient exposure to be relatively long, to give as good exposure to the background as possible, while the flash lights the foreground. This not only softens the effect of the camera flash, but also allows you to enjoy the mixture of color temperatures (the cool colors of the flash and the usually warmer background light).

■ **By pointing my flash** *at a wall, I softened the light on the model. A direct flash on her would have produced horrible results with hard shadows. However, the space behind her is too dark. I should have used a longer exposure to mix the light.*

■ **With a shutter time** *of quarter of a second, I gave enough exposure to the available lights so that the whole image appears lit up. But a close look at the model shows the danger: note the movement in her face, even though she was asked to hold still.*

■ **This shot shows** *a perfect balance between the flash exposure – on the girl in the foreground – and the exposure for the distant buildings. However, it also shows uneven lighting from the flash, which was unable to cover the extremely wide angle of view.*

Hints for great lighting

You will greatly improve your photographs if you bear these lighting tips in mind.

① Use as few lights as possible to achieve the desired effect. Start with one light only and use reflectors to shape its output. Only if this is insufficient should you add more lights.

② A reflector placed facing the main light to bounce light into shadows is usually more effective than using another light source to reduce shadows.

③ A large light source, such as an umbrella reflector, produces softer light and more diffused shadows than a small light source.

④ Remember: a small light source – for example, a spotlight or a small reflector bowl – produces harder light and sharper shadows than a large light source.

Flash exposures

All flash exposures consist of two separate exposures occurring at the same time. While the shutter is open or the photosensor is receptive, ambient light gives one exposure. The ambient exposure takes on the color of the prevailing light: it exposes the background, if sufficient, and it is always longer than that of the flash itself. The other exposure is in addition to the ambient exposure: the flash of light is very brief (possibly less than $\frac{1}{1,000}$ of a second, but studio-flash duration may be as long as $\frac{1}{200}$ of a second) and its color is determined by the characteristics of the flash tube, though this may be filtered for special effects.

Because there are two separate exposures, it is necessary to balance them for good photographic control. It also means that you can make creative use of their different contributions – for example, flash can stop movement and make a sharp image, but that can be added to a blur from the long ambient-light exposure.

A simple summary

✓ Your camera's exposure setting controls the amount of light that reaches the photosensor.

✓ Most digital cameras can work out the exposure once the aperture is set, and vice versa.

✓ Silhouettes are created by setting the exposure for the background and disregarding the foreground.

✓ Many cameras offer a backlight button to lighten the foreground if the background is very bright.

✓ High-key images have few, if any, black areas.

✓ Low-key images are those in which white-bright areas are kept to a minimum.

✓ High- and low-key effects can be added after shooting.

✓ Electronic flash often overexposes the foreground or underexposes the background.

✓ Red eye can be reduced by having your subject look away from the camera.

✓ When lighting a subject, use as few lights as possible, adding more only if absolutely necessary.

PART THREE

Turning to Digital

YOUR OLD PHOTOGRAPHS – prints and film – can also play a full part in the digital revolution. Just scan them in and, for all the computer knows, they are digital files like those from a digital camera. In this part, we learn that the more carefully you scan, the better your final prints will be.

Chapter 9

Entering the New World

SCANNING IS NOTHING LESS THAN A MAGIC WAND – it literally transports images (and words) from one world into another. In the process it frees you from the physical world to enjoy all the benefits of the digital domain: unlimited and perfect duplication, desk-based image manipulation, and a widened choice of ways to print out and use the image. Within this promise there is a catch. Any mistakes you make in scanning will follow you forever, so you had better get the magic right! This chapter will show you how.

In this chapter...

✓ **Scanning: the basics**

✓ **Scanning for output**

✓ **Mastering resolution**

✓ **Scanner problems**

✓ **Flat-bed scanners are cameras**

THE WORLD OF DIGITAL PHOTOGRAPHY IS GETTING BUSIER EVERY DAY

Scanning: the basics

SCANNING IS LIKE READING, only done by a machine. Just as you read a novel line by line, so a scanner digests an image one line at a time: it reads the first detail in the top corner of an image, then across the width until it reaches the edge. It sends a stream of data down for the scanning software to interpret. Then the sensors are moved down a fraction of an inch so that the reading process continues. This cycle is repeated until the whole image has been covered.

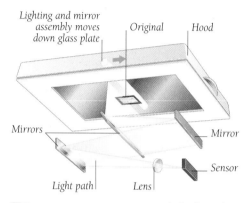

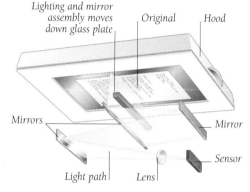

■ **In transparency scanning,** *light from the hood passes through the original. This modulates the light beam, which is then analyzed by sensors.*

■ **In reflection scanning,** *a lamp beneath the glass plate shines light on to the original. Mirrors then relay the image to the sensors.*

Collect the originals required for the job at hand – you may simply need to make a few prints of family portraits or gather images for your club's website. Next the scanning itself takes place in three steps.

 Use the **scanner driver** software to make a pre-scan. This allows you to check that the original is oriented correctly, to set the scanner to scan only as much of the original as you need (that is, to crop the scan), and to set the final image size and resolution.

 You then make the scan itself.

 When the scan is complete, you will need to save it on to the computer's hard disk.

Once the job is finished, be sure to put away your originals so you can find them again, and, if your work is critical, make a backup of the scans.

> **DEFINITION**
>
> *The **scanner driver** controls the scanner from your computer. With it you can set image size and resolution, name the file, and also make color and other corrections.*

Getting organized

Streamlining your work will ensure that you obtain high-quality results while minimizing effort.

 Plan ahead: collect all your originals together.

 If you have many scans to make from different kinds of originals, sort them into types to save you changing settings all the time.

 Scan landscape-oriented pictures separately from portrait-oriented pictures; this saves you rotating the scans.

■ **Original negatives are lost** *more often than prints because they are so rarely looked at. Scan precious pictures immediately in case the prints are damaged or simply fade in time.*

 Clean your scanner's glass plate if you are working on a flat-bed scanner.

⑤ Clean your originals by blowing dust off with compressed air or a rubber puffer. Wipe prints carefully to remove fingerprints, dust, and fibers.

⑥ Use file names that other people can understand.

⑦ When you scan, crop as much extraneous image as is sensible to keep the file size small but still allow yourself room for maneuvering if you need to crop further.

⑧ You may need to make your output image slightly larger (say, an extra 5 percent on all sides) than the final size. Sometimes this is essential, like when you want your image to extend to the very edge of the paper – that is, to bleed.

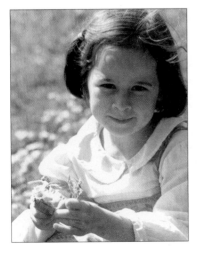

■ **If you work** *with very different images one after another – landscape, portrait, dark, light – you may find scanning confusing. Try to scan your work in batches of similar-looking originals.*

Scanning for output

THE KEY TO SUCCESSFUL SCANNING is always to scan with what you want to do with the image uppermost in your mind. It is easy to make the mistake that you need to make the finest possible copy of the original and cause yourself needless work.

Right first time

You may have to live with a scanned image for some time. Careful scanning ensures you have a good-quality image to work with – one that saves you unnecessary corrections.

 1 Let the scanner warm up for at least 5 minutes before making any scans.

2 Line up any rectangular original as carefully as you can. Rotating the image after scanning to square it up can degrade image quality, especially of line art (black-and-white artwork).

 3 When scanning a large book, take care not to damage the hinge of the scanner lid by forcing it down to flatten the book. Use another book to hold your original down.

 4 Check that the colors and brightness on the pre-scan match those of the final scan.

5 Save your images to the file format that is easiest for your software to use. It is a waste of time having to change file formats more than necessary.

Tidy up

When you have made the scan, it is good practice to tidy it up. There may be parts of the slide mount, film rebate, or an extreme edge to be removed. Remember that although you may ignore unwanted parts of the image, they will still be taken into calculations of, say, Levels or Color Balance. By cropping off unwanted portions, you also reduce the size of the image. Next, examine the image very carefully for sharpness and look out for defects. It may be that the scanner failed to focus correctly: rescan now. Clean the image of dust and other particles.

■ **This print** *of an old family friend was poor to start with and much faded after the years. A scan and a few minutes' work made great improvements.*

Scanning printed material

There is a wealth of printed material that appears ripe for scanning. But beware: since the copyright of nearly all published material belongs to someone, you are likely to be in breach of their rights if you scan such material without permission. However, in general, if you are scanning just for fun and to learn how to use the software for personal purposes (in legal parlance, "for individual research and study"), then you will be allowed to make the copies.

Extracting text from print

If you present a scanner with a page of printed words, it will scan it as if it were a picture – it just happens to be made up of words. If you want to work with the words themselves, however, you will not be able to. You need to teach the scanner to read, and that is done with optical character recognition (OCR) software, which is essentially a special scanner driver. Scan your document and the OCR software will deliver a word-processor document. This, incidentally, will be far, far smaller than a scan of the document as an image, so it is better for archiving documents.

OCR software can make mistakes, such as replacing a lower-case l with the numeral 1. These errors can be numerous if the document is poorly printed.

Using film scanners

If you need to scan your legacy of negatives and transparencies, whether black-and-white or color, then it is best to use a special film scanner because these produce better results than flat-bed scanners. This is particularly true for scanning color transparencies. Unfortunately, the inexpensive models produce disappointing results.

■ **This is what happens** *when you try to scan a transparency on a flat-bed scanner – flat results and poor details in shadows. Notice in the close-up shot (above) how the shadows appear full of detail but are, in fact, full of noise, where the pixels give no information.*

Mastering resolution

THE MOST COMMON PROBLEM IN SCANNING, known to make grown men weep, is working out the correct resolution. A simple solution is to count how many pixels you have. Too few pixels will lead to too low a resolution, which causes the image to look unsharp, lacking in detail, or **pixelated**. *More pixels give higher resolution, which promises higher quality. But having more pixels than necessary leads to more time spent scanning, and the resulting files needing more storage space.*

> **DEFINITION**
>
> **Pixelated** *images are those in which the individual picture elements – square blocks of color – can be easily seen.*

Higher resolutions do not guarantee better quality results. A good-quality image needs not only sufficient pixels, it should also be sharp, color-correct, and exposure-correct.

Two approaches

There are a couple of ways to work out the appropriate resolution when you are scanning images. You can scan specifically for the task in hand, and if a different use of the image calls for a higher resolution, you can make a new scan later. This is the most economical way if your workloads are not too great. Alternatively, you can scan every image at the highest resolution you are likely to need, producing files at least 30 MB in size. You can then make copies, adapting image resolution to each task. This saves on repeated scanning, but you will need a lot of data capacity.

Checking image size

The simplest way to check image size is to work by the size of the image file. Use the table opposite as a guide for color images; for black-and-white, use files a third of the size of those recommended for color – so, instead of 1.9 MB for an 3 x 5-in (8 x 13-cm) print, use 0.6 MB.

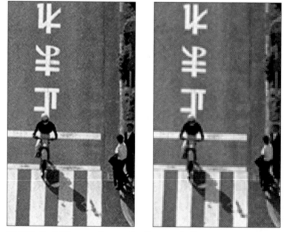

■ **With 541 pixels** *on the long side for defining detail (above left), you can read the road signs easily and see transitions of light and shade. With only 142 pixels (above right), you can easily see pixelation – image detail spoilt by individual picture elements being visible.*

Selecting the correct image size

When you make the pre-scan and crop to the part of the scan that you want, you need to tell the scanner driver what size you want to print out. Set this. The driver will then tell you the size of file you will obtain after scanning. If it is not the right size, change the resolution settings until you obtain approximately the file size suggested by the table below.

Remember that, in calculating the image file size, the size of the original is irrelevant: whether you reduce a poster to fill a monitor screen or enlarge a postage stamp to fill the same screen, the correct file size is exactly the same.

RECOMMENDED FILE SIZES

Use this chart as a guide: if the size of print you desire is in between one of these sizes, your file size should also be in between. Print sizes assume an image resolution of 300 pixels per inch, so the file sizes are generous; you may obtain satisfactory results with files about a third smaller.

FINAL USE OF FILE	SIZE	OPTIMUM FILE SIZE
Ink-jet print	3 x 5 in (8 x 13 cm)	1.9 MB
	4 x 6 in (10 x 15 cm)	2.7 MB
	8 x 10 in (20 x 25 cm)	5 MB
	A4	6.9 MB
	A3	12.6 MB
Image for Web page	480 x 320 pixels	0.45 MB
	600 x 400 pixels	0.70 MB
	768 x 512 pixels	1.12 MB
	960 x 640 pixels	1.75 MB
	1280 HDTV	2.64 MB
	Web banner	82 KB
Book or magazine printing	A4	18.6 MB
	8 x 10 in (20 x 25 cm)	13.6 MB
	A5	9.3 MB
	5 x 7 in (13 x 18 cm)	6.7 MB

SAPHIR ultra2 Set up

			LAB	High

Name	2234

TIFF
3.2 MB G3 HD: Desktop F..r: DPH pix G3 [...]

Ruling	None	166 lpi
Resolution	400 dpi	

Scaling	By Factor

	↔	↕
Input	71.37	63.36 mm
Factor	100.00	100.00 %
Output	71.37	63.36 mm
Mirror	**F.**	↺ 0.00 °

Calibration	Reflection SAPH...
Contrast	Lights
Colour Assist	Off [...]
LCH Corr.	Uncorrected [...]
CMYK Corr.	Uncorrected [...]
Filter	Sharpen Less [...]

Reset	Prescan	Scan

Settings

Job:	Positive 1
Type:	RGB colours
Res:	166 lpi (1.5x)

Scan Frame x Scaling = Output

W:	0.946		6.000
H:	1.284	634.11	8.140

Image Size: 8.7 MB Inch

☒ Fixed Scan Frame
☐ Fixed Output Size Transform: **F**
☒ Keep Proportion

Scanner Profile	Kodak Positive Fi...

☼ D-Range	No Correction
W & B Points...	No Correction
Tine Curve	No Correction
B & C	No Correction
Colour Corr	No Correction
Filter...	None

Reset

■ **The dialog boxes for scanners** *can be intimidating; take them in step by step. In both of these examples – a flat-bed scanner (left) and a film scanner (right) – the top half is for setting size and resolution; set these first and leave the others at the factory, or original, settings. The bottom half controls the appearance of the scan – use this once you have a preview image to work with.*

Calculating the resolution required

The more rigorous approach works on the fact that the number of pixels needed to be input from the scanner equals the total number of pixels needed for the output. The calculation is as follows:

$$\text{Input resolution} = \frac{(\text{size of output x output resolution})}{\text{size of original}}$$

If you use this formula, you must be careful about the units you use.

Do not mix inches and centimeters. It is important that you use the same unit of measurement in each part of the formula.

THE THEORY IN PRACTICE

You may take size of output and size of original from simply one dimension, say, the length. Suppose your original is 2 in (5 cm) long and the print you want is to be 10 in (25 cm) long. If you need an output resolution of 300 lpi (lines per inch), then you need 300 x 10 pixels – that is, a total of 3,000 pixels – for output. The input resolution must therefore be 3,000 divided by 2 (the size of the original in inches), which gives the required scanner resolution of 1,500 ppi (points per inch).

If you are concerned about mixing units of measurement, the following formula keeps things simple. Note that percentage increase is often marked "scale" in scanner controls:

Input resolution = percentage increase in size x output resolution

The key is to determine the correct output resolution.

- For ink-jet printers, you may use anything between 80 and 300 lpi depending on the quality of paper, using a lower figure for rougher or more absorbent paper.
- For screen-based work, use 72 dpi (dots per inch) or 96 dpi (but it does not matter exactly what figure you use).
- For reproduction in print, use 225 ppi. Some authorities recommend 300 ppi.

Lowest resolution, highest efficiency

Experiment with using the lowest resolutions that do not compromise quality. This exercise is most valuable when outputting to an ink-jet printer. Using the smallest possible files will save you time and money.

After a while, your work is likely to fall into a pattern. Keep a note of the settings that give you satisfactory results and reapply them. If you are working with a commercial printer, ask for their recommendations.

If your image has a higher resolution or more data than can be used by your printer or screen, it will simply be ignored. But don't feel you have to make the file smaller: do so only if you want to speed up operations like opening, applying effects, and printing. Remember: discarded data can never be recovered.

Scanner problems

SCANNING TURNS YOUR FILM-BASED WORK into a digital form for your computer. The quality of this step is crucial to the quality of everything you do subsequently, so it is important to go carefully at this stage. Here are some suggestions for what to do in common situations.

File too small

The most common error is working with a file size that is too small for the intended task (see p.133 for details on how to calculate the optimum file size). Always check your image's file size before you do any work on it: you don't want it to be too large – it will slow you down – or too small, because the quality will be too low.

Solution: Rescan the print if the file is too small.

Image Size		
Pixel Dimensions: 16.2M (was 3.3M)		OK
Width: 2660	Pixels	Cancel
Height: 2128	Pixels	Auto...
Width: 25.4	cm	
Height: 20.32	cm	
Resolution: 266	Pixels/inch	
☑ Constrain Proportions		
☑ Resample image: Bicubic		

■ **You should never** *see settings like this in your dialog box. If a 3.3-MB file is enlarged to 16 MB, the result will be broken-up detail.*

Jitter and other artifacts

Before you start working on a scan, examine it closely for any elements that were not present in the original. Even the most expensive scanners can introduce artifacts, such as tiny black dots in light areas, but these may be so small that they are invisible at normal size. Some errors, however, such as the jitter or uneven movement of the scanner head, cause defects – jagged, uneven lines – that can be seen at normal print sizes.

Solution: Rescan, or scan using a better quality scanner.

■ **These streaks** *were produced by the uneven movement of the scan head on an inexpensive scanner. Here, the streaks have been exaggerated for reproduction purposes, but they would have been visible when printed anyway.*

Moiré from books

This comes from a clash between the regular pattern of the dots on the printed page and the regular pattern of the scanner. This can cause a new pattern – the moiré – to be superimposed over the image. The result is usually quite unsightly.

Solution: Try a slightly different resolution setting, or try aligning the page at a slightly different angle on the scanner's glass plate. Some scanner software offers filters that remove moiré patterns, but often at the cost of softening image detail. Using sharpening filters may bring out moiré.

■ **In this scan**, *you can clearly see the array of half-tone dots that made up the original image in a book. It seems as though the scene is being observed through a chicken-wire fence!*

Newton's rings

When you place a film strip directly on to the glass plate of a flat-bed scanner, you may trap a thin wedge of air under the film without realizing it. This causes the light to interfere with itself and split into rainbow-colored patterns. These patterns are known as Newton's rings.

Solution: Avoid putting film directly on the glass plate. Most scanner manufacturers provide holders for film. Alternatively, ensure that the scanner is well warmed up – hot dry air seems to reduce the incidence of Newton's rings.

■ **This film was** *too large to fit in a film scanner so was scanned in a flat-bed. When it was held down by the scanner's lid, trapped air caused the ring effects visible in the center of the image. Their size and coloring make them very difficult to remove.*

Flat-bed scanners are cameras

IT MAY HAVE OCCURRED TO YOU that what a scanner does is essentially take a picture of what you present to it. In other words, it's a camera – a special kind. This opens up interesting possibilities of using the scanner as a camera.

Collecting small things

A scanner is perfect for any hobby that involves collecting small, flat objects. If you collect coins, stamps, postcards, or other ephemera, then a flat-bed scanner has been invented especially for you. It's also great if you're interested in handwriting (graphology) or any historical research.

Scanning solid objects

You can scan anything that you can place on a scanner (but make sure it does not damage the glass). The ideal materials are objects that are almost two-dimensional, such as textiles, embroidery, textured papers, wallpaper, dried leaves, and flower petals. But small objects – such as jewelry, seashells, insects, seeds, and pebbles – also scan very well. Food items – for example, rice and other grains, dried pasta, spices (not the powdery kind), and cake decorations – can be fun to scan, too.

Flat-bed scanners, being designed to scan flat objects placed on the glass plate, have a limited depth of field. As a result, the parts of an object above the glass will be rendered unsharp. However, you can still experiment with larger objects – for instance, some artists have made portraits by scanning faces. Interesting results can also be obtained if you do not flatten objects such as leaves, flower petals, and textiles.

When scanning solid objects, you will need to experiment with which background to use. If you lift the scanner lid, your objects will be presented against a black background. If you need a white background, you will have to cover your objects with white paper – but beware that the scanner may pick up the texture of the paper, which can be hard to remove if not wanted. You can shine light on the paper during scanning to brighten the background and reduce the impact of texture.

Scanning other objects

If your objects are semi-translucent such as jewelry, or fine textiles, like organzas and lightweight silks, you can try scanning them as if they were color transparencies – that is, by using the transparency adapter for the scanning and setting the scanner software to scan in transmission mode.

■ **I needed a high-tech illustration,** *so I looked in my spares box and found an old hard-disk drive that looked promising. I scanned its circuit board as if it were a print. Then I found an unusual CD case, which I scanned as a transparency.*

■ **In order to obtain** *the image shown on the next page, just three layers and two layer modes were required.*

■ **I experimented by combining** *the CD case on top of the printed circuit, trying out different layer modes. For more variety, I duplicated the CD layer and tried out further combinations.*

CARE OF THE FLAT-BED SCANNER

If well looked after, your flat-bed scanner should provide you with years of faithful service and blemish-free scans. Just follow these few golden rules.

- Do not scan anything damp or wet; water may enter the mechanism and corrode it.
- Take care to avoid damaging the glass bed with acid or stains – for example, from fingers or colored food.
- Avoid scratching the glass. In particular, be extremely careful if you scan jewelry, pebbles, and other materials that may be harder than glass.
- Do not force the lid down on an object in order to try to flatten it: you will strain the hinges, which are usually weak. Flatten the object before placing it on the scanner bed or keep it in place with a flat object such as a book.

A simple summary

✓ Once you have made the scans necessary for your given job, put the originals in a safe place where you can find them again.

✓ Scan prints of similar shape and tone together; this will save you changing the settings too often.

✓ The most successful scanning is done with the output in mind.

✓ OCR software creates word-processor documents of typed pages or books.

✓ A film scanner is better for scanning transparencies than a flat-bed scanner.

✓ Certain problems may be encountered in scanning; learn how to deal with them.

✓ Flat-bed scanners can be used to "photograph" small, flat objects, such as stamps and coins.

✓ Look after your flat-bed scanner and it will reward you with blemish-free scans.

Making Digital Data Work for You

I T IS NATURAL AT FIRST TO BE AFRAID of digital files – after all, you can't see them. You're terrified of losing them because you have no idea where they are going. This chapter is for you: it explains the different types of files and how to make them do what you want. And there is help to ensure that you never lose any files by accident – these days, that is entirely preventable.

In this chapter...

✔ **File formats**

✔ **Getting the right colors**

✔ **Organizing files and backups**

✔ **Images on the Internet**

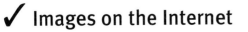

DIGITAL FILES CAN APPEAR TO HAVE A MIND OF THEIR OWN – BUT, WITH PATIENCE, THEY CAN BE TAMED

File formats

DIGITAL OR COMPUTER FILES *are nothing more or less than a long row of numbers and letters. If printed out, they would look like gibberish – even word-processor files. To the computer, however, it is anything but: all the information is in code designed to hold information concisely, minimizing wasted "words," and in ways that make it easy to process. The main difference between image files and other files is that image files are enormous compared to other types.*

Image-file formats

Unlike most other types of files – which are produced specifically by **application** software to be used only by that software with limited interchange – image files can be opened, used, and manipulated by a large range of different applications, from desktop publication, word processing, and Web production, as well as image manipulation. This is possible because image files are constructed into widely recognized data structures or formats.

> **DEFINITION**
>
> An **application** *is a computer program designed to do a certain job.*

File formats are ways of organizing data in order to make them more efficient for the use they are put to. A file format for images is very different than one for databases.

While there are dozens of formats in existence, most are specialist ones, for use in science. The following formats are very widely used and supported.

TIFF

This method for storing image data is much used across different computers and is pretty much a standard. It supports millions of colors per pixel, with data such as dimensions, color look-up tables, and so on stored as a "tag" added to the top, or header, of the data file. TIFF is the best choice for use in print reproduction. Its **suffix** for Windows is .tif.

The format can be compressed without loss using **LZW compression**. This reduces file size by about a half but slightly slows down the opening of files. It is safe to compress TIFF files.

> **DEFINITION**
>
> A **suffix** *is the dot and letters following a file name. It's used by some operating systems to recognize the type of file.*
> **LZW compression** *is a way of reducing file size that does not damage image quality.*

JPEG

Joint Photographic Expert Group is a format based on a data-compression technique that can reduce file sizes to less than 10 percent of the original with no loss of image quality. It is the best choice for photographs for Internet use. The suffix for Windows is .jpg. This format is more widely used than it appears, since formats calling themselves PictureViewer, QuickTime, and so on are essentially JPEG files.

JPEG QUALITY SETTINGS

When you save files to JPEG, you have to choose from different quality levels. For general use, a middle setting (5 or 6) is sufficient because it gives very good file-size reduction with little visible loss in quality. A high setting (9 or 10) is best for high-quality work – the file size is still smaller than that possible with LZW compression, yet the image quality is well preserved.

Photoshop

This is a format that belongs to, or is native to, the Photoshop application. It is so widespread and recognized by other software that it is almost a standard in itself. It supports color management, 48-bit color, and layers. Many scanners will save directly to Photoshop format, and the format may in fact be Photoshop even if the name suggests otherwise. The suffix for Windows is .psd.

GIF

Graphic Interchange Format is a compressed file format designed for use over the Internet. It comprises a standard set of 216 colors chosen from 256, and it is best for images with graphics – that is, larger areas of even color. GIF is not recommended for photographic images with smooth tone transitions. It can be LZW compressed (see previous page). Its Windows suffix is .gif.

PDF

Portable Document Format is a file format native to Adobe Acrobat. It is based on PostScript, and preserves the text, typography, graphics, images, and layout of a document without the need to embed fonts or illustrations in the document. The suffix for Windows is .pdf.

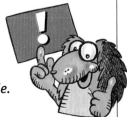

PDFs can be read, but not edited, by Acrobat Reader, which is freely available.

Photo CD

Kodak's Photo Compact Disc format has a pyramidal structure, with compressed versions of each image stored at different resolutions – from 128 x 192 pixels to 2,048 x 4,073 pixels. The Pro (professional) version accepts resolutions up to 4,096 x 6,144 pixels. Photo CD formats are used for transferring files from scanners on to CDs. They use a proprietary color model and can specify color corrections to match different sources. To open Photo CD files, you need the appropriate plug-in or filter in your software; they are best saved as TIFF or JPEG. The Windows suffix is .pcd.

PICT

Macintosh Picture is a graphic file format widely used on Mac OS. It contains raster as well as vector information (see p.251) but is nominally limited to 72 dpi, being designed for screen images. PICT2 supports colour to 24-bit depth. PICT files can be opened by very simple programs, such as SimpleText.

PNG

Portable Network Graphics is a file format for compressed images recommended for use on the Web.

PNG is intended to replace GIF in the future and may well also kill off TIFF on the Web.

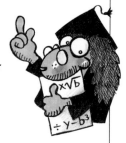

Getting the right colors

ONE OF THE FUNDAMENTAL, and frustrating, problems in digital photography is controlling colors. In classical photography, you have an entire industry working to ensure colors across different countries and media are held accurately to international standards. The situation in digital photography is quite different. Not only is it a very complicated subject, but there is not even agreement on the monitor's image brightness or its basic (white-point) color.

Color limitations

You may notice that even though you haven't changed the image itself, it looks different on the print than it does on your monitor; and when you view it on your friend's monitor it looks different again. It is hardly surprising that different devices, such as a monitor and a printer, produce different colors, but even monitors from the same manufacturer do not show exactly the same colors.

What is happening in these situations is that the same information is being interpreted differently. It is similar to having some text read out aloud: a native speaker will speak without an accent, but the same words will be accented and receive different emphasis from a non-native speaker.

In digital photography, the best we can hope for, without getting too complicated, is to ensure at least one thing is right. The cornerstone to all our digital work is the monitor.

■ **These two images** *simulate the different appearances they would take on according to monitor settings. One is bluish and darker (the one on the left), an image typical of monitors set up for Windows computers. Notice that the image can appear more blue even though there are no obviously blue colors present. The other is warmer and brighter, typical of monitors for Apple Macintosh computers.*

Setting up the monitor

The secret to getting your files to print out the right colors is to **calibrate** the monitor on which you view all your images. The first step is to make the screen image as contrasty as possible using the monitor controls. Then, call up the various calibration utilities available and follow the instructions. To make sure that you are working on a stable system, leave the monitor on for at least 15 minutes before doing any adjusting.

> **DEFINITION**
>
> To **calibrate** *is to adjust a device, such as a monitor, so that it meets certain standards.*

> **DEFINITION**
>
> **Gamma** *is a combined measure of how bright and contrasty the screen image appears.*

When you are asked which **gamma** to set, choose the Mac or Windows default, depending on which system you work on. For the white point, you should set the standard daylight of 6,500 K (also called D65).

Industry standard

You may find D65 too yellow, but it is close to bright-white glossy paper. Serious workers prefer to work to a white point of 5,000 K (or D50), which is even more yellow but is an industry standard.

If you change any setting on the monitor – or even if you just move the monitor – it is best to run through the calibration again.

■ **Simple utilities** *such as Adobe Gamma, widely found on personal computers, can go a long way to helping you work with accurate colors on screen.*

Organizing files and backups

WORKING IN CONVENTIONAL PHOTOGRAPHY, you may return from a trip with, say, 20 rolls of film, some 700 images – an easily managed number. The equivalent in digital photography is probably more than 1,000 image files. Dealing with this many digital files can get out of hand if you are not well organized – and once you start to make copies, save new versions, and acquire more images, chaos can ensue. Here are some hints for a smooth workflow.

New job, new folder

Folders in computer file management are similar to paper folders: it is best not to keep too much in each one. If you have hundreds of files in a folder, it takes longer to find a file and the computer may slow down or even crash when trying to display them all.

Instead of keeping all your working files in the same folder (and this should never be the same folder as your image-manipulation application), start a new folder for each project. As a project grows, you can subdivide it into smaller folders.

On a recent shoot in New Zealand, I created separate folders for each day's shoot: some days there were only a few shots, but on a good day there were dozens. The folder scheme meant that I also had a visual diary of my work.

File naming

Digital cameras automatically give file names to each of the images they capture. Make sure that your camera gives a unique file name every time, irrespective of the memory card inserted, and be aware that some cameras start from the beginning whenever you reinsert a memory card. If possible, turn off this function so that every single image has its own unique file name.

It is a good idea to separate your working files from those acquired through scanning or on a digital camera. When you open a scanner or digital-camera file, immediately save it as a new file with a new name. Keep the name descriptive, so that anyone can understand it.

VALUE YOUR WORK

Not only will you produce innumerable digital files in a short time, you may print off lots of ink-jet prints. You should value all this work – after all, you have put in a great deal of skill and time. Manage all these assets by labeling all prints with the file name and all relevant printing details, like the color space or special settings of the printer. Keep the successful printouts carefully – store them in good-quality boxes, preferably the type produced for keeping photographic prints. And you should, of course, *archive* and back up your digital files.

> **DEFINITION**
>
> To **archive** *is to store a permanent copy of something you don't need to access very often.*

Backing up

Since today's hard disks are capacious and relatively inexpensive, the best way to back up your work is to mirror your main drive. This means that all new files saved on one hard disk are also saved on another. Some systems actually enable you to keep archives of early working or in-progress files, not just the final files. These may create useful records for historical reasons. And sometimes ideas that do not fit one project may be useful for another – but chances are that you won't know this until months or years later.

■ **Supplementary hard-disk drives** *are relatively inexpensive – cheaper, at any rate, than losing precious images.*

Archiving

The safest way to archive your digital files is to copy them on to a CD-R (Compact Disc Recordable) using a CD writer. CD-R can be used only once, but they are not too expensive – each costs less than an average cell-phone call.

For small to medium-size collections, the most versatile cataloging system is to give a number and type for each disc – for example, CD 009 or Zip 034. Don't forget to use leading zeros, since system software will sort disc number 100 ahead of disc 99. For large collections or a busy production, you will need a more sophisticated cataloging system, such as by subject or project number.

■ **Zip disks** *hold just under 100 MB of data. They are sturdy and reliable, and drives are widely used in computers. Higher capacity, 250-MB Zips are also available.*

Keep your archive in a different location from the computer and other equipment... just in case of disaster!

Images on the Internet

YOU WILL FIND DIGITAL PHOTOGRAPHY creates new dimensions for your experiences on the Web, and the Web can help your digital photography. Not only can you easily e-mail images to your friends and family, you can also send pictures to be printed, download pictures to use, and more.

E-mailing images

For friends and family, you only ever need to send very small files via e-mail – not more than 0.25 MB full size, and with a compressed size of less than 100 KB. They will not thank you for sending large files anyway, since they take a long time to download. Send the images in JPEG format.

INTERNET

www.google.com

Click on the Images tab on Google's home page and type in what you are looking for.

Free pictures

There are more and more websites from which you can download good-quality images for your own enjoyment. Large sites like Kodak and picture agencies, as well as those of magazines on photography, all have download sites. You can check out sample pictures from digital cameras using these sites, which can be a useful exercise.

Do not abuse the trust people have placed in you by offering their images for you to play with. They are not for you to use in any commercial way, nor should anyone pretend that someone else's image is their own work.

Web-based services

A great deal of innovative effort is going into offering Web-based services to digital photographers. A well-tested and growing service is remote printing: you send your images to a website, and they print your images on to photographic paper and mail the results to you. There are also services that allow you to manipulate your images even though you don't have image-manipulation software – you just need to log on. Other services include being able to store your images on a website so you do not clutter up your own computer.

Many Web-based services are great ideas in theory, but much depends on whether you have a fast, preferably broadband, Internet connection. If not, sending more than a few images will become a tedious and costly exercise.

A simple summary

✓ Image files are far larger than other types of files.

✓ There are several types of image files, including TIFF, JPEG, GIF, and PICT.

✓ Color control is fundamental in digital photography, and monitors rarely display colors as they will be printed.

✓ Calibration is the adjustment of a device – for example, a monitor – to certain standards.

✓ Get into the habit of starting a new folder with each new project. The folder can be subdivided later if necessary.

✓ Give your images logical, descriptive names.

✓ You should manage and archive your files and prints carefully.

✓ The Internet is great for digital photographers – not only for e-mailing your work to friends, but also as a resource.

PART FOUR

Perfecting Your Images

DIGITAL PHOTOGRAPHY gives you unprecedented control over the quality of your images as well as the content. You're not quite Mistress or Master of the Universe but certainly of your image. In this part, we learn how to tweak and finesse the image.

Image Editing

Y OU'VE SEEN AND CAPTURED A GORGEOUS IMAGE, one that speaks both to you and for you. You will want the message to come across clearly, uncluttered, and without hindrance, so it needs to have just the right level of brightness and sparkle, have the correct colors, and be squeaky clean – free of defects. That is what you can achieve, and a whole lot more, with image editing.

In this chapter...

✓ **Starting up and opening up**

✓ **Cropping and turning**

✓ **Checking size and sharpness**

✓ **Assessing the image: Levels**

ORIGINALLY DULL AND LACKLUSTER, THIS IMAGE NOW LOOKS LIKE WHAT I SAW, THANKS TO SOME IMAGE EDITING

Starting up and opening up

LET'S START AT THE BEGINNING: how do you start your image-manipulation software? At first, you probably need to rummage around your folders looking for one containing your application – PhotoSuite, Photo-Paint, or Photoshop, for example. Double-click on the icon with that name. It will either open a folder – in which case you may have to find the application icon and double-click on that – or the application will start up.

DEFINITION

*An **operating system** is a special type of software that controls the computer itself and the way it interacts with you. It does things like organizing files, managing connected devices, and putting the display on to the monitor.*

Your computer's **operating system** makes it easy for you to open applications. If you find yourself always opening the same few programs every time, you can instruct the operating system to open, or launch, your favorite programs as part of the starting up or logging on.

Using shortcuts

You can also create shortcuts to your favorite programs. How you do this depends on the operating system you use.

The biggest single contribution to working effortlessly and rapidly is to use at least the basic shortcuts for your operating system (open and save files, print, close windows, switch applications) and your program.

■ **It is a special feeling** *to look closely at your images for the first time. Your first view is a small image only offering hints, and perhaps not even the right way round (see below). However, once the image is turned around and expanded, you will be rewarded with views that bring back great memories.*

There are two types of shortcuts: on-screen ones are stand-in, or alias, icons that can be conveniently located – on your desktop, for example – so that you can find them easily, but they refer back to a program held somewhere else. Clicking on the icon will open up the application. Keyboard shortcuts, on the other hand, are ones you define so that simply pressing a button on the keyboard – for example, F6 – opens up your application.

Behavior problems

If your application takes longer to open than usual, or if it behaves oddly – for example, you can't find certain menu items or they don't work – don't just struggle on hopefully. The program may be trying to tell you it needs to be reinstalled. Run the installation again. By the way, this is a rather good reason for using legal software at all times.

■ **Modern keyboards** *allow you to program special keys as shortcuts for many repetitive computing tasks.*

Create a folder

Nothing encourages you to get organized as much as having a shiny, new folder to put things in. With digital photography you don't even need to go to the shops to buy one – just tell the operating system to create a new folder, and give it a suitable name. You will save your images to this folder, as well as any work-in-progress or component images that you may need. You can copy images from your digital camera to this folder so that everything you need is easy to find.

Starting the application

When you first open the application, it may ask you whether you want to create a new image or open an existing one. Some programs offer you various projects to do. When you are using software for the first time, don't be afraid of trying out anything and everything. You cannot do any harm to the computer. In the early days of image-manipulation software, computers frequently crashed, froze, or brought down the entire operating system. Even so, all you had to do was start again – then it would crash all over again! These days, however, such instability and consequent frustration is unusual.

Opening the file

You can open image files simply by double-clicking on the file icon. But you soon learn that sometimes the wrong application gets opened. Typically it's the scanner or digital-camera software that created the file – useless for much of what you want to do. That is why it is better to open images from within the image-manipulation application. There is another reason: it ensures you know where the files are, which helps you stay organized.

Checking the details

When you open from the application, you can check details like the type and size of the file. These details can save you from opening a file that is the wrong size, for example. If you cannot find the file you want, it may be in the wrong format for the application so its name is not displayed. This may occur if your digital camera produced certain basic files (known as RAW or Raw format) that must be processed before they can be used by other applications. You won't encounter these unless you are working with professional-grade cameras.

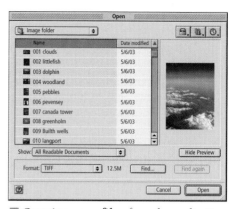

■ **Opening your files** *from the applications lets you check the details and location as well as giving a preview of the image.*

Saving a copy

It may seem odd to save a file when you've only just opened it, but we want to save a copy. The best way is to Save As. This creates a new file and enables you to give the file a descriptive name – such as "Jim at sea" – rather than "IMG_0344.jpg" – the unique but cryptic name given to it by the camera. Also, you will save this duplicate into your work folder. Depending on what your software allows, you will have the duplicate file open or you may need to close the original file and open the duplicate.

It is well worth going through this process since it is the only safe way to ensure you do not compromise the quality of the original file.

■ **For safety's sake,** *save a copy of your image as a working file in your work folder.*

Checking the image

It may seem obvious, but you'd be surprised how often people do wonderful things to an image only to discover later that it was too small or too low in quality. These defects may become apparent only when you print out the image. I've done exactly that: in a rush to meet a deadline I have worked on an image for hours before discovering it was rather poor quality when examined carefully.

The most important thing to do when your picture first appears on the screen is to check it carefully for quality.

QUALITY CONTROL

We will look at how to check the quality of an image as we work through this chapter, but there are several questions you should ask yourself about an image before you begin working on it. They are:

1. Is the image sharp? Are the colors clear, and do they look accurate?

2. Is there an excess border to the image caused by inaccurate cropping during the scanning process?

3. Is the file big enough? It should be adequate for your purposes, but not significantly larger.

4. Is there a good range of data – that is, lots of light, dark, and mid-tone pixels?

5. Do the horizon or any verticals need to be corrected?

Crop to save

Cropping is the process of removing bits of the image you don't need. This makes the image and, therefore, the file size smaller, which speeds up all the operations. Besides, cropping to correct the orientation of the picture – needed if it is slightly skewed or tilted – can remove quite a lot of the image. So it's safest to crop early in your work.

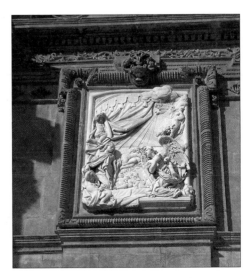

If an image is not in the correct mode, many adjustments are not available or give strange results. For example, an image scanned to 42-bit or 48-bit color or 16-bit grayscale should be changed to 24-bit color or 8-bit grayscale first.

■ **On your scanner** *it may be difficult to crop the preview image precisely, so it's easier to allow generous margins, then crop the scanned image later. It will save you time and space.*

Cropping and turning

IT MAY SEEM OBVIOUS, but remember to check that the image is the correct way round – that is, that left to right in the original is still left to right. This is seldom a problem with images captured by a digital camera, but it is easy, when scanning, to place the film the wrong way round, which results in a flipped scanned image. This is particularly the case when scanning film on a flat-bed scanner.

This is most important if there is any writing or lettering in the image, since these elements instantly alert viewers to an image that is reversed.

Cropping

Cropping is one of the most basic operations in classical photography, and it is also a vital part of digital photography. But there is an important difference.

Not only does digital cropping of an image reduce the picture content to what is required, thereby helping to concentrate attention on the main subject, it also reduces file size.

■ **When you place** *an original on the scanner and fail to crop right up to the edges, you will see the scanner's workings. Cropping to the image will speed up the scanning and save on file size.*

Note that for critical applications, you shouldn't crop to a specific resolution until the latest stages of image processing, since interpolation may be required and that will reduce image quality – usually by causing a slight softening of detail. Cropping without change of resolution does not require interpolation.

Removing borders

In general, however, at the very least you will want to remove the border or margins caused, for example, by inaccurate cropping when the scan was made. The large area of white or black not only takes up valuable memory, it can greatly distort tonal calculations such as Levels and Equalize.

If you need a border, it can be added at a later stage by adjusting the Canvas Size. When an image has no border, the canvas size is the same as the image size: adding a border makes the canvas size larger than the image size.

■ **In an image** *such as this direct scan of a seashell, you can trim the black right up to just before its edge. If you really want to save on file size, you can even rotate your object so that the rectangle surrounding it is as small as possible.*

Crop to fixed size

Some image-manipulation applications, such as Photoshop, allow you to crop to a specific or fixed image size and to specific output resolution – for example, to 5 x 7 in (13 x 18 cm) at 225 dpi. This is useful because it combines two operations into one. It is particularly handy if you know the exact size of image needed – for a picture box on a page design, for example. Enter the details in the appropriate boxes together with the resolution. The crop area will then automatically be of the correct proportions so you can adjust its overall size and position to obtain the crop you require. Cropping to fixed size is useful for working rapidly through a lot of scans.

Turning

Normally, the horizon in an image is parallel to the top and bottom sides of the image. A slight error in aiming the camera can be corrected by rotating the image before printing it out. In film-based photography,

this is achieved in the darkroom, but in digital photography, rotation is a straightforward transformation performed on the whole image. In some applications, rotation can be performed as part of cropping the image.

■ **A hastily grabbed shot** *(carelessly, if I were to be honest) begs for the horizon to be corrected. But to do so fully would lose a great deal of the image, with damage both to the swans and the sailing boats. A partial correction may be the answer.*

Any rotation that is not 90 degrees or a multiple of 90 degrees will need interpolation. Repeated rotation can blur image detail – sharp edges can become soft – so it is best to decide exactly how much rotation is needed, then perform it in one step.

SAVE AS YOU PROCEED

Get into the habit of saving your file as you proceed: press Command+S (Mac OS) or Control+S at regular intervals. Remember that the image you see is only virtual – it exists while the computer is on and functioning properly. If your file is large and the work complicated, the risk of the computer crashing is increased and the loss of your work likely to be grievous. If your file is so large that frequent saves inconveniently interrupt your work, then you definitely should be saving it as you work.

Checking size and sharpness

YOU MAY BE LIVING AND WORKING with your image for some time to come. Before you start this relationship, check out the suitability of the image. It is easy to dive in and make all sorts of wonderful images only to discover that the file size or quality is insufficient for your needs. And if the quality is far in excess of what you need you will spend time unnecessarily waiting for the computer to complete the processing.

What size do I need?

For the time being, all you need look at is the actual size of the image file – how much computer data you have. Don't worry about things like resolution, output, dpi, and all that. When you first opened the file, you were probably told anyway, but all image-manipulation software allows you to change file size.

■ **This nighttime image** *is very dark, and it is not very sharp due to the long exposure time. It is easily made acceptable, provided it is not made too large.*

Go to the File or Image menu, then Image Size or a similar command. This will show the current file size.

Now, the answer to the question, "What size do I need?" is, fortunately, not that irritating counter-question, "How long is a piece of string?" But it is another question – to which you already have the answer: "What do you want to use the picture for?" If all you wish to do is learn how to use the application, you need a very small file – around 1 MB. As you need bigger pictures, you need more and more data. And if you scanned the picture yourself, you already know the answer. See the table Recommended file sizes on p.133 for a guide.

■ **The original image** *was sharp, but what if it hadn't been? The intention was to introduce a great deal of blur to soften the model's features to bring out her fine profile – it is almost an inconvenience that her outline is so sharply defined.*

What is sharpness?

Sharpness is a subjective judgment of how clearly details can be seen in an image. That judgment is based on whether distinct boundaries – for example, the outline of a leaf – appear distinct or blurred. Some subjects – such as pictures of children, portraits of a young woman, and some landscapes – may look fine whether they are sharp or not. But others – buildings, cars, and other man-made objects, for example – are acceptable when blurred or unsharp only for specific reasons, such as to create moody or special effects.

The problem with assessing sharpness of a digital image is to decide at what size to view it. The technically correct answer is 100 percent – the pixels of the image should correspond to the pixels of your screen.

You may think that you should work with the best quality all the time. But working with the best quality costs you more in time, waiting for files to open and filters to render. If you don't need the quality, reduce the file size.

Assessing the image: Levels

THE CONCEPT OF LEVELS comes straight out of statistics: it is a representation of the distribution of tone values as a histogram. This means that the more pixels that have a certain value, the higher its column will be in the graph. From this, you can get a quick assessment of the image. The Levels control offers several easy and powerful ways to change the global tone distribution.

Auto or not

The easiest thing to do is to click on the Auto button (in most applications); however, this does not usually give good results. Auto takes your darkest pixel to maximum black, the brightest pixel to maximum white, and everything else in between is spread out evenly. This often also changes the overall density of the image.

■ **This somewhat underexposed** *shot of orchids has produced a Levels display in which nearly all of the pixels are bunched up to the left – this means they are all darker than mid-tone gray.*

Experimentation is the key

Adobe Photoshop actually applies a type of "Olympic" filter (so that extreme values may be discounted) when applying the Auto Levels, just in case the darkest and lightest pixels are not, in fact, representative of the whole image. The best way to learn the effect of the various pointers and controls on a Levels dialogue is to experiment. They do vary from one application to another, but most will have at least three controls: two to set the maximum black and white, and a central one that controls exposure. Moving this has a powerful effect on the image, making it darker or lighter overall.

Another control that may be available is the Output Levels. This sets the black and white points – that is, to the maximum black or white at which they are output in a printer.

You should make a practice of setting the white point to at least 5 less than the maximum; and you should usually set the black point to at least 5 more than the minimum.

Both of these adjustments will help improve results when outputting either from a desktop printer or a printing press. They will also save you ink.

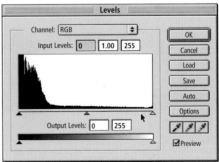

■ **The corrected image** *will not show a greatly changed Levels display since most of the image is dark anyway. But notice the pixels ranging to the right; the original image had no pixels at all in that region.*

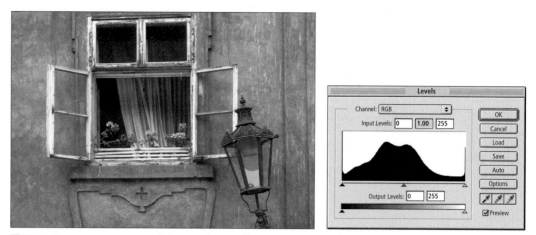

■ **Here is a very average subject** *with a totally average range of tones – neither wide nor narrow – and the accompanying Levels display confirms first impressions. There is a bunching of tones around the middle, as we'd expect, with a tailing off into shadows and highlights at both ends.*

HOW TO READ LEVELS

Levels displays are quite easy to read once you know what you're looking for.

a If all values across the whole range are filled, with one or more gentle peaks, you have a well-exposed or well-scanned image.

b If the histogram is heaped up with most values low, for example, to the left, the image is overall low key or dark. If values are heaped up with most values high, the image is high key or bright. This is not necessarily undesirable.

c If you have a very sharp peak toward one or another extreme with few other values, you probably have an image that is over- or underexposed. Tonal and color changes to this are likely to produce patchy or unpredictable results.

d If the histogram has several narrow vertical bars, the image is very deficient or is an index-color file with very little color data. Corrections will be hard to make, because results can be unpredictable.

e If the histogram is comb-like, it is a poor image with many missing values and too many pixels of the same value. Such an image looks "posterized," displaying sudden changes of tone or color.

A simple summary

✔ Starting up your image-manipulation software is as simple as double-clicking an icon – once you have located it.

✔ Using shortcuts for your computer and programs helps speed up any work you do.

✔ It is always best to open an image file from within your image-manipulation software.

✔ Once you have opened an image, the first thing you should always do is save a copy, using your computer's Save As option, giving it a descriptive name.

✔ Before spending hours (or days) working on an image, check it carefully to ensure the quality is high enough for your needs.

✔ Cropping is the removal of parts of the image that are not needed.

✔ When scanning a transparency on a flat-bed scanner, make sure that it is placed the correct way around.

✔ Turning may be necessary if, for example, the horizon of a landscape is not parallel with the top of the image.

✔ Get into the habit of saving your work at regular intervals. If you use a keyboard shortcut it will take just a few seconds.

✔ Check that your image is sharp enough for the purpose for which it is intended.

✔ The Levels dialog box visually represents the distribution of tone within a chosen image.

✔ The best way to learn the effects of the controls of your Levels box is through experimentation.

✔ Most Levels boxes have at least three controls: one to set maximum black, one to set maximum white, and a central one controlling exposure.

✔ In a well-exposed or well-scanned image, values will be present across the whole range.

Chapter 12

Cleaning and Tidying Your Images

IF FEW THINGS ARE PERFECT IN THIS WORLD, many photographs start life with at least one imperfection. It may be as small as an errant speck of dust, or it may be as substantial as a horizon that is tilted or a building that appears to lean backward. With digital photography, however, we have unprecedented powers of perfection.

In this chapter...

✓ **Dust problems**

✓ **Removing distractions**

✓ **Changing size and shape**

✓ **Correcting parallels**

AIM TO CREATE A PERFECT WHOLE FROM ALL YOUR SEPARATE ELEMENTS

Dust problems

DUST MIGHT BE VERY PRETTY when it is raised by galloping horses backlit by a setting sun, but that's the only good thing I can say for it. The rest of the time, dust is photography's Public Enemy Number One. Most of us have spent more time removing dust specks from images than we care to remember.

Dealing with dust

Defects are usually dealt with by *cloning* – covering the problem area with more acceptable parts of the image, or even another image. To do this, select an area that is to be the source of the clone, then apply, or clone, that area into another part of the image. Cloning is fundamental in image manipulation, constantly used for tidying up parts of images – for example, to replace a dust speck in the sky with an adjacent bit of sky.

Using filters

Digital dust filters can remove specks and defects in the image if the offending items are sharp and well defined. You are probably thinking, "If there is such a filter, why bother with all that cloning stuff? One click and we've zapped all troublesome zits and specks."

■ **A filter for removing** *dust and blemishes is a tempting proposition, but only if the blemishes are sharply defined and you are prepared for some loss of detail. Here, the subject tolerates softness.*

The answer is that specks are often about the same size as details in the image, so when you remove the specks, you also reduce the detail. That is why it matters that the defects are well defined, as they often are when you scan glossy prints. It is easier, then, for the filter to distinguish defects from the softer, less contrasty detail belonging to the image.

Avoiding the problem

Better than any dust-removal technique is having no dust in the first place. Keep your films, your processing, and any subsequent handling scrupulously clean.

Do not stack negatives on top of each other – the pressure marks the film. And even digital cameras suffer: dust can settle on the sensors, particularly those of SLR cameras with interchangeable lenses.

When you are looking at scanners, it is worth considering buying one of the models that remove dust automatically during scanning. This process does increase your scanning time, but it will save you time in the long run. Early versions of dust removal blurred the image a little, but the modern techniques are extremely effective and do not impair the image quality.

CLONING HINTS AND TIPS

The following pointers will help you produce good cloned images:

1. Clone with the tool set to maximum pressure or 100 percent. Lighter pressure will produce a smudged or soft-looking clone.

2. In areas with even tones, use a soft-edged or feathered brush as the cloning tool. In areas of fine detail, use a sharp-edged brush as the cloning tool.

3. You do not need to eliminate a dust speck entirely – reducing its size or contrast may be sufficient.

4. Work systematically from a cleaned area into areas with specks, or else you may be cloning dust specks themselves.

5. If your cloning has produced an unnaturally smoothed-out area, introduce some noise to make it look more natural: select the area, then apply the Noise filter.

Removing distractions

ONE OF THE REVOLUTIONS introduced by digital photography is the change in the way we shoot. Whereas we may once have ignored a scene cut through with a telephone pole or power line, now we can carry on regardless, confident that such problems can be deleted later.

In some ways, this new-found ability to remove problems, often through cloning, may make us lazier photographers, but it arguably releases us from unnecessary burdens.

If you expect to apply extreme tonal changes or settings to a whole image, it may be better to do so before cloning, rather than after. Extreme tonalities can reveal otherwise-invisible cloned areas by highlighting the boundaries between cloned and uncloned areas.

Clean clones

Cloning tends to produce smooth areas; you can reduce this tendency by reducing the spacing setting. Most digital brushes are set to apply "paint" in overlapping dabs – typically, each dab is separated by a quarter of the diameter of the brush. Your software may allow you to change brush options or settings to that of zero spacing, so that the brush is applied continuously, for the cleanest results. Look in the Brush Settings or the instruction manual for the control.

■ **Experiment with** *different brush settings to find the best results.*

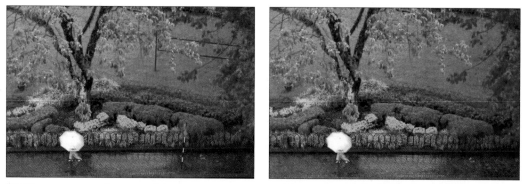

■ **When you are photographing,** *you may not notice features that really become intrusive once you see them. In this scene in rainy Sarawak, Malaysia (above left), I felt the ironwork's sharp lines detracted from the flow of the rest of the image. A few minutes of cloning left me with a more satisfactory image.*

REMOVING RED EYE

The first time you see the red-eye effect in a photograph, it's scary – and familiarity does not make it any prettier. The easiest way to remove red eye is to zoom right into the eyes, select the red spots, and then desaturate them – this is most easily done with the Sponge tool. Red eye is such a common problem that the majority of image-manipulation software offers a tool dedicated to its elimination.

■ **This typical group photo,** *of Kyrgyz academics at a restaurant, is spoilt by red eye.*

 Look close up

A close-up view shows that one lady has it bad, but so does her companion.

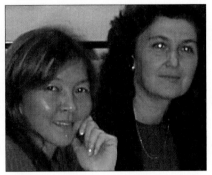

 Desaturate the red

By desaturating the red in the eyes, we substitute one problem for another: the catchlight is way too large to look natural, so we must reduce that, too. We also take off the slight red in the right eye of the other lady.

 Darken the pupils

We zoom in very close and use the Burn tool to darken the pupils, while still leaving a little catchlight.

Problems with noise

Noise is quite different from dust: it comes from defects in the electronic circuitry and processes, making it a kind of digital dust. It can arise from a digital camera or scanner. It causes most problems in shadows or during photography at night. Dealing with noise is technically tricky.

 Make your shot on manual exposure settings.

 With the lens cap on (so that it is totally black), take another picture at the same settings as the proper shot.

 Noise shows up as lighter spots in dark areas, so you must neutralize light spots with dark. Invert the shot taken with the lens cap on to make the light spots dark.

4 Combine the two images, with the inverted image on the top layer, and set the mode to Screen, or whichever mode on your image-manipulation software gives the best result. You may need to experiment with layer opacities, too.

Reducing JPEG artifacts, such as noise, can be done with specialist filters such as Image Doctor. However, it is better to avoid them in the first place. Do not compress your files more than you need to, and try to shoot at your digital camera's top quality setting.

Changing size and shape

ONE OF THE MOST COMMON ACTIONS using image-manipulation software is changing the size of the image prior to use. In practice, you will set only a small range of sizes – from postcard to small poster – but the sizes available can be up to very large advertising displays. Furthermore, while size changes are uniform across the image, the changes can also be non-uniform – in such cases, you are distorting or transforming the image into a different shape.

Using distortion

You can distort the image to make it fit a space, or you can change the shape from the usual rectangle just for a change (see p.200). Images with faces or recognizable shapes are often the least successful when distorted because the familiarity of the shape tends to focus attention on the distortion effect rather than on the role of the image in the design. On the other hand, you may create a distortion for comic effect – greatly enlarging the head and shrinking the body, for example.

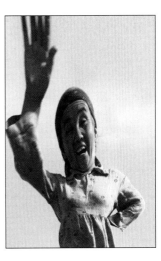

■ **An image already distorted** *by being shot from a very low angle has been taken to comic extremes here (see right). The upper part of the image was widened by about 50 percent, and the lower part was reduced by the same amount. The empty areas were were then cropped off.*

Fitting a space

There may be rare occasions when you choose to squeeze or expand an image to fit into a specific space because you do not wish to crop it. The easiest way is to resize the image but not keep the same ratio of depth to width. This is a size change that is not constrained to the original proportions.

Correcting parallels

IMAGES FEATURING SUBJECTS with straight lines, such as buildings, will appear uncomfortable if lines that were parallel at the time are recorded as converging or sloping together. At the same time, regular shapes can appear sheared or squashed. This is projection distortion, and it is not caused by a fault of the lens or camera, it's simply because of geometry.

If the camera is not square to the subject, the plane of the film is not parallel to the main surface of the subject. This means that one side of the film is closer to the subject than the other. The part of the film nearer the subject receives a somewhat larger image of the subject than the part of the film further away. This is the source of the distortion, which causes regular shapes to look skewed or distorted.

Using the Transform tool

The Transform tool is often used for resizing or for the occasional distortion of an object before it is placed in a montage or composition. However, it also has a use that neatly solves one of the problems in photography, namely projection distortion, which is commonly seen in photographs of buildings.

CORRECTING PROJECTION DISTORTION

The change in size of the image is due to a change of image magnification – the image is reproduced at a different scale from one part of the scene to another because of the gradually changing distance between your camera and the object. The top of a building is further away from you than the base when you point the camera upward to contain the building. As a result the upper, more distant part appears smaller than the lower, closer part.

The captured image must be distorted to compensate for the varying magnification across the image field. The whole image has to be selected, and the Transform or Distortion tool in the image-manipulation software is then used to pull the image. If you have changes of magnification in two planes, both will converge and you will need to compensate for both.

1 **Problem verticals**

Because the scene has been shot from ground level with the camera angled upward, everything appears to lean backward.

2 **Manipulating the image**

Using the Transform or Distortion tool, it is possible to stretch the top right corner of the image to solve the problem.

3 **All correct**

In the corrected final image, the verticals are upright and the whole scene looks more like it did in reality.

Compared to the equivalent technique in the darkroom, which involves tilting the enlarger baseboard, the process of correcting projection distortion with a computer is clean and simple. It is a combination of careful cropping, allowing for losses at the corners if you have to rotate the image, followed by distortion of the entire image. Note that all these steps require interpolation – the calculation of additional or removal of pixel values based on the values of existing pixels – and, therefore, involve the irretrievable loss of information.

Choose your viewpoints with attention to the tilting. Try to compose keeping lines in the center of the image vertical. Try to compose maintaining a symmetry on either side of the middle of the picture.

A simple summary

✔ In photography, dust is Public Enemy Number One.

✔ One of the most commonly used methods of eliminating dust specks is cloning.

✔ Filters can be used to remove dust specks, but only if they are sharp and well defined.

✔ Better than any dust-removal technique is the avoidance of dust in the first place.

✔ One of the beauties of digital work is the ease with which even quite large distractions can be removed from an otherwise perfect image.

✔ Red eye can be eliminated quickly and efficiently in image-manipulation software.

✔ Noise in an image – a kind of digital dust – can be tricky to deal with.

✔ Image-manipulation software is often used simply to change the size or shape of an image.

✔ Projection distortion is the convergence of lines in a photo that were parallel in life.

✔ The correction of projection distortion involves cropping, rotating, and distortion of the entire image.

Chapter 13

Tonal and Color Perfection

NCE YOU HAVE CLEANED UP YOUR IMAGE, it is time to get some polish and put a shine on it. Just getting the overall brightness and contrast right, and to balance the colors so they are neutral, is an achievement – make no mistake. Once you've done that, you've already gone a long way toward producing a professional-quality image.

In this chapter...

✓ **Controlling tones**

✓ **Rescuing wrongly exposed images**

✓ **Why you need to sharpen up**

✓ **Color-balance adjustments**

✓ **Turning color to black-and-white**

A DISPLAY IN A GARDEN CENTER COMBINES REAL PLANTS WITH A POSTER – BUT WHICH IS WHICH?

Controlling tones

THE HALLMARK *of competent photographers is their ability to control* **tone reproduction**. *In classical photography, tone control is largely set by industry standards in film and print processing, so photographers can influence only exposure and lighting – unless they do their own development and printing.*

The need for tone control is just as crucial in digital photography as it is in conventional work – get it wrong and it gets in the way of the image's ability to communicate.

Despite the prevailing importance of tone control for digital work, the old technical restrictions have been unceremoniously pushed aside.

BRIGHTNESS AND CONTRAST

This sequence of pictures shows the differences and similarities between changes in contrast and in brightness. Compare, in turn, each of the adjusted images to the image as originally captured (see near right). While there may be no change to the whitest and blackest parts of the images, their visual impact varies considerably. This is because what matters most is the way in which mid-tones are reproduced.

■ **Perfectly exposed** *sunlight and skies bring out the color and tonal subtleties in this shot of a Buddhist temple in Penang, Malaysia.*

■ **This brightened image** *appears paler than the normal shot and seems to lose contrast, but darker colors remain strong.*

Approaches to tone

Digital photography allows you to turn a picture really bright or really dark, with poster-like coloration, and either sharp or dull in contrast – all within seconds. And best of all, there is barely a drop of chemical or scrap of paper in sight. Tone control consists broadly of:

- **Brightness** This is used to raise or lower the brightness levels of every pixel by the same amount at the same time.
- **Contrast** Use this to change contrast by clipping or increasing the brightest and lightest pixels, and adjusting all others in proportion.
- **Levels** This allows you to move (or "map") the current brightest, average (or middle) value pixels and darkest pixels to new values by moving some sliders on the screen.
- **Curves** The secret weapon of digital photography, Curves can give you near-total control over not only the tonal reproduction of an image but also over the way each color component reproduces. Curves takes the Levels control one big step further.

Do not use the Brightness/Contrast control. It gives quick results, but you will soon learn that it destroys information that you can't get back.

■ **Darkening the image** *can give the feel of increased contrast: while the bright areas remain bright, the mid-tone areas become darker.*

■ **When you increase contrast,** *the image may appear to be darker, but that is because the colors become much stronger.*

■ **This low-contrast** *image seems gray and dull. The weak colors overall make it appear lighter than the normal image.*

Rescuing wrongly exposed images

IF YOU FIND THAT some of your photographs are wrongly exposed, it's not the disaster it used to be. In the world of digital photography, it is quite possible to correct these images using Curves, regardless of whether they are over- or underexposed. Read on…

Dealing with overexposure

An overexposed image is one that appears too bright. As a result, shadows may not be dark enough, colors in the crucial middle range are pale because they are too light, and a majority of the image is light. This means that overall the contrast is too low.

Correcting overexposure therefore calls for two things to happen: you need to darken it overall, of course, but you also need to improve the contrast if possible. With luck, you may then improve the quality of color in the image, but you'll soon learn that this part of the job is often the hardest.

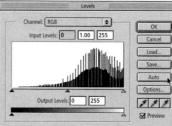

■ **The columns** *bunched up toward the right show there are lots of bright pixels in the original shot but very few dark. Click on Auto to spread out the pixels.*

■ **Before:** *Clearly too bright, too pale, and lacking in contrast, this original shot needs help. The first thing to do is call up the Levels dialog box.*

■ **After:** *This is the result (right) of hitting Auto in the Levels box. It's better, but not convincing. Nonetheless, it will serve if you need a quick fix.*

CORRECTING OVEREXPOSURE

A better way to correct overexposure than using Levels is to use Curves (see pp.201–3). This method is slightly more involved, but it will also give you far better results.

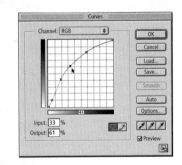

1 View the Curves box

Open up the Curves command and this is what you will see – a straight line, meaning you have made no changes.

■ **Before:** *Here, again, is our original shot – overexposed and lackluster.*

2 Alter the curve

Click on the curve and watch the results. Your curve will have a different shape according to whether it runs from dark to light or vice versa.

■ **After:** *This is the result of all the work. It may seem tricky and involved, but once you've done it a few times, you'll zip through images correcting them like a professional.*

3 Shift the coloring

The result of the new curve was superior to the Auto Levels adjustment, but it needed a little improvement to the color saturation (above).

Dealing with underexposure

As with overexposed images, you need to correct exposure and contrast, and probably color **saturation**, too. If you worked in good light, it should be easier to obtain an acceptable image, because there will be good color in the brighter areas.

CORRECTING UNDEREXPOSURE

In this example of underexposure, the shadowed region of the shot became too dark due to the exposure being set for the sunlit area.

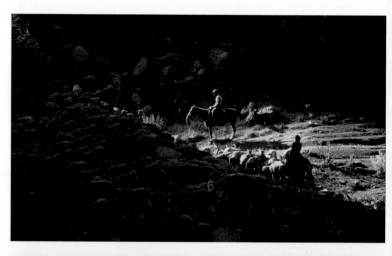

■ **Although it is** *rather dark, a case could be made for accepting this image as it stands. But let's suppose we want to see more of what is going on in the shadows.*

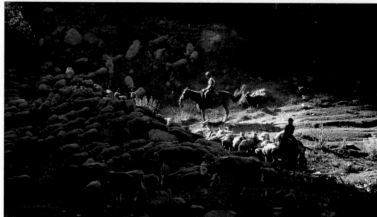

■ **If we select Auto** *in the Levels dialog box, the result is not very satisfactory: the blue colors in the shadows (on a clear day, shadows are illuminated by blue sky) are overemphasized.*

How much you can cure an image of its exposure ills depends on the brightness or luminance range of the scene as well as, of course, on how badly wrong the exposure is. Images with a narrow range of brightness are easier to correct, as are images in which you can see details in either shadow or highlights.

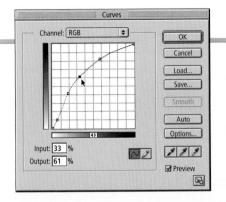

1 Bring up the Curves dialog

In the Curves of your original image, open up (lighten) the shadows while minimizing the effects on the brighter areas.

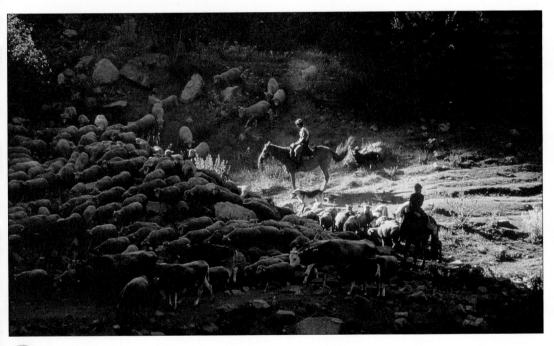

2 Check the effect

The main changes that have been introduced into the image are in the tones darker than mid-tone. It is now possible to see the sheep more clearly, while the sunlit zone is not much brighter than it originally was.

Distributing tones with Burn and Dodge

The main purpose of tone reproduction is to match the image's overall tone to how you want it to look. At times your aim will be to recreate the original scene's tonality as closely as possible; at other times what you saw is only the starting point for something else altogether.

Try to have an idea of what you want before you start experimenting, but keep an open mind for unexpected results. Some of the best discoveries come from accidentally choosing the "wrong" effect.

After the tone controls, the most important ones are the Burn and Dodge tools, used for **burning-in** and **dodging**.

> **DEFINITION**
>
> **Burning-in** *is the alteration of the local contrast and density of an image by making certain parts darker, while masking off the rest of the picture.*
> **Dodging** *is the opposite: the selective lightening of parts of the image that would otherwise appear too dark.*

HINTS FOR BURNING-IN AND DODGING

There is a handful of pointers that you should bear in mind whenever burning-in or dodging to bring out the best results. They are:

1. Work at light pressures or low strength of effect – set 10 percent or less – and build up to the effect you require.

2. When burning-in highlights or bright areas, set to burn-in shadows or mid-tones; do not set to burn-in highlights.

3. When burning-in mid-tones or shadows, set to burn-in highlights, or mid-tone at very light pressure; do not set to burn-in shadows.

4. When dodging mid-tones, set to dodge highlights, or mid-tones at very light pressure; do not set to dodge shadows.

5. When dodging shadows, set to dodge highlights; do not set to dodge shadows.

6. Use soft-edged or feathered brushes.

7. Work on a copy of the file if you're experimenting. Don't be afraid of "reverting to saved" – that is, abandoning all your changes and starting again.

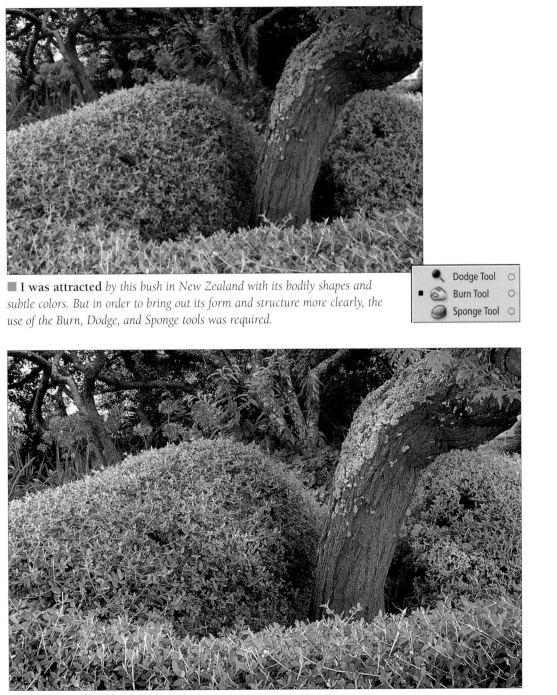

■ **I was attracted** *by this bush in New Zealand with its bodily shapes and subtle colors. But in order to bring out its form and structure more clearly, the use of the Burn, Dodge, and Sponge tools was required.*

🔍	Dodge Tool	○
■ ✋	Burn Tool	○
🧽	Sponge Tool	○

■ **The Burn tool,** *set to Shadows with very light pressure, darkened the lower part of the bush and the central dip. The Dodge tool, set to Highlights, increased the contrast of the upper leaves of the bush and the trunk. And the Sponge tool, set to Saturation, was used all over to bring out some leaf and trunk color.*

Why you need to sharpen up

THE NEED TO STAY SHARP is fundamental to all walks of life – from cooking, to martial arts, to digital photography. Just about every step in the photographic process reduces sharpness, creating blur and destroying detail.

The ease with which image-manipulation software can make a soft image appear sharp seems almost magical. Of course, there is no real increase in the amount of information in the image, but the available information is put to good use – edges are more clearly defined through improvements in contrast. This means that the dark side of an outline is made just a bit darker and the lighter side is made lighter, thus increasing edge contrast.

Unsharp Masking

The most versatile and controllable method of sharpening an image is to use Unsharp Masking (USM). This takes a whole grid of pixels at once and performs a calculation designed to increase edge definition without introducing artefacts.

When working with USM, view the image at 100 percent or, if that is too large, at whole fractions, such as 50 percent or 25 percent. This avoids problems with the way the monitor displays the image at other sizes.

The difficulty with using USM is knowing which values to set. As a guide to start with, for all images, set Amount to 100–150 percent. If the image has a lot of detail or if it's a small file (under 5 MB), set a small Radius – usually, you do not need a Radius larger than 1. If your image lacks detail or is very blurred, set a larger Radius, say between 2 and 10. Finally, set Threshold to 0 for maximum effect, but if the image is grainy or noisy, raise Threshold to 10 or greater to avoid sharpening the grain.

At all times, keep an eye on the preview to see if the results of your settings are satisfactory. It is as easy to overdo sharpening as it is any other filter effect. Oversharpening appears as telltale pale halos around boundaries (see the screen shot opposite).

For commercial reproduction, the image on screen should look slightly oversharpened, to the point that halos on outlines are just visible.

Experimental settings

You can learn a lot from experimenting with different settings, like how very different settings can produce similar results. For example, if you set a low Amount, you can set a large Radius. Setting extremely large Amounts can pep up the contrast of an image.

■ **This shot (right)**, *grabbed just before my train arrived, is not too sharp. It is easiest to apply a simple, one-click sharpening to an image. However, one shot of the Sharpen Edges filter makes no discernible difference. Improving its sharpness in the Unsharp Mask dialog box will make its strong graphic lines usable.*

■ **This finely sharpened image** *(see above left) reveals just enough detail without looking artificial. Imposing an excessively strong USM effect creates a different kind of image – not an accurate representation, but not lacking in visual interest either. Try out various settings; don't be restricted by pedantic rules.*

Color-balance adjustments

COLOR BALANCE MEANS NEUTRALITY rather than harmony or equality. A sunset scene rich in orange tones that turn skin to incredibly sexy tanned colors appears beautifully harmonious, but color balanced it is not. In theory, we want the illuminating light to be white; it is not tinted with color – the setting sun is certainly tinted, so it does not provide a color-balanced view (thank goodness, or everything would look the same).

Trial and error

The aim of correcting color balance is to render a scene so that it appears as it would if illuminated by white light. The most usual way to balance color is to "slide and see": turn to the Color Balance control (all software will have this) and manipulate the sliders until it looks good.

You may not realize it, but your eyes will be trying to make any neutral areas look neutral, trying to make sure no colors predominate – indeed, to balance the colors.

Technically, a neutral or achromatic color such as gray, black, or white in a color-balanced scene will be recorded without any hue, and will not be colored in any way.

Trivia...

Man-made systems such as color film, monitors, or color prints can reproduce, at most, about a third of the range of colors that can be perceived by the human eye. And some animals can see colors that we can't see. Yet it's all confined to a tiny section of the possible spectrum.

GETTING MEMORY COLORS RIGHT

For many images, just concentrate on one color to get that right. Once that's done, you will usually find that the other colors adjust to that and balance themselves out. In portraits, the most important color is the skin tone, while in landscapes you might want to get the right blue for the sky or green for the leaves.

With still lifes, aim to get the colors of the fruit right – often a side benefit is correct color balance.

■ **Different software** *offers variations on the variations: here we see a choice of different color corrections as well as brighter and darker options. By setting the slider, you can make the variations finer or more coarse.*

■ **Many scanners** *also offer variations. It is a good idea to get the image looking as correct as possible when you scan.*

Ringing the changes

When you work with pictures for the first time you may find it tricky to see small changes in color balance on the monitor screen. And even if you can, how do you know which is right? The easiest way is to use a "ring-around" – that is, variations in which a different correction is applied to your image and you choose the best-looking variant. You will set quite large changes to start with, which often means no choice is quite right. However, you can home in on the perfect image by setting smaller and smaller variations (see above).

When correct is not correct

However, there are different standards for white light, different white points. For example, to correct an indoor scene illuminated by domestic lamps so that it appears as it would in broad daylight would not look natural – a warm-toned white is called for (see following page). On the other hand, for the most brilliant colors, a cool-toned white point is called for. This gives colors like those from a bright Mediterranean day.

In general, a color balance that is slightly warmer than neutral is preferred by the majority of viewers.

USING COLOR BALANCE

This step-by-step box demonstrates the way in which Color Balance is used.

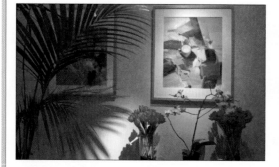

1 Look at the original

A stylish interior shot in domestic lighting comes out very warmly tinted. In many circumstances, the image is acceptable, but see how it looks if you reduce the orange cast.

2 Reduce the orange

Open the Color Balance dialog box and click on Midtones. The orange is reduced by pulling down the red and also the yellow (in other words, increasing both cyan and blue).

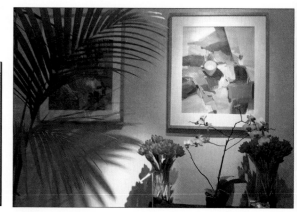

4 Change the Highlights setting

Once you have dealt with the mid-tones, click on the Highlights button and pull down the magenta just a little.

5 Check the result

The image has been greatly improved. It's still not perfect, but perhaps perfect is not ideal here: the warm tone is appropriate to the image.

Balancing preferences

The Color Balance control makes global changes in the image's primary or secondary hues.

When I need to make a large change to the color balance of an image, I find it helps a lot to turn away or close my eyes as the change is applied. If I don't look away, my eyes make me think I've made a bigger change than in fact I did.

In some software, you can restrict the changes to shadows, highlights, or mid-tones. This control is useful for quick changes to the image affected by an overall color cast but is less useful in more complicated situations.

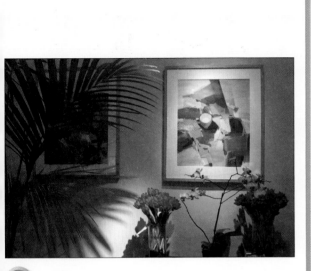

3 | See the effect

The result of the changes is an improvement overall, but notice that the highlights are tinted magenta (bluey-pink); you can see this most clearly in the border in the picture frame, for example.

Saturated with color

Richness of color is important to us – generally, we like deep, rich colors in our images. Along with blurring of image detail, there is a tendency of capture devices like scanners and digital cameras to reduce color saturation (technically, it is a blurring effect of color detail). In general, you will be looking to improve saturation in your images. With digital technology it is easy to increase color saturation – it is a matter of increasing color purity by removing mixtures that create gray. All image-manipulation software offers a Saturation control.

6 | The ideal

A more fully corrected image might look like this. However, placed next to the previous image, most people would prefer the warmer toned version.

Aim to increase saturation until you can easily see the improvement, but no more.

Too much saturation

Going further than what is easily discernible may look good on screen, but remember: while very pure colors are easily seen on a computer monitor, they are extremely difficult to reproduce in print.

Note: if you push saturation too far, you may create uneven, blotchy results.

■ **With its varieties** *of white, this image (see above) may look like the photographic equivalent of watching paint dry. But wait until you power up the software. By pumping the Saturation to the highest levels — usually not to be recommended — colors barely suspected or hinted in the original are brought right out (see below).*

Turning color to black-and-white

IF YOU ARE NEW TO PHOTOGRAPHY, you may wonder why anyone should want to turn a color image to black-and-white. After all, barely weeks after the invention of photography was announced, people were complaining about the lack of color in the images.

DEFINITION

Color space *is an abstract way of showing how different colors relate to each other. The most common color space is that created by RGB (pure red, green, and blue colors).*

Personal taste

Ultimately, color or black-and-white comes down to a matter of taste and personal preference for refinement. If color is like the prose of novels, then black-and-white is the poetry; if color is a big orchestra, then black-and-white is the intimate band. Black-and-white, then, cuts to the chase; it reveals the essentials. However, in digital photography you can work with black-and-white in color. This confusing statement means that you should continue to work in the **color space** even if the image looks gray because you can work with the color information.

■ **Bright and competing colors** *between the well-formed behind and the bathroom elements are placed on a level playing field in black-and-white. This allows the focus of the image to come through clearly.*

193

GRAYS IN COLOR

Take a simple landscape – here, I will use some low clouds in southern Kyrgyzstan as an example – and remove the color. Keeping it in grayscale – that is, just black-and-white – is fine, but it is not very exciting. Leaving it in RGB color opens up far more opportunities for you.

 Choose your shot

An early-morning stop in the south of Kyrgyzstan rewarded us with hill mists on the point of being dispersed by the sun. As a result of the low light, colors are muted and the range of colors is limited by the mountain environment. This shot is altogether ideal for turning into a black-and-white image.

2 **Select grayscale**

The easiest route to black-and-white is simply to discard the color information. The result (right) is entirely acceptable – in fact, it looks very much like a straight gelatin-silver print (remember them?) of fair quality. But we digital photographers know we can do more, and better.

Color Balance

Color Balance

Color Levels: [0] [0] [+100]

OK
Cancel
☑ Preview

Cyan —————Red
Magenta —————Green
Yellow —————Blue

Tone Balance
○ Shadows ● Midtones ○ Highlights
☐ Preserve Luminosity

③ Use RGB mode

If you keep the original image in RGB (either by desaturating all the colors fully or by converting the image to RGB mode), the overall tone can be changed by applying the Color Balance control.

④ Apply a blue tone

We could take a hint from the original coloration and add a blue tone. A strong blue added to this image transforms it into an attractively cold-toned print. Notice that the contrast has rise, as have the maximum densities, resulting in a well-grounded, solid image.

⑤ Make a sepia image

We could go back to the original once again, and this time turn the image brown – perhaps to explore the sepia-toning potential (see p.216). Keep your touch light or you may find the colors print out too strongly. Some colors appear weaker and lighter on a monitor screen than when they are printed out. You will find that subtle colorations are superior to very strong toning, especially with warm tones.

Color to grays

To convert color images to black-and-white, you replace a color with an equivalent gray. But how do you choose which gray? You can simply go by the brightness of the color, irrespective of the color. This is how most image-manipulation software works.

Be aware that two contrasting colors of the same brightness – for example, a bright red and a bright green – can end up as identical grays.

To avoid the problem of two different colors becoming the same gray, you need a method that can distinguish between different colors when making the conversion – that is achieved through channel mixing.

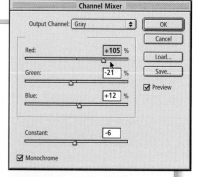

CHANNEL MIXING

The best technique for creating black-and-white images from color is to use the Channel Mixer, if available in your software. This function gives total control over the way in which a color is turned to a gray tone because you can alter the balance of one color over another.

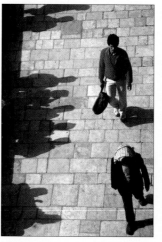

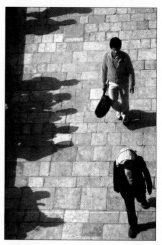

■ **In this view,** *the dominant colors are reds and browns, so a conversion to grayscale should not be difficult.*

■ **A simple conversion** *makes the bareheaded man's top too dark and the other man's coat so dark that it lacks detail.*

■ **In the Channel Mixer** *(top), emphasize the reds a little and pull back on other colors to give a snappier image.*

A simple summary

✔ In digital photography it is easy to alter the brightness or contrast of an image.

✔ Tone control aims at brightness and contrast using the Levels and Curves controls.

✔ When adjusting your image, try to have a goal in mind; but don't close yourself off to results that you had not considered.

✔ An overexposed image is one that appears too bright, while underexposure leads to too dark an image.

✔ When it comes to wrongly exposed images – whether over- or underexposed – digital photography, again, permits you to make amends.

✔ Saturation is a measure of color intensity. A highly saturated color is often called pure.

✔ After the tone controls, the next most important are those used for burning-in and dodging.

✔ Image-manipulation software can make soft images appear sharp with very little effort on your part.

✔ The most versatile way to sharpen an image is to use Unsharp Masking (USM).

✔ The weakest link in the digital imaging chain is your monitor. The way your image looks on screen is not the way it will print out.

✔ Remember: in digital photography, you can work with black-and-white in color.

✔ When changing colors to black-and-white, use channel mixing to prevent different colors of equal brightness from becoming the same shade of gray.

✔ The Channel Mixer gives you total control over the way in which colors are turned into tones of gray.

PART FIVE

Image Manipulation

EXPLORE THE BOUNDLESS POWER of image manipulation – it's all good, clean, utterly absorbing fun. Better still, you can try out hundreds, if not thousands, of different effects without wasting a single sheet of paper or drop of ink. And you can't harm the computer, either, however much you experiment.

Chapter 14

Simple and Effective Techniques

H ERE WE START ON THE SERIOUS FUN and fireworks. This is the best-known face of digital photography: weird, wonderful, and wild effects. We can embellish the image, adding just about anything we like to our masterpiece (but we try to hold back on the mayo), making it as large, small, simple, or elaborate as we fancy. We have total mastery over the image – the tricky part is doing it with discretion and good taste.

In this chapter...

✓ Framing the image

✓ Curves: subtle or wacky

✓ The art of compositing

✓ Blurring and fudging

✓ Distortions and morphs

PHOTOMOSAICS – IMAGES MADE UP OF NUMEROUS OTHERS – ARE FASCINATING AND FUN

Framing the image

ONE OF THE SIMPLEST THINGS you can do to distinguish your image from countless others is to work with its shape. Once you move it from the standard rectangular format, it immediately becomes different from literally billions of other images.

Unusual shapes

The precise and clean-cut rectangular outlines of images can become boring and predictable. And at times, it is simply not appropriate – for example, on a website in which the rest of the design is informal. Besides, it's certainly not the only way to show a picture.

■ **The modern look** *of this portrait, with its textured lighting and dark shades of the* Matrix *generation, is carried through with techno shapes and geometrical lines.*

■ **The domestic clutter** *of party shots is almost impossible to avoid but can be disguised. You might turn an acceptable shot into one that is more fun. Here, a flower shape seems perfect for the subject.*

Picture frames

For most picture use, a clean margin is appropriate and, despite many attempts to vary it, the best solution. With the less formal space of the Web page, a looser frame can be effective. Scan textures and shapes that you would like to use as frames and drop them on to the margins of your images. Many software applications offer simple frame types that can be applied easily to any image. Specialist plug-ins such as Extensis PhotoFrame simplify the application of frames and provide numerous customizable frames.

On occasion, a picture frame can crop the image without actually making it smaller.

Think carefully about creating fancy picture frames for your images. Frames don't, in fact, make the picture better, so they are not a great method of improving pictures. Frames usually work best when relating an image to the surrounding design or to signal intended context, such as a wedding, the birth of a baby, or a Valentine's greeting.

Remember: no one notices a picture frame when they see a great photograph.

■ **To give variety,** *you may take a perfectly fine portrait and put a different slant on it. Here, the frame, resembling film with perforations (remember them?), changes the composition of the portrait, giving some tension to it.*

Curves: subtle or wacky

*THE CURVES CONTROL may remind experienced photographers of the characteristic curve for films. There are similarities, but equally important differences. Both are effectively **transfer functions**.*

The curve is always a 45-degree line at the beginning. This shows that the output values will be exactly the same as the input. You can manipulate the curve directly either by clicking on the curve and dragging it or by drawing it yourself. This way, you can force light tones to become dark, mid-tones to become light, and other variations in between. In addition, you may change the curve of each channel separately. What you have is a very powerful tool that can produce visual results impossible otherwise to achieve.

With less extreme curves being used, you can improve tones in the shadows while leaving the mid-tones and high values alone. By altering curves separately in a color channel, you can adjust color imbalances with great precision. Color changes can be smooth, so that the new color moves into the current colors without obvious gaps.

THROWING CURVES

Taken on a dull day, which is what they usually have in Scotland, this image looks like it will repay some work. The application of a mild curve improves the tones, but more extreme curves have their uses too.

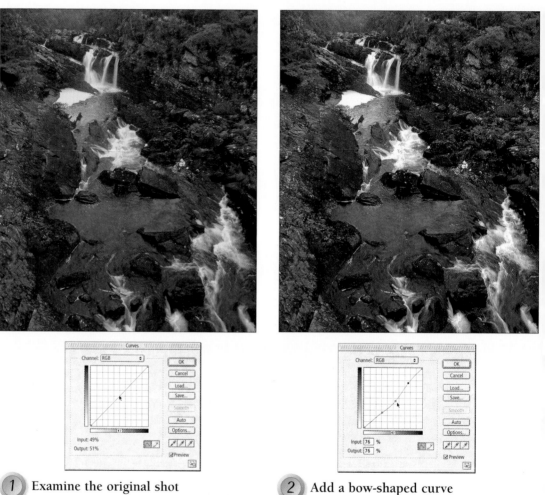

1 Examine the original shot

The original shot of the Scottish waterfalls is rather dull and lacking in life. Still, this can be rectified by using the Curves dialogue.

2 Add a bow-shaped curve

By applying a bow-shaped curve to the image, you can put some sparkle into the mid-tones, at the same time making the whole image lighter.

The catchphrase most often heard in the painting studio must be "Less is more!" And are those not also the words to pin above your monitor, the doors to your digital painting studio? Economy of means (not, however, of effort) is so often the best guide to effective picture-making.

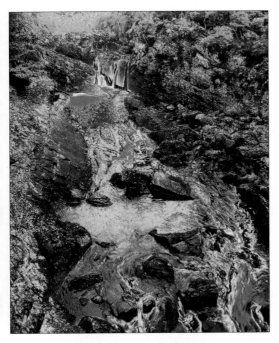

③ Experiment with extremes

To apply an extreme curve, click on the curve to "anchor" a point, then click-drag on the other parts of the curve. Alternatively, you can draw the curve directly. Small tweaks can make big changes.

④ Different colors, different curves

You can also apply different-shaped curves to different color channels. Here, a peaked curve on the blue channel creates a landscape with completely improbable colors.

The art of compositing

NEVER MIND THE ART, some people have turned **compositing** *(also known as collage and, sometimes, montage) into a battlefield of elaborate masking effects, layering, and blend-mode techniques. In Chapter 16, we will look at the more advanced tricks, but to start with, here is an easier-to-understand way: you build up your image by cloning.*

DEFINITION

Compositing *is the putting together of parts of different images to create a new one. Its similarity to sticking bits of pictures and other things together gives it the alternative name of collage.*

Building within an image

If you have all the materials you need within one image, all you have to do is clone parts of the image to elsewhere in the same image (see pp.168–70). For example, if you want to increase the blue areas of a sky, simply replace clouds with sky. It is easy to make a horrendous visual mess, but practice will make you better, if not perfect.

■ **This little collection** *of poppies (above) was very pretty, but I wanted to "improve" on it. Setting an existing poppy as a source, I cloned it on to a green shoot without a flower. I then cloned and used another poppy. Each clone is a new source, reducing the chances of a pattern emerging and offering fewer clues to the manipulation.*

HANDMADE MOSAIC

A simple but very effective way to build up an image is to create a mosaic from smaller images. You have software to do it automatically (see pp.246–7), but it's more satisfying, if more demanding, to do it yourself. For a commission, I used not-very-exciting images of office activities and workers to build up a big question mark, since the client specialized in evaluating the effectiveness of organizations.

1 Gather the images

The images to be used should first be collected together. It can be easier to have them all on one file, and then you just select the one you want to copy over.

2 Place the components

Select, copy, and paste each component into the image, then move them into position. Flipping or reversing images, and making them light or dark, means you do not need a huge variety of images. Here you can see my incomplete image, awaiting some more components.

3 Make a focal point

In this example, as a finishing touch, the outline of the question mark was made clearer by local burning-in to darken where necessary and dodging to help accentuate the form. Individual images can also be adjusted to prevent them from being distracting.

BUILDING WITH MULTIPLE IMAGES

The key to any sophisticated manoeuvre in digital photography is to plan ahead. In this case, make sure that your images are all the right size and of the same resolution. You should also make sure the tones and contrast of the various elements match or are appropriate; for example, ensure that if the main subject is lit from the right-hand side, all the other components are similarly lit.

Don't try to combine a digital-camera shot at 72 dpi, for example, with a scanned image at 2,000 dpi.

Open both images and create a new layer for the image you wish to build up. Next, you simply clone from the source image to your destination image – the one to be built up.

Great viewpoint

The boy in the tree always seemed to me to be attracted by the view from high up. So I thought I'd give him a really high overview, using a picture of a mountain valley.

1 Take the original image

This is the silhouette shot seen earlier in the book. It seemed a little too plain and needed some texture to put variety into the heavy shadows.

4 Increase background canvas size

I took this overview of a valley and increased the canvas size – in other words, kept the image itself at the same size but added extra area to it – ready for cloning in the boy in the tree. I added only to the height of the canvas.

2 Add some texture

I blended the silhouette with a shot of an evenly lit ceiling – perfect for adding texture. However, the result was at first rather dull.

3 Sponge and repair

Lots of use of the Sponge tool, to increase saturation, and minor repairs to the image yielded this livelier version. The brightness can be dealt with later.

5 Make a new layer

This is what the bigger canvas looks like. I made a new layer so that I could adjust the strength (opacity) of the clone, as well as ensuring I could adjust the tones independently of the valley image.

6 Clone in the boy

Cloning in the boy in the tree is like "painting" it on, so you can paint on only as much as you want. I omitted the building in the lower right-hand corner, giving an uncertainty to the centre of the image.

Blurring and fudging

BLUR EFFECTS make an image less sharp – meaning boundaries are less distinct – and lower in contrast, as well as lacking in visible detail. You may wonder when you'd ever need to do that to an image.

Emphasizing the subject

Blurs can, paradoxically, be used to make an image appear *more* sharp – to help emphasize chosen features. If you make a background much more blurred, by comparison, the foreground image will seem sharper than it really is.

■ **A trendy approach** *to portraiture is to guide the viewer's eye through strong blurring. Here, I applied varying amounts of blur to the background of the image in order to focus attention on the red lips. Weak blur was applied to all but the lips, increasing the amount the further away I moved from the centre.*

Softening a portrait

Softening is very useful with portraiture, as well as any time you want to create a mellow mood. Softening is a whole lot more useful than blurring, but it is more complicated to produce.

DEFINITION

Softening *is an effect that surrounds sharp outlines with blur, often with more blur at high-contrast edges than at low-contrast ones.*

To create softening effects you will need a software package that works with layers and blending modes. You will be softening one copy of the image and blending it with the original so that the softened areas show through. First you duplicate the image into a new layer. Choose or make this layer active and apply a Lighten or Luminosity blend mode: this lets through the lighter parts of the top (or source) layer.

Next, apply a blurring filter – use Gaussian Blur or another filter whose strength you can control. Monitor the results on screen. You may need to lighten or increase the contrast of the top image to make it look better. When you're satisfied, you can flatten the image. You may need to apply Blur or Sharpen filters to tune the effect to a fine degree.

Note that the blur may look different on screen than on a printout. As always, check the image when it is printed out, and don't depend on how it looks on screen.

■ **This portrait was taken** *with one of the sharpest lenses there ever was, but a softened shot seemed more appropriate. At first I tried blurring the image, but it merely looked unsharp. I then duplicated the layer and changed the layer mode to Lighten. Then I applied a blur to the top layer and adjusted the Opacity (here, it is at 57 percent) to taste.*

Distortions and morphs

IN CLASSICAL, FILM-BASED PHOTOGRAPHY, distortion for visual effect had to be done directly to the image – stretching or pulling on a negative or print. In digital photography, we are mercifully freed from such direct intervention; and with that freedom comes limitless possibilities.

The potential for distortion is so great in digital photography that we use the term **morphs**. The effects of morphs are impossible to achieve physically, and a level of control is offered that is way beyond anything that has been possible before.

■ **This photograph** *of a flower has such strong lines that it is a perfect candidate for morphing effects.*

Morphing images

You can obtain software specifically designed for distortion – these applications are often aimed at those who wish to make cartoon caricatures of faces. They are great fun for a few minutes.

■ **We can simply** *push pixels around, as if the image were a film lying on a liquid and we pushed and pulled at the layer to change its shape. But note that the boundary remains strictly rectangular.*

■ **Some application programs** *offer more sophisticated tools, such as one that imitates a reflection, thus creating an image that appears to reflect itself as if printed on a buckled metal sheet.*

Morphing can also be useful if you want to create animated sequences in which a face turns from glum to grinning, for example.

As with any effect, distortion and morphs should be used sparingly for maximum impact.

■ **Another distortion tool swells up** *any pixels that it is placed over – in this example, the center of the flower. Such an effect can be useful with faces and for small local adjustments in scale.*

A simple summary

✔ By changing the shape of your image, you can distinguish it from billions of square and rectangular photographs.

✔ Textured picture frames can help put across an image's intention, but a good picture frame will not improve a bad picture.

✔ By using Curves it is possible to subtly or dramatically alter your image's appearance.

✔ Compositing is the embellishing of an image with elements taken either from within the original shot or from a different shot.

✔ Cloning is a simple form of compositing.

✔ Blur effects can be used on a background to make the foreground appear sharper.

✔ Blur is commonly used to give a softer feel to a portrait.

✔ Distortions and morphs – localized digital distortions – are easy to achieve in digital photography.

✔ Software is available that is specially designed to distort, for use in caricatures, for example.

Chapter 15

Visual Extravaganzas

THE OLD-SCHOOLERS AND DIEHARDS may frown, but wild visual effects are inextricable parts of today's photography. Powered by awesome computers, facilitated by fantastic software, the sky's the limit. Well, actually it's not – good taste is the limit. Good taste and appropriate choices for the job at hand. But that's no reason why you shouldn't have a lot of fun – go on, don't be embarrassed.

In this chapter...

✔ **Tinting your images**

✔ **Darkroom effects**

✔ **Filter effects**

✔ **Grain and noise**

EXTRAVAGANT VISUAL EFFECTS ARE BEST APPLIED TO STRONGLY STRUCTURED IMAGES

Tinting your images

IT IS NOT ALWAYS NECESSARY for color images to be strongly colored or saturated. You can use desaturated colors, which contain more gray than hue, to be more subtle or to point to composition. The selective removal of color from an image is also useful for reducing the impact of distractions.

Limiting desaturation effects

For global reductions in color, you need only turn on the Color Saturation control, often linked with other color controls, such as Hue, to reduce saturation or increase gray. Here, you can limit desaturation effects to a selected area. When working at this, try looking away from the screen for each change: the eye finds it difficult to assess continuous changes in color.

A picture often looks as though it has died when color is suddenly removed. Look again to see it more objectively.

If you need further control, all image-manipulation software offers a Desaturation tool: this is a "brush" that removes colors evenly as it is passed over pixels. Ensure the brush has a very soft or feathered edge – sharp boundaries are often inappropriate.

Selective fading

A further method of being selective is to choose by color or range of colors. If you increase the saturation of certain colors, leaving the others as before, then desaturate globally, the highly saturated colors will retain more color than the rest of the image.

■ **This gentle scene** *(left) is suffused with warm light, but I wondered what would result from some selective reduction in colors. By applying the Sponge tool set to Desaturation, the urban setting becomes much clearer and contrasts with the glow around the children.*

BOOSTED COLORS

If you have an image in which the subject is made up of reds and browns, as here, and the background does not noticeably display these colors, it is simple to make the subject stand out.

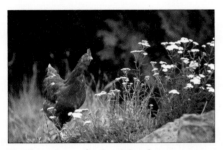

■ **This shot of a healthy** *free-ranging hen (above) seemed too brightly colored, and I wanted to create an image in which the hen would stand out from the more pastel background (below).*

1 Reduce overall saturation

I tried reducing the saturation overall using the Hue/Saturation control, but that just made the whole image rather dull.

2 Boost the reds

Once I realized that the hen should be brighter than the rest, I returned to Hue/Saturation and selected the red colors to boost purity.

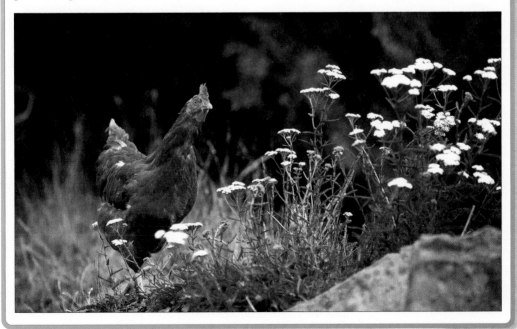

HAND-TINTED STILL LIFE

Knowing what the original colors were may be a help when it comes to tinting an image, but it can also be a hindrance. With this still life, I tried using natural colors but soon found unnatural colors more interesting.

■ The original image
offers clean, strong lines – perfect for a tinting exercise.

① Paint over a layer

I created a new layer and painted on it my chosen colors. Don't worry that it looks a mess – it will sort itself out when you reduce the strength of the color.

Darkroom effects

THE DIGITAL METHOD of producing darkroom effects is free of working with liquids – some of them rather poisonous – and is therefore hypoallergenic! Some photographers have had to give up darkroom work because they became hypersensitive to darkroom chemicals.

The most popular darkroom effect is the sepia tone – a warm-brown overall tone. Traditionally tricky, digital sepia tones may be a mere mouse-click away. Here, we look at achieving sepia tones as well as Sabattier effects and split toning.

Sepia tones

To create a sepia tone, you need first to remove all color while retaining brightness information – that is, you desaturate the image. This produces a neutral, gray image. Next, increase red and green (or yellow) to make the image more brown. Although the image looks colorless, it is in fact full of color; it is just that they are all in balance, so overall it looks gray. If you change the balance of one or other, you create a tint.

2 Choose Color mode

I changed the layer mode to Color (also called Colorize in some software). This adds color to underlying pixels without altering their brightness.

3 Refine the effect

These soft colors really suit the subject. I like the untidiness in the painting. If you don't, you can paint more carefully in step 1; or, in step 2, blur the color layer.

4 Try new colors

Here, I tried changing the colors. There are many ways to do this, but I used Hue/Saturation. The result is less predictable and more interesting.

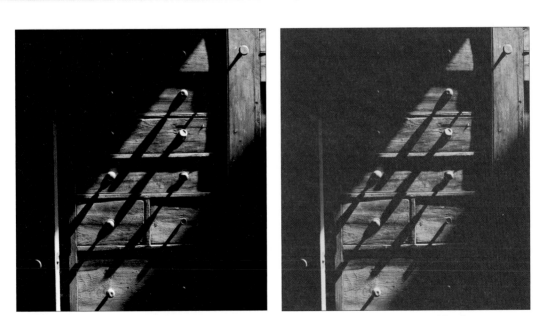

■ **This black-and-white image** *(above left) is gorgeous, with rich black tones created by dense amounts of silver. In the darkroom, sepia toning replaces the silver with a complex of other elements to give a brown tone. In digital photography, we simply dial up the brown (yellow and red) in the shadows.*

Sabattier effect

When a partially developed traditional black-and-white print is exposed to light, the tonalities reverse because the developed areas are desensitized, but the relatively undeveloped areas can be further developed. The result is an intriguing mix of reversed and correct tones – this is the Sabattier effect. In the darkroom, this effect is notoriously difficult to control, but it is simple on a computer.

There are several techniques for simulating the Sabattier effect. The most controllable and powerful method is to invoke the Curves control and draw a valley-shaped curve, with a more or less pronounced hollow in the middle. Introducing small irregularities in the curve makes for unexpected tonal changes.

The advantage of working with curves is that you can save them and load them on to another image if you wish. The Sabattier effect also works with color, but of course the colors become reversed, too.

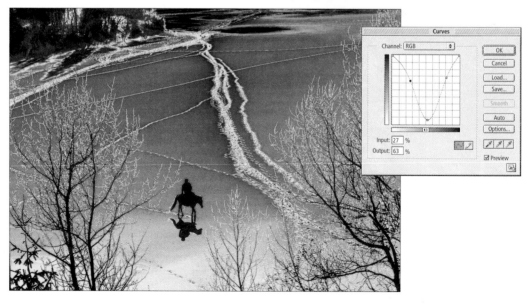

■ **A clean image** – *with clear-cut shapes and outlines (see right) – is best for effects such as Sabattier. When manipulating the curve you can watch the effect on your image and stop when you get just the right effect. Save the curve shown here as a starter for your own experiments.*

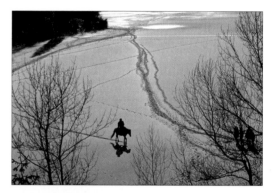

Split toning

One of the subtlest and most beautiful darkroom effects is split toning. At its best, the delicacy of colors and iridescence achieved in the traditional method are beyond the capacity of any digital process. But we can do our best – at least creating split tones in the computer does not need bottles of smelly chemicals.

Split toning is easiest to effect in software that allows color balance to be adjusted differently in highlight, mid-tone, and shadow. If your software does not allow this, you will have to use curves, working in each color channel separately; this can take a lot of experimenting.

The images that respond best to split-toning effects are those that have well-separated tones to begin with.

■ **From the black-and-white** *original (see left), shot in Paris, I made the highlights reddish and then turned to the shadows, which I made bluish using Color Balance. The result was quite strong, so I reduced the saturation. Here, it has been left quite strong (see below) so that it is visible in print, but you should soften the colors further.*

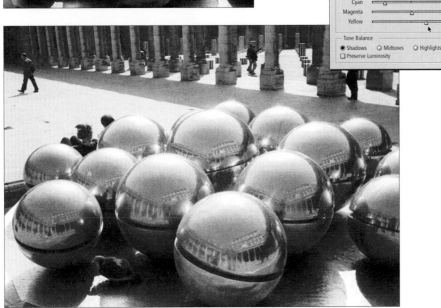

Filter effects

THE MOST SEDUCTIVE CHARM of digital photography must lie in its ability – at the touch of a button – to create the most fantastic visual effects with no effort at all. Available effects range from the most alluring to those that challenge good taste, and the repertoire continues to grow.

While filter effects amaze and impress, they are often solutions looking for visual problems. The experienced digital photographer tends to work with filters only with a definite aim in mind.

Types of effect

Filter effects are most useful as tools for special occasions. They are excellent supplements to the more general, more photographic controls, and their judicious use can lift an image into the extraordinary. However, not all filter effects produce garish effects. Some, such as Unsharp Mask, are essential tools that you will use very often. Since the variety of effects is bewildering at first glance, it may help to classify filter effects into broad groups.

EXAMPLE OF A BLUR FILTER

- **Sharpness and Blur filters** These affect the image or selected area uniformly, looking at edges in image detail to increase differences at the boundaries, thus to sharpen edges or else decrease the differences, which result in softening or blurring details.
- **Distortion filters** Used for changing the shape of the image – either overall or in small areas – Distortion filters can be tricky to control and should be used carefully.

EXAMPLE OF A DISTORTION FILTER

- **Art Materials and Brushstroke filters** These filters aim to simulate effects such as charcoal drawing or paint-brush strokes by using the image information and combining it with effects based on an analysis of artists' materials. Filters that break up the image into blocks or that add noise may also be considered part of this group.

EXAMPLE OF A BRUSH FILTER

● **Stylizing filters** These use geometric shapes, such as bricks, to build up the image, or else they base the new image on features such as the edges of the image. Stylizing filters are effective for producing blocks of color.

EXAMPLE OF A STYLIZING FILTER

● **Texturizing filters** These tools are similar to Rendering filters in 3D modeling programs, in that the effect produced and the base image have a complicated but controllable relationship – for example, lighting effects simulate a light shining on the image. By altering the "surface" of the image, the light appears to give the image a texture or relief feature. These filters make heavy demands on the computer: you may find large files cannot be processed at all if your computer does not have enough RAM (random access memory) for the file sizes you use, because the entire image has to be held in RAM for processing.

EXAMPLE OF A TEXTURIZING FILTER

WORKING WITH FILTER EFFECTS

The following tips will help you make the most of filter effects:

a Practice on small files. Get to know filter effects and the best settings before you need them in earnest.

b Try the same filter on different types of image to learn which filters work best on which kind of image.

c Filters are often best applied to selected areas of your image.

d Repeated applications of a filter can lead to unpredictable results. Also, don't forget: you can apply more than one filter on the same image.

e Apply filter effects before refining the image's overall tonality. You usually need to adjust image contrast and brightness after applying a filter.

f Remember: you are likely to use an image at a far smaller size than you view it on screen. Reduce it to final size on screen to check if you can see the effect.

The variety of filter effects

When you first learn about filters, it makes a lot of sense to apply one, then return to the original image and apply another. But combining filters extends their potential enormously. What's more, the fun is greatly increased because the results can be very hard to predict. After years of playing around with filters, I'm still learning.

Certain filters need enough RAM to work with the entire image at once – for example, the Rendering (Lighting or Texturizing) and Distortion filters. If you run out of RAM, the application program will stop working and tell you that it needs more memory. You can try reducing the image's file size a little at a time until you can perform the operation: rendered images seldom need the resolution of an unblemished one, so you can resize the image without worrying about loss of image detail. However, if your image is smaller than 40 MB and you are running into these problems, it will be necessary to install more RAM into your machine.

■ **Pictures with clear shapes** *and simple composition, such as this shot in Zanzibar, work best with filter and distortion effects.*

■ **Art materials effects,** *such as the Crosshatch, remove detail to bring out shape and form. The result can look, at first glance, to be more painting than photograph. Tune the settings for each image.*

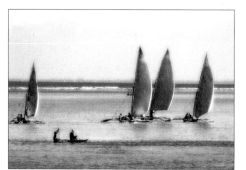

■ **Tone-enhancing** *filters, such as Diffuse Glow, are great for giving unexpected results. With fine adjustments of the settings, you can reveal the shape of the image most clearly.*

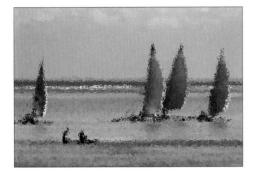

■ **Distortion filters** *are often best used as steps toward a final image – they seldom produce images that are successful in themselves. With Ocean Ripple, you could create a texture to imitate an oil painting.*

■ **Filters can create** *textures, as here. With Mosaic Tiles, we have made an image that could grace the walls of a restaurant in a tropical land. As in this example, such effects are often best printed very large.*

■ **Rendering filters** *work on the entire image at once and cannot transform small parts at a time. Here the Lens Flare effect usefully occupies an empty area of sky, but make sure the shadows fall in the right place.*

■ **Art materials effects** *alter not only the way the image is built up, but also the tones. You usually need to make adjustments after applying one of these filters. Here, Water Paper calls for lower contrast and saturation.*

Stylize filters *can give you weird and wonderful effects, but keep to images with strong, simple shapes.*

Stained Glass *is a captivating effect used with the right images. Once the image has been highly abstracted in this way, you can try changing colors*

Polar Coordinates *is an example of an extreme effects filter that is easy to overuse because its effects are so striking. It is fun to experiment with different images – you can never tell how the image will turn out.*

Plug-in filters *greatly extend the range of filters available to your software, whatever you use. Here, the Smoke filter from the Alien Skin set gives marbling effects that can be used to create backgrounds for Web pages. This is one filter that may work better with complicated images.*

■ **Terrazzo** *is one of my personal favorites in filter effects, because it works simply, powerfully, and is a delight to use. It creates tiled or repeating patterns that powerfully transform the impact of even the simplest picture. This is one filter that can work with any type of image.*

■ **Terrazzo with layer effects** *places two controls into one: the patterns you create can be superimposed on to the original image in different ways, so creating even more effects. You can achieve the same effect by duplicating the image, applying an effect, then changing layer mode.*

■ **Photocopy** *is an example that shows why you should not take filter names too literally. The best way to know what effect a filter has is to use it, and not just once or twice but many times over.*

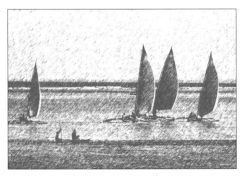

■ **Graphic Pen** *is a Sketch filter that drops color while adding an "artistic" texture. If the resulting image is not interesting in gray (it was not), you can change the overall color to something more attractive.*

Grain and noise

ALTHOUGH OFTEN REGARDED as enemies of the perfect image, grain and noise do have their uses. For a start, the very imperfections caused by grain help make the viewer think they're looking at a real photograph. Images that are free of grain look mechanical, as if computer generated (which they are), and just too glossy to be believable. Throw in a few imperfections and you can believe you're looking at real photography: simply apply one of the Noise filters.

Ever wondered why computer heroes and heroines like Lara Croft wear skin-tight clothes? Making them look sexy is just a fortunate by-product of the fact that crumpled clothes are extremely hard to create from scratch. And it's even harder to keep track of the changes that loose-fitting clothes undergo with movements.

Noise and speed

It is well known that films that are faster are also grainier – you can see the individual specks of the silver more easily. With digital cameras, we have a corresponding phenomenon: as you increase the sensitivity of the photosensor, your images show more noise (see p.20). In very low-light conditions, you would increase sensitivity to as high as it will go. You'll have lots of noise in the image, but that is almost expected. The point of this discussion is that noise can add to the realism of the shot – literally increase the grittiness – to enhance the sense of how dark and difficult the circumstances were. A pearly smooth image would simply suggest comfortable shooting conditions.

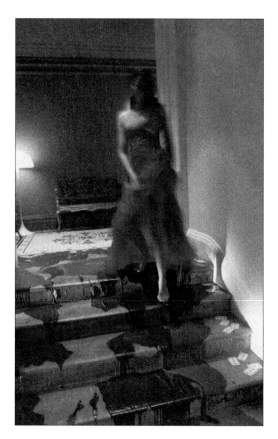

■ **In the very low light** *in a nightclub, even a high sensitivity is not sufficient to stop the movement of a lively model, and yet you will still have to pay the price – that is, a noisy image, with poor colors.*

■ **Clean, blue skies** *with a few fluffy clouds and sparkling seas are some of the toughest subjects to print successfully, because the slightest unevenness of printing will be evident. Help your printer by giving it some grain or noise to work with. The noise is barely visible, but the evenness can be improved.*

A simple summary

✓ Color images need not be strongly colored; desaturated colors offer more subtlety.

✓ Try increasing the saturation of certain elements then desaturating the whole image.

✓ It is easier to create effects digitally than in a darkroom – and no chemicals are needed!

✓ Effects such as sepia toning and the Sabattier effect are just a few mouse-clicks away.

✓ Split-toning effects work best on images that have well-separated tones.

✓ There is a wide variety of filter effects available. Experiment with as many of these as you can. Combining filters can produce interesting results.

✓ Grain and noise can be of benefit to your images. Adding a little of either can give the impression of a traditional photograph, rather than a digital one.

Chapter 16

Composites and Montages

COMPOSITES – MADE BY COMBINING elements from many images – are scary for the beginner. Tricky to do, hard to follow every step, and impossible to match. Never fear – you will get better with experience and practice. This chapter shows you how to get the basics right, after which the rest is largely repeated application of those basics. The trick is to have some idea what you are aiming at: the solution then comes more easily.

In this chapter...

✓ Selections and masks

✓ Removing the background

✓ Working with layers

✓ Galaxy of blend modes

FANTASTIC EFFECTS ARE JUST A FEW TWEAKS AWAY

Selections and masks

THE FOUNDATION FOR COMPOSITE IMAGES – *those made up of parts of more than one image – is making the **selection** in the first place. The selection enables you to "lift" parts of an image off and place it somewhere else.*

Selections

By selecting an area of the image, you will be able to apply an effect only to the selected pixels. The process of selection does not change pixels in any way, but it allows you to control where the change has effect. It is similar to selecting a block of text in a word-processing program: once selected, any change to the formatting – for example, making the letters larger or bold – is applied only to the selected letters.

There are many ways of making a selection. One way is to select every pixel that is contained within an area drawn using, for example, the Lasso or Marquee tool – these pixels can be of any value or color.

Selected areas of an image are marked with an animated white line. This graphic device is often referred to as "marching ants," since that is what the line resembles.

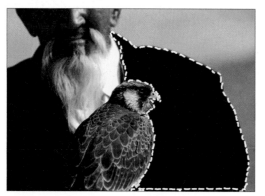

■ **You can instruct** *the Magic Wand tool to select not only pixels similar to those you have selected, but also that they should be touching each other – that is, contiguous. This allows you to change tolerance as you work on areas with different characteristics.*

■ **Suppose I want to lighten** *just the dark areas. By instructing for non-contiguous selection, I easily pick up all the black areas, and then I can apply a Levels change just to the blacks without affecting the rest of the image.*

Magic Wand

You can also select pixels from across the image that are the same as, or similar to, a color you specify using a tool often called the Magic Wand. By setting the **tolerance** you tell the program how choosy it needs to be about the pixels to select.

Selections of a feather

One important aspect of selection is that you can partially select a pixel near the edge of a selection – this technique is known as feathering. There is a gradual transition across the selection boundary from pixels that are fully selected, through those that are partially selected, to those wholly out of it. This means that changes made to a feathered selection are only partially applied to the selection.

Feathering smooths out any sudden changes between the selected and non-selected areas of your image; it makes the boundary line fuzzy and its application is crucial to artful image manipulation.

Because feathering smooths out transitions between selected and non-selected pixels, it also smooths out fine meanderings in the edge of the selection, tending to round off sharp corners. It follows, then, that you can't have a large feather radius and a very detailed selection at the same time.

> ### DEFINITION
>
> *The* **tolerance** *setting determines how different a pixel can be before it is ignored. A low tolerance selects very similar pixels; a high tolerance selects a wide range of pixels.*

■ **With a Feather setting** *of zero, it is possible to make a very accurate selection around your subject, with tight corners and narrow folds. You could even, in fact, go as far as selecting individual pixels if necessary.*

■ **A larger Feather setting** *rounds out the selection. The actual effect of feathering depends on the number of pixels you have in the image: the larger the resolution, the less effect a large Feather setting has on the tightness of the selection.*

TIPS FOR SELECTIONS

Making a selection is fundamental to image manipulation, so it's important to know some handy hints.

a Learn about the different ways of making a selection. Some are obvious, such as the Lasso or Marquee tool, but your software may have other, less obvious methods, such as Color Range in Photoshop, which selects a band of colors according to the sample you choose.

b Adjust the feathering to suit the task. If you are creating a vignetted effect, use very wide feathering, but if you are trying to separate an object from its background, very low feathering gives the cleanest results. Set the feathering before making a selection.

c Marching ants can be very distracting, and on many applications it can be turned off or hidden without losing the selection. Learn how to hide the selection.

d In most software, when you make an initial selection, you can alter it by adding to or subtracting from the selection by using the Selection tool and holding down the appropriate key. Learn the method used by your software to save your having to start selecting all over again.

Turning selections into masks

Since we are on the verge of looking into masks, let me say this: almost anything you can do with masks you can do with selections.

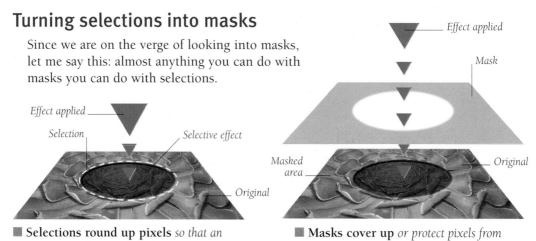

■ **Selections round up pixels** *so that an applied effect is limited to just those pixels, with a transition zone depending on the Feather setting.*

■ **Masks cover up** *or protect pixels from an applied effect, again with a transition zone depending on the Feather setting.*

Furthermore, it is convenient to turn a selection into a mask because masks are easier to store and reuse – even for other images. It is good practice to turn any selection you make into a mask – just in case you wish to reuse it – particularly if it took you a long time to create the selection.

Having a ball with masks

Masks work like selections in that they allow you to isolate and protect areas of an image from changes in colors or filter effects that you apply to the rest of the image. As with a face mask, you can see only through the holes, while the rest of the image remains hidden. Unlike real-life masks, however, the digital kind is far more flexible: you can, for example, alter the mask's opacity, or level of opaqueness, so that you can see more or less clearly through it. In image manipulation, when you save masks, you create *alpha channels* that can be converted back to selections.

> **DEFINITION**
>
> **Alpha channels** *are selections stored as masks in the form of grayscale images. Fully selected areas appear white, non-selected areas as black, and partially selected areas as shades of gray.*

Masks only work over layers, not on the background. Using a mask is rather like cutting areas out of a print: you can't do that if the print is stuck to the table. In most application programs, when you first open the image, you need to move it to a layer before you can apply a mask.

If your image-manipulation software does not offer masks, do not worry. It is still possible to carry out a good deal of work just through the cunning use of selections.

Mask-making

Software designers have taken two approaches to creating masks. You paint as if you were creating a *rubylith* (in imitation of a darkroom technique), which you turn into a selection that is then turned into a mask. This is the approach of the Quick Mask facility in Photoshop: it gives direct control and you can see the effect of any transitional zones. Alternatively, you can simply create a selection that is then turned into a mask. This is quick and easy, but transitional zones can't be assessed.

> **DEFINITION**
>
> *A **rubylith** is a red paint applied to negative film that prevents painted areas from being printed out.*

Technically, masks are grayscale channels – just like the channels that represent colors – so you edit them with the usual painting and editing tools.

Quick Masks

The Quick Mask mode allows you paint a mask on to a layer – usually with a pink color. Once you've painted where you want to, you can turn the painted area into a selection. Remember that you can invert the selection – that is, select the pixels you did not first select. Sometimes it is easier to select an area, such as a bright sky behind a silhouette, by selecting the silhouette, then inverting the selection.

MASKING A COMPLICATED AREA

Let's place a towering block over a pretty, quiet square in France. Removing the plain sky involves many tiny areas enclosed by the branches of the trees, so we need the help of non-contiguous selection. Note that in many types of software, before you can work with selections, you need to place the image on a layer first, and not leave it as the background. Because the image is full of detail and complicated shapes, you need to set a small feathering for any selections or you will smudge details. Fortunately, the contrast between the branches and sky is high, making clean selections relatively easy.

1 Make your selection

I chose the Magic Wand tool and clicked on Non-contiguous, setting a generous tolerance of 44 for quick results. To refine the selection – for example, among the branches of the tree – I switched over to Contiguous to ensure I didn't select too much.

2 Refine the selection

To refine the selection further, I switched to Photoshop's Quick Mask mode. By painting on to or erasing from the mask, you can clean up any irregularities in the selection. At this stage you can work as carefully as you wish: choose a small brush with a sharp shape and work at high magnification.

What is happening is that the layer mask is simply a layer that makes all of the underlying pixels disappear. The advantage of using the Quick Mask is that it is often easier to judge the effect of painting a rubylith than by making lots of selections. Quick Masking is at its most effective where you have many separate elements that you want masked out at the same time. Once you have the mask in place, you can apply whatever effects you wish.

3 Create a mask

When you exit Quick Mask, the program creates a selection. Now I needed to create the mask proper, so I pressed the Mask button or called up the Make Mask command. In this case, I got the opposite of what I wanted, so I selected the inverse, reversing the selection.

4 Check the result

This is the result I was aiming for. Note, however, that some areas in the sky will still need to be cleaned up. However careful you are, it is very hard to avoid these missed patches. Turn to the Erase tool to remove them. Larger patches can be lassoed together, then deleted – this is faster than using the Eraser.

5 Combine the images

To complete the job, I selected the whole of my image and then pasted it on to an image of a tower block. Here you can see the result. To ensure that the images will fit, check their sizes before pasting one on to the other. Nonetheless, you will probably need to make small adjustments: select the appropriate image and apply distortion effects (see pp.172–5).

Removing the background

PERHAPS THE MOST OFTEN USED image-manipulation technique is that of creating a plain white background. In fact, this task is so fully accepted that most people don't even realize it is a type of image manipulation.

Removing the background is used so much that there are specialist application programs that do only that. They are needed for really tricky subjects, such as models with flying hair, translucent glass partially showing the background, and where the background and subject are very similar – for example, black fur against a shadow.

USING COLORS TO SEPARATE

In order to separate the red flowers from the leaves in this example, we exploit the difference in color. The Color Range tool selects pixels that lie within a certain range. That way, we can separate the greens from the reds. Once the colors have been

1 Choose a selection tool

Removing the red flowers from the leaves is easy, due to the contrast in colors. Use a selection method that picks similar-looking pixels – Magic Wand or Color Range.

2 Highlight the reds

Call up Color Range and click on the red colors holding down a modifier key (one that adds or subtracts from what's selected). The selection shows in white.

3 Remove and invert

If you remove what you select, you are left with a white hole – the opposite of what you want. So invert the selection. This option will be found in the Select menu.

Lasso for last

The most straightforward method for removing the background is by first defining what you want to keep – for this, you use the Lasso tool. However, this task is also the most prone to error and is a real test of hand/eye coordination. Generally, it is easier to use a tool that selects similar pixels – Magic Wand or Color Range. Better still, use specific extraction tools, such as Extract in the Filters menu of Photoshop, if you can.

For detailed work I find it impossible to use a mouse, even those with the latest optical sensors, so I use a graphics tablet. It costs more than a mouse, but if you plan to do much image manipulation, it should be high on your shopping list. Best compromise in size is A5 – not too small, not too big.

separated, we can simply delete them. In fact all methods of removing backgrounds depend on the careful definition of similarities and differences at the edge of a selection. There, the pixels you want to select are more likely to be similar to those you know you want to keep than those that are different. You can make the method described here very precise by doing the selections in stages and then combining the results.

4 **Make a layer**

If you want the flowers to float over another image, so that the rest of the image is transparent, turn the background into a layer. Hide the leaves by using a mask.

5 **Mask the background**

Applying a mask to everything apart from the red flowers makes the background transparent. If you place an image under the flowers, it will fill the background.

6 **Use a plain background**

Alternatively, you can just place the image against a plain white background. This will be easy to change later or can stand as an image in its own right.

Working with layers

SO FAR, WE HAVE USED LAYERS in a conservative way, consistent with what photographers and artists used to do in the darkroom and studios. One of the most liberating features of digital photography – and a constant source of innovation – is to let layers interact with each other. Really it's just a lot of mathematics – playing around with numbers – but, as you can see from the variety of effects here, the results can be surprising, delightful, or striking.

The basic color image is itself made of layers – normally called channels – that represent red, green, and blue. In practice, the terms layers and channels may be used interchangeably. In fact, masks, too, are essentially channels, in that they work with a layer to affect the appearance of another.

Layer modes

The interactions between layers are tricky to learn because the precise effect on the image depends on the value of a pixel on the source (or upper) layer compared with the corresponding pixel on the destination (or lower) layer. The most frequently used method is simply to try them out one by one until the effect looks attractive. This method can distract you from your vision by offering you an effect you had not thought of – that is part of the fun of working with powerful software. With experience, you will get to know the blend modes that you find most pleasing and plan your images with them in mind.

The effectiveness of a mode may depend on the opacity you set on the source layer. Sometimes a small change in opacity turns a garish result into a visually persuasive one, so if you find an effect that does not look quite right, try changing the opacity.

■ **The choice of layer modes** – *different layer interactions – is large. The names don't help much either: to learn, simply try out each one each time.*

Galaxy of blend modes

ILLUSTRATED HERE is only a selection of the blend modes that are available – and if you add what different software offers, there's even more to work with. Remember that many modes apply not only to layers, but to painting and cloning, too.

■ **These are the two shots** that I have used for the blend examples for the next three pages. Try to identify their elements in each image.

Here are a few points to note as you look through the various blend modes.

Blend-mode extras

The Color Dodge and Color Burn modes often produce colors so extreme that it is not possible to print them. A Sabattier-type effect can be achieved using the Exclusion mode: simply duplicate the top layer (which is left as Normal blend) and apply Exclusion to the duplicate layer – now uppermost. Try the layers in different orders when working with layer modes, particularly with Color, Hue, and Luminosity.

■ **The Normal blend** is often ignored, but it is a proper blending mode in itself if you lower the top layer's opacity below 100 percent, making the lower layer progressively more visible. Here, the top layer at 55 percent shows a useful possible blend, one that cannot be replicated by other blend modes.

■ **The Dissolve mode** works by randomly making holes in the top image, allowing the lower layer to show through. It can be used to add chunky noise to the image.

■ **The Multiply mode** darkens the images greatly. This can be used to help recover images that are too light. Duplicate the overly light image into another layer, then set the new layer to Multiply.

■ **Screen is a useful mode** *for lightening an overly dark image (just the opposite of Multiply): just duplicate the image on to another layer, set the top to Screen, then adjust the opacity.*

■ **Color Dodge** *is like Screen but more dramatic. Black in the upper layer has no effect on the receiving layer, but all other colors tint underlying colors and increase saturation and brightness.*

■ **The Overlay mode** *is often used for blending layers, since it is capable of mixing colors from both layers without favoring one or the other; it is very responsive to changes in opacity.*

■ **Color Burn** *increases saturation and contrast, producing darkened images by replacing lighter underlying pixels with darker top pixels and increasing color at the same time.*

■ **Soft Light** *darkens or lightens colors, depending on the blend color. Painting with pure black or white produces a darker or lighter area without resulting in pure black or white.*

■ **The Darken mode** *applies only darker pixels from the top layer to the bottom layer. This mode does not change colors strongly, so it cannot be used to darken an image.*

■ **The Difference mode** *reverses both tones and colors at the same time – the greater the difference between corresponding pixels, the brighter the result will be.*

■ **In Saturation mode,** *the color purity of the underlying layer is changed to that of the matching pixel in the top layer. Where Saturation is high, the lower image returns a richer color.*

■ **The Exclusion mode** *is a softer version of the Difference mode: it returns gray to pixels that have medium-strong colors, rather than strengthening the colors.*

■ **In Color mode,** *hue and saturation of the upper layer are transferred to the lower layer, retaining the brightness of the receiving layer. This is used for simulating hand-tinting of black-and-white prints.*

■ **In the Hue mode,** *the colors of the top layer are combined with the saturation and brightness (luminosity) values from the lower layer. The result can vary widely depending on the images used.*

■ **Luminosity** *is a variant of Hue and Color. This time, however, the luminosity of the top layer is kept, but the color and saturation of the underlying layer is applied.*

■ **This image appears to be very complicated.** *However, in fact, I used only two layers, the top one of which was set to Difference mode (see p.241).*

■ **Here, silhouettes** *of just three or four pigeons were duplicated, rotated, and resized in order to multiply them, and then they were set to Difference mode.*

A simple summary

✓ A selection is a defined area of your image on which you can work and apply effects.

✓ Selected areas are marked with a dotted white line often referred to as "marching ants."

✓ There are several ways to make selections, depending on which software you use.

✓ Masks work like selections, but they allow you to see through the "holes" in a selected area.

✓ The Quick Mask mode allows you to paint a mask on to a layer.

✓ Selections can be inverted, allowing you to select everything that was previously unselected.

✓ Removal of backgrounds is the most-used image manipulation.

✓ Highly contrasting colors within an image make separating the image elements easier.

✓ Interactions between layers can be difficult to learn, since they change with different images.

✓ There is a huge variety of blend modes available, including some specific to certain software.

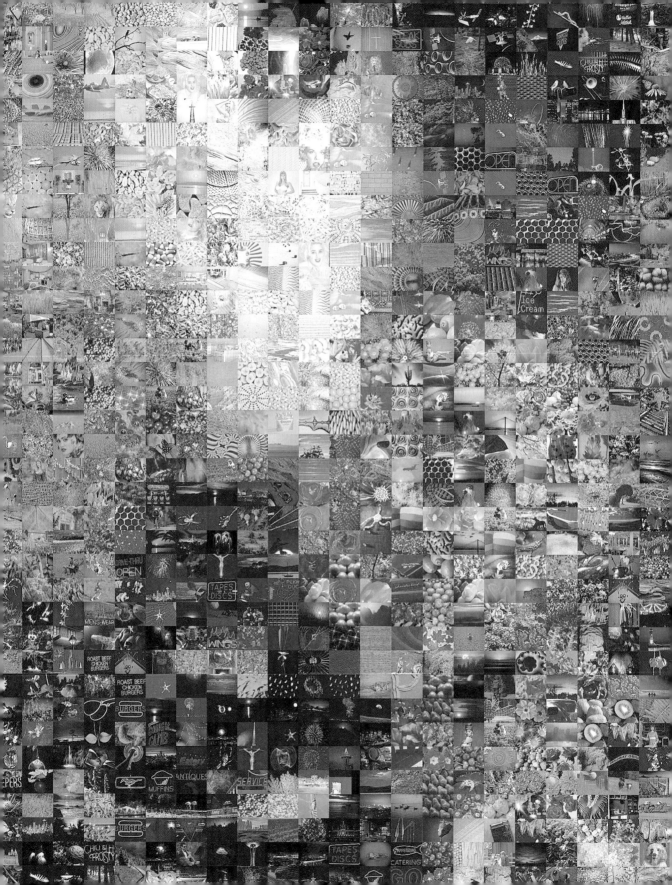

Virtuoso Elaborations

AS YOU GAIN MORE EXPERIENCE, you will become more ambitious. Unless you already use professional-grade software such as Photoshop or Photo-Paint, the limits to what you can achieve may be set by the programs you use. Even so, there are some techniques that even Photoshop cannot manage easily – techniques that call for specialist software. These need not cost a great deal, but they can give you results impossible to achieve any other way.

In this chapter...

✓ **Fantastic photomosaics**

✓ **Creating panoramas**

✓ **Mixing text and pictures**

A PORTION OF A LARGER PICTURE IS RENDERED AS HUNDREDS OF SMALLER IMAGES TO MAKE A PHOTOMOSAIC

Fantastic photomosaics

IF DIGITAL IMAGES are made up of an array of individual pixels, it is only a short step to making up an image from an array of individual pictures. This is the principle behind photomosaics: you can replace an image's pixels with tiny individual images, or mosaic pieces.

Creating texture

Photomosaics may be regarded as a special kind of compositing. You need to prepare a set of images with which to create the mosaic. The small mosaic pieces may be tiny versions of the larger one or be completely different in content. Photomosaic software treats individual pictures as if they are pixels, looking for the best matches between the density and color of the small images to the pixel of the larger image that is to be replaced. The resulting images offer a unique texture. Through careful selection of the mosaic pieces, you can subtly alter the texture of a photomosaic from relatively smooth to very rough – that is, with sudden transitions between contiguous mosaics.

■ **Mosaics are** *at their most fascinating when you look at them close up. Once you see the elements that make up the whole image, you will discover another level of appreciation. The detail (above) reveals images that are totally hidden in the original (left).*

PERFECTING PHOTOMOSAICS

To achieve the best results when creating photomosaics, follow these tips.

1 Provide a wide range of images to make up the mosaic pieces.

2 Remember that by using smaller mosaic pieces, you will be able to produce finer, more detailed photomosaics.

3 Start with subjects with very clear or recognizable outlines – that is, avoid complicated subjects lacking clear outlines – because the photomosaic destroys all but the largest details.

4 Remember that if you create images in which a high level of detail is replaced with large mosaics, the resulting files will be very large.

5 The rendering process that creates the photomosaic can take some time, so be prepared to put in some work.

A visual game

Photomosaics also promise a visual game in which the viewer looking closely into the image is rewarded with fascinating juxtapositions and a sense of new order arising out of chance and chaos.

Photomosaic software usually provides libraries of mosaic pieces for you to work with, but it is more fun to create your own. However, the large numbers of images needed mean that this can be a long-winded process. Another source of mosaic pieces are the thumbnails (small image files) used by collections of royalty-free CDs for cataloging.

■ **Photomosaic software** *can sometimes get it wrong. See how little resemblance this mosaic bears to the original shot, the silhouettes first seen on p.98. Yet the image has some attractions. You could delete it and start again, or else treat it as a starting point for more experiments.*

Creating panoramas

PANORAMIC VIEWS are created digitally by "stitching" or overlaying images side by side. There are two steps to the process. First, you take a series of pictures that traverse the horizon (or they can go up and down – think of tall buildings). Then you use image-manipulation software to stitch the images together.

The component shots

A digital camera produces true panoramas by swinging its view so that the field of view in the image is greater than the field of view of the taking lens. Ideally, support the camera on a tripod, and pivot it so that the image does not shift but you see a different part of it. Some digital cameras have a panorama function; this indicates where succeeding pictures should be taken, with the previous image shown in the LCD as a guide. Set the camera exposure manually: as you pan across a scene, varying light may cause the camera to change the exposure. If possible, set the white balance to manual, too.

Finding the axis of rotation for perfect blends needs experimentation and the right equipment. Beware that panoramas made of subjects at close to mid-range will show a perspective distortion in which the center bows toward you.

■ **The trick with panoramas** *is to find interesting and less predictable views to work on. By working under a bridge, the distortions in size are greatly exaggerated in ways that are rather exciting.*

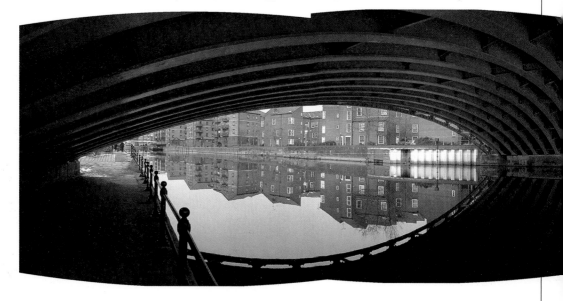

Software stitching

You do not need specialist software to achieve adequate panoramas if the original pictures were taken with care. Just create a long, wide canvas and manually drop images side by side, overlapping them as well as possible. However, even small errors in the original photography can slow this manual process. Specialist panoramic software makes it easier to join the components. Some programs try to match overlaps automatically and blend the shots together by blurring the overlaps. The results look crude but are effective for low-resolution use. Other applications recognize if the overlaps are not matching and try to accommodate: some by distorting the image. Many digital cameras supply panorama-creation software as part of the software bundle.

I like to experiment with breaking the rules – for example, placing incongruous images together, or distorting perspective so that the components clash.

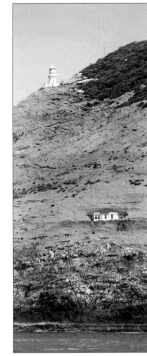

■ **Panoramas need not** *be very obvious, nor do they need to run along the horizon. It was not possible, using the lenses I had, to show the lighthouse and its position on the steep ground in one shot, so I took two in quick succession as we passed in a boat.*

■ **A normal panorama** *would be accurate and depict the space objectively, but this more explosive, less controlled version gives a better feeling for the sense of the space.*

CREATING PANORAMAS

The main points to watch when creating panoramas include the following.

1. Place the component images together into a folder. Note: some software will not allow you to use different folders.

2. Ensure the images match as closely as possible to make blends smooth.

3. Beware that a panorama resulting from half a dozen average-sized images will be a very large file. Reduce the size of the component images in order not to stress your computer.

4. If you want to create a panorama that covers half the horizon or more, it may be better to stitch it in stages, three or four images at a time, then stitch the resulting panoramas. Keep an eye on the image size.

5. For greatest ease of viewing by others, use QuickTime VR as the format. This enables viewers to move around the panorama, rather than seeing the whole view at once.

Mixing text and pictures

TYPEFACES OR LETTER FORMS can be treated in many ways in image-manipulation software that are impossible with other applications. You can make letters flame up, dissolve into clouds, appear transparent over another image... the possibilities are unlimited. Your application will offer a basic range of effects, but if it accepts Photoshop-compliant plug-ins, you can extend its repertoire.

Bitmap and vector graphics

There are two types of graphic images. Digital cameras produce bitmap, or **raster**, images, based on a grid of data (the colored pixels). The other type – vector, or object-oriented, graphics – can be scaled to any size and printed at any resolution without losing detail. Text sits uncomfortably with pixels because type is best encoded as vector graphics, while photos are best bitmapped. When combining the two, the text must nearly always be turned into a bitmap image, resulting in a loss of clarity. Then, as you increase the size of an image with text, the outlines of the letter forms become ragged. Always work with text at the full output size, and avoid changing the image size once text is applied.

> **DEFINITION**
>
> **Raster** *is the grid-like arrangement of pixels or dots of ink, like that of a chessboard.*

■ **Text effects for digital imaging** *are varied and can be quite wild – from simple coloring (see top left), to flames licking through the letters (top right), shadow and 3D effects (above left), and a combination of inner and outer glows with shadows as well as writing on a curved line (above right).*

COLORING TEXT WITH A PICTURE

You can decorate text by placing an image under it, so that parts of the image "stroke" the text. To do this, you need software that works with layers and paths.

1 Select your bottom layer

Choose a striking, colorful image that will work with the copy you have. Change its shape to fit the intended use. Make it the bottom layer.

2 Build a top layer

Create the type on a new layer with another image. Make sure the letter forms are chunky and bold, as seen in this example.

3 Create a mask

Turn the type into a mask that will allow the lower image to show through unmasked areas. Some programs have a special tool for this task.

4 Put it all together

Apply the mask to show the lower image through the letters. Tweak the results with the Burn or Saturation tools. Flatten the image to finish off.

Text-usage tips

To make effective use of type in images, bear the following points in mind.

 Check the typeface at full size, preferably on a printout, to check its legibility. Recheck it if you change the face – different typefaces vary in legibility.

 Use typefaces with narrow lines where they contrast well with the background; use faces with broad shapes where the contrast is less obvious.

 You can use typefaces with narrow outlines if you create effects that separate the text from the underlying image – for example, with outside glows or drop shadows.

4 For masking or to allow images to show through, use faces with broad lines.

5 Avoid using more than 30 words when combining text directly with images.

Avoid using faces with narrow serifs (the little extensions to the end of a stroke in a letter) because they are easily lost in the underlying image. Also, avoid combining images with letter forms with hollow strokes or those made up of double strokes.

A simple summary

✔ In photomosaics, each of the image's pixels is replaced with an individual smaller image.

✔ Photomosaics can be made manually or using software.

✔ A panoramic view is one that takes in more of the original scene than was visible to the field of view of the lens or naked eye.

✔ Panoramic views are made by digitally "stitching" or overlaying images side by side.

✔ Lettering can easily be mixed with pictures in image-manipulation software.

✔ The possibilities when creating an image composed of photos and text are limitless.

PART SIX

Venturing Out

DIGITAL PHOTOGRAPHY puts all the creative power into your hands. You really can control much of the process – which is itself a big part of both the challenge and the enjoyment. In this part, we learn how to control that power, to make your pictures shine.

Chapter 18

Planning and Printing

Y OU'VE WORKED AT YOUR IMAGE to the best of your ability. Okay, let's be honest: it may be no masterpiece, but it is still something you're proud of, something of which you want a permanent record. This chapter shows you how to produce good prints without having to tear out your hair in the process.

In this chapter...

✓ Finding your feet

✓ Printing your images

✓ Other ways of printing

✓ Permanence: inks and papers

YOU'VE HAD FUN WORKING UP YOUR IMAGES – IT WOULD BE A SHAME NOT TO SHARE THEM WITH OTHERS

Finding your feet

AFTER A FEW MONTHS of snapping away with your camera, you may feel that you need some direction, or some point, to your photography. The number of images grows alarmingly, but you may not know what to do with them all. You may even lose motivation and feel in need of some inspiration.

Projecting forward

One of the key ways to make photography satisfying is to pick a project. This can be, indeed should be, simple and achievable. Follow your garden through the seasons. Follow the cat around. Make an album of portraits of all members of the family. With experience you can work on more ambitious projects, but the key is to start with modest aims, keeping your goal in mind as you go about making the pictures or when you're just walking around. The effort of focusing your mind on a goal can have a wonderful effect on your photography: it will feel directed, and after a while, photographs will almost make themselves for you. Will you depict only objects and locations, or do you need some portraits and group pictures? Will you work in color or in black-and-white – or, indeed, both? Do you need to research archives for historical views or deceased people?

■ **These images** *were obtained in under 10 minutes wandering about the house – and it's not the most inspiring treasure trove of artefacts or stylishly designed interior. But careful observation yields many pictures that could be used for anything from abstract patterns to strong graphic shapes.*

Workbook jottings

Many people find a workbook (day-book, project log, or diary) helpful. This is a collection of anything to do with your photography: paste in magazine cuttings that catch your eye, jot down reminders and shopping lists, to-do lists, and any stray thoughts or musings, or keep working prints or failures as reference. In time, the workbook will build up into a valuable resource, one that you return to repeatedly; but remember: it is for you. It does not have to be neat like a homework assignment; it does not have to be immaculately presented. You are not intending to show it to anyone, so you can be free and wild in it. Writing without censorship will help release your inhibitions.

Sometimes I have what I think is a brain-wave, a flash of creation. I go to jot down the idea in a tattered old notebook only to discover a previous entry that shows I'd actually had the idea years ago!

Be a visual vacuum cleaner

With digital photography, you can record or copy anything that takes your fancy or that you might want as reference or a reminder. It costs you nothing to be experimental, to try out anything that comes to you. The more often you press that shutter button, the more your eyes will open and inspiration will come to you. Just go around and suck it all into your camera.

Printing your images

DIGITAL IMAGES CAN BE PRINTED on normal photographic paper or film. You can also turn a digital image into a negative, which you can use like a normal photographic negative – this is great for multiple prints.

Printing a digital file on photographic paper can disguise its digital origins extremely well, giving fantastic results and beautiful colors that neither ink-jet nor straight photographic processes can equal.

The process of checking a file before committing it to print is called pre-flighting – think of the need to make sure everything's working on an airliner before taking off.

Working with paper

Today's ink-jet printers offer truly fantastic quality (and I'm not on the payroll of any printer manufacturers). Low-cost printers can produce results that could pass for professional-level work without close inspection. Pay a bit more and even real pros would have a problem outshining you.

The crucial factor is the paper. Choice of paper is the single most important and easily controlled factor for best quality output. The range of paper today is superb – from transparent film, to mechanically glossy papers, to those imitating handmade papers. And, of course, there is every kind of white, too. So much for the good news. The bad news is that you do need to experiment. You can purchase sample packs from manufacturers so you that can try out a whole range of papers without having to fork out for 50 sheets of a paper that you eventually decide you don't like.

Testing target

When trying out papers, choose a good-quality image with a mix of plain areas, details, and skin tones, and a range of colors, as your standard, then run off your prints. Make sure that you note on the back of each print the name of the paper, to keep track of your trial prints.

Once you've found a paper you like, stick to it: get to know its strengths and weaknesses, get to know what kinds of images print well on it. Once you know the paper, and its limitations, you can look for other papers.

Don't work with too many papers at once – you'll just confuse yourself.

■ **It is easy** – *and can be fun – to make up your own test targets for printing. Make sure you use a range of colors and subjects – from pure colors to skin tones, greens, and even tones such as a blue sky. Also throw in difficult detail like the writing on book spines.*

Inking the best

Inks for ink-jet prints fall broadly into four types:

- **The manufacturer's own cartridge** This is a sound choice, usually of high quality and guaranteed to work with your printer, but it could work out quite costly.
- **The so-called compatible types** These are priced to be cheaper than the manufacturer's own brand and may or may not be guaranteed to work with your printer. Also, the ink may not last as long and may be of lower quality. Some compatible brands may be made by the same factory that produces the printer's own-brand cartridges, so there may be no significant difference in performance.
- **The refillable ink** This type is known derisively as "rubber glove and squirt" because you may have to perform surgery on your cartridge by using a syringe to inject ink into the spent cartridge. Yes, it's messy and requires skill.
- **The professional-grade inks** Strictly for the experts, these may actually be superior to own-brand inks in terms of color and longevity, but they cost a whole lot more.

Previewing

The key to efficient printing practice is to check and confirm as much as possible on the monitor screen before committing to print. This is called soft-proofing. The better software has a setting that simulates how the image will look when printed: usually bright, highly saturated colors print more dull, while very dark colors – especially violets and blues – will become grayer and less brilliant.

Reviewing the results

If your image looks as you hoped, many congratulations! It's a good achievement. But if not, always remember that a mismatch between the monitor image and the printer is not, in the first instance, caused by either your printer or monitor working wrongly.

GETTING THE PRINTS RIGHT

Here is a checklist to make sure you get the right results every time you print. Remember: you're the boss.

1. Check that your image is sized to the correct output dimensions. Some printers can print right to the edge of the paper, so you can fit a 6 x 4-inch (15 x 10-cm) image on to a 6 x 4-inch piece of paper, but others need a little margin. If so, make sure the image is smaller than the paper otherwise some of it will be cropped off.

2. Ensure your image has enough data for the size at which you want to print it. Generally, an output resolution of around 200 dpi is ample for prints being output on ink-jet printers.

3. Position your image the right way to fit the paper – usually portrait format. If your image is landscape format, rotate it before printing, since this speeds up printing.

4. Use the correct side of the paper. Most ink-jet papers are coated only on one side – often the wrong side is lightly overprinted with the manufacturer's name.

5. Always have a good supply of ink in the printer.

6. Check that the image is flattened – that is, the image lies on the background. This is not always necessary, but it is good practice and allows faster printing.

The basic problem is that the monitor produces colors by emitting a mix of red, green, and blue light, whereas a print reflects a mix of light to give you the colors you see. These are fundamentally different ways of producing color, and it is this that makes a difference in **color gamut** inevitable.

You have to live with the fact that prints cannot look as lively and brilliant as an on-screen image. However, take the print away from the monitor, and – so long as the blacks are quite deep, mid-tone colors are rich, and there are a few highlights – within seconds you will find that the print looks great. At least such a print will please the great majority of viewers, and that's what really matters.

> ### DEFINITION
>
> The **color gamut** is the range of colors that can be handled or output by a device such as a printer or screen.

PRINTING PROBLEMS

Things can go wrong when printing, but problems are becoming more and more rare. Here are some common complaints; see your printer's manual for help with others.

■ **Sudden disintegration** *of image: Printer driver may be out of memory or the file has corrupted. Restart with only necessary programs.*

■ **Ink won't stay well** *on glossy paper: Use paper recommended by the printer manufacturer or guaranteed to work with your printer.*

■ **Poor-quality printers** *or blocked ink nozzles cause streaky, banded printouts. Clean the printer using its software utilities, or get new cartridges.*

■ **Garbled text** *after printer or computer problems, usually if printing without turning the printer off first: Turn off the printer and try again.*

Other ways of printing

IF YOU HAVE A BROADBAND Internet connection, you can send your images to a bureau to be printed. Give your credit-card details to authorize payment, and your prints will arrive in the mail a few days later. These prints can be on photographic paper or be ink-jet prints, as you wish.

Even if you do not have an Internet connection, you can benefit from these services. Just sent them a CD with your images and instructions, and you too can receive excellent quality prints through the mail, with your CD returned.

Printing at a console

Another welcome development is the rapid growth in the number of automated machines in supermarkets, photography retailers, and pharmacies that can give you on-the-spot service. Simply insert your memory card, CD, or Zip disk into the machine, follow the on-screen instructions to select the images you want printed, then order prints. Minutes later, you will be handed a pile of prints on photographic paper. The only element missing from this delightfully painless process is having those prints come out smelling like freshly baked cakes!

INTERNET

www.apple.com
www.fotango.co.uk
www.kodak.com
www.photobox.co.uk

These sites all offer some sort of online printing service for the digital photographer.

Making big prints

It is a treat to see your images enlarged to poster size. It does not have to be a great picture – sometimes the simplest image is the most effective – and the digital file from which it is output may not even need to be of the highest resolution. This is because large prints tend to be seen from a distance, in which case detail is not necessary.

The simplest way to make large prints is to use an oversized ink-jet printer. These range from self-standing machines somewhat larger than desktop printers, to monsters capable of printing on the entire side of a bus. Obviously they are all too expensive for the average digital photographer to own and run, so you will need to take your file to a print shop for the output.

Before you prepare your file, ask the print shop for their preferred format (usually RGB TIFF uncompressed) and which type of media they accept (all accept a CD, and most accept Zip disks). You also need to check the shop's preferred resolution and adjust your file to the output size you require.

TILING PRINTOUTS

One way to make prints larger than your printer can print is to output the image in sections, or tiles, that you then join up. The easiest way is to enlarge the image to the intended size, then crop parts of the image to create new images. Print the component images, trim the prints to remove overlaps, and butt the joins – that is, stick the sheets together without any overlap. Where economy is important but critical image quality is not required, tiling is most cost-effective.

If the edge to be joined is dark, take a felt-tip pen and run it down the edge of the paper using the side of the pen. This darkens the edge and can achieve miraculous results.

■ **If you were tiling** *this image to make a big print, you should try to make the joins in places where they are harder to detect. The branches in the tree help hide errors in butting up the edges, as does Nelson's Column itself.*

Permanence: inks and papers

IN TODAY'S FAST-MOVING WORLD, the impermanence of printed color is seldom a problem. Long before an image in a portfolio starts to fade, it should be replaced with more recent work. Exhibited prints are rarely shown long enough to suffer fading. However, sometimes stability is important: when prints are sold to museums or clients who may want to display the image for years on end.

Contributions to impermanence

The two main factors involved are the materials used and the showing or storage conditions. Materials are made of two main components: the ink used to make the image and the substrate, or supporting, layer. Either or both of these will contribute to the impermanence of an image.

For an ink to be stable, its colors must be fast and not fade in light or when exposed to the normal range of chemicals in the atmosphere. For paper to be stable, it should be neutral and buffered – that is, be able to remain neutral when attacked with a small quantity of acidic chemicals.

THE LIFE OF A PRINT

Types of color prints are listed here, the most permanent first. In practice, the top spot is a tie – the true longevity of the pigment ink-jet is still unknown.

1. Pigment-based ink-jet print on recommended paper

2. Dye-destruction color print – for example, Ilfochrome Classic/Cibachrome

3. Dye-sublimation color print

4. Photographic color print – for example, RA4, R-3

5. Ink-jet print

INTERNET

www.wilhelm-research.com

This is where you can find out the latest data on print longevity.

An ink should not depend on volatile chemicals for its color or physical state (some materials, for example, become brittle when they dry out), and it should not color with exposure to light. These are tough criteria. Note that when colors fade, one is likely to fade more rapidly than others – this is quickly visible as a color shift.

With ink-jet prints, the ink is the weak link. Those based on pigments (materials that are themselves colored) are more permanent than dyes (dissolved pigments that give color to materials).

Storing up a long life

Careful storage can ensure that even very unstable images are preserved, but this may not be practical. Archive professionals store prints at nearly freezing point, with low humidity, and in total darkness. The rest of us try to limit exposure to direct sunlight and fumes. In normal room conditions, most materials will last a few years, but if you keep pictures in the kitchen or bathroom, or exposed to the afternoon sun, you can expect shorter lifespans for your prints.

A simple summary

✓ You can make your photography interesting by giving yourself a simple, achievable project.

✓ Focusing your mind on a short-term project can have a great effect on your photography.

✓ A workbook is an invaluable tool for photographers. It can include magazine clippings, reference photos, and lists of ideas.

✓ Printing on photographic paper can help disguise the origins of a digital picture.

✓ Most ink-jet printers are capable of good results – the important factor is the paper. Try out several until you find one that you like.

✓ To print efficiently, check your file carefully before printing it.

✓ Prints never look as lively and bright as they do on screen.

✓ Large prints can be made by a professional, or you can try tiling.

✓ The permanence of a print is dictated by both paper and ink.

Chapter 19

Images for the World

FROM THE HEADY DAYS of dot-com wealth and wonder, the Internet has settled down to become an important utility for modern life. Digital photography fits perfectly into the Web life: all digital cameras produce files immediately usable on the Web. The Web is the best place to find photographs and to learn about digital photography. It is even becoming a good place to print a picture, strange as that sounds – but these prints may be just what you're looking for once you consider putting on an exhibition of your work….

In this chapter...

✓ **Spreading the picture**

✓ **Making your own picture website**

✓ **Showing your best side**

ANCIENT-WORLD BEAUTY AND CUSTOMS MEET WITH THE MODERN

Spreading the picture

OF ALL THE ASTONISHING CHANGES made to photography by digital technology, perhaps the most amazing is the ease with which your images can be viewed around the world on the Internet.

E-mailing pictures

You do not even need a website if you want your pictures to be seen by friends and family – simply attach your image as a JPEG file to an e-mail and send it. However, you should observe some rules in consideration of your recipients.

1 Keep image files as small as possible. Images are easily read at 240 x 180 pixels and even smaller, and most images need not be larger than 640 x 480 pixels in size. For convenience, and from convention, set the resolution to 72 dpi. Send only JPEG format, with compression as high as possible.

2 If you have a lot of images, tell people what is available and to ask for them if they want them. Make sure you warn them that some of the images could take a while to download. They can then choose and not have other e-mails disrupted by the arrival of a huge amount of data.

The best way to share your images is to place your pictures on a website and e-mail a link to everyone.

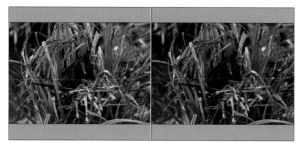

■ **This compares** *not only one large file (left) with a heavily compressed one, but the image on the right is shown as it would appear on a Windows computer screen, which is darker than it would be on an Apple Mac (left).*

■ **One file is nearly** *5 MB in size (see top), which would take several minutes to download on a normal telephone line. But the other has been heavily compressed and the file size shrunk to just 168 KB, meaning a download time of around 30 seconds. Can you even tell the difference?*

Making your own picture website

IF YOU HAVE ACCESS TO THE INTERNET – that is, you subscribe to an Internet Service Provider (ISP) – it is likely that you already have some Web space reserved by your ISP to host or hold your personal Web pages. Check with the ISP to find out how much you have. Then all you have to do is to create your Web pages and transfer or upload them to your ISP's server. If your ISP does not enable you to have a Web presence, you can place your pages with a Web Presence Provider, some of which – such as Geocities, Xoom, and Tripod – are free.

Another source of space are the free services offered by manufacturers of digital cameras, software, and online printing companies. These allow you to set up your own picture albums, which can be visited by anyone on the Web. Some services even make it easy for visitors to order prints: you receive a fee and the printing service charges for the print. For these, you do not even have to create a Web page – simply send in your pictures.

Simple structure

The basic structure of your website should be very simple. There will be a home page, or welcome page, which will carry the title and any other details you write. On this page will be a set of thumbnails – small, low-resolution images – that are linked to a larger image. If a visitor clicks on the thumbnail, the larger image is called up from the ISP's server to be displayed on your visitor's computer. At any time, your visitor can return to the home page or thumbnails. You may be able to add extra features, such as making it easy for visitors to e-mail you.

■ **It takes literally a minute** *to generate a Web page that looks like this. It could be refined, but it is an excellent start.*

Copyright protection

A common fear of photographers is that their images will be stolen when placed on the Web. There is nothing to stop anyone from copying your image: the latest Web browsers allow the image file itself to be downloaded and anyone can capture the screen image using screen-grab utilities.

The risk of theft is one reason to keep the size of the image small – so that it is really of no use except when viewed on a monitor. At any rate, you should also display clear copyright notices on your site, preferably on every page – discreet but visible.

Watermarking the image – placing your name or copyright notice in pale text over the image – stops image theft but is unsightly and also stops people looking at your image.

■ **The simplest way** *to protect your images from theft on the Web is to put a clear copyright notice on the picture itself. It is a nuisance for the would-be thief to remove the notice. Unfortunately, though, it does not enhance your image either.*

Showing your best side

AFTER SOME TIME MAKING PHOTOGRAPHS, the urge to share them with other people may start to grow. Banish any doubt that your work is not good enough to show to the public. An exhibition is exactly that: you make an exhibit of yourself.

Visualize the show

You may not feel you're ready to show right now, but one day you will be. Try to imagine in your mind's eye what the show will look like: visualize how you would light it, how you will position your images for maximum impact, how to sequence them to create an atmosphere and flow of meaning or narrative. Picture to yourself the size of the prints, how they will glow in the light, and so on. This will help focus your mind and guide your energies as well as your picture- or print-making.

■ **It can be** *surprisingly easy to convert a space into a gallery. Here, the stage of a museum has been used for over 100 prints. Simple boards are inexpensive and easy to set up.*

ESSENTIAL EXHIBITION TIPS

Here are the basic steps toward an exhibition:

1. Choose and book your venue early to avoid disappointment.

2. Choose your venue creatively. Any public space can be used – indeed, some may be more suitable for some kinds of work than a "proper" gallery.

3. Budget with your brains, not your heart: put on the best show you can afford, not one that costs more than you can manage.

4. Produce drawings of the layout of the whole exhibition. This involves little thumbnail sketches of the prints in their hanging order: it is easier to visualize the effectiveness of picture order this way.

Approaching sponsors

Before long, your thoughts will turn to sponsorship. How can you persuade someone to lavish help on you? The key to success in obtaining sponsorship is to approach it as if you are looking for a partner. Sponsorships work only when benefits flow both ways. It is obvious you will benefit from being offered services or the use of equipment you can't afford, but what does the sponsor get out of it? The approach to the sponsor that starts, "I can arrange for your company to be mentioned in trade news" is more likely to succeed than one starting with, "I need money for a great idea."

Tell potential investors how you can publicize their products or services, or how their image will be improved by association with you. When they ask, "What's it going to cost?", you know your foot is in the door.

SELLING PRINTS

Remember that silver-based prints will continue, for a long time, to sell for higher prices than any digitally based print. Here are some hints for ensuring good, continuing relations with your buyers.

1. Don't make claims about permanence that you can't substantiate.

2. Give people advice about how to care for the prints: do not store in humid conditions such as a bathroom; do not expose to direct sunlight.

3. Never exceed the run when you offer limited-edition prints. Run off a specific, guaranteed number and not one single print more.

4. Always print on the very best-quality paper you can afford or that which is recommended by the printer manufacturer.

5. Remember that in selling a print, you are not giving up copyright – that remains with you.

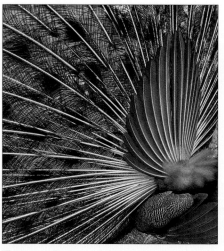

■ **Strong lines** *and fascinating detail make this kind of image (the plumage of a peacock) ideal for presentation or even for sale.*

Ask for what you need

It is always easier to obtain services or products than it is to obtain cash. Printing materials, exhibition space, scanning, processing, drinks… anything but cash. And ask in good time – people have budgets to maintain.

When you obtain support, always ask for an endorsement letter – one saying that the named company supports your activities. Such a letter could open more doors. This, incidentally, helps ensure you do receive the sponsorship, for you should be careful about committing yourself financially without first receiving the help.

Even if the answer is no, you can ask for one final thing that can be even more valuable: information. Ask for suggestions of who else you might approach or which company might be interested in the idea. Finally, say all your thank-yous. Photography shows can bring together many people to produce it. They are your sponsors just as much as commercial sponsors. Always thank everyone who helped you. Always acknowledge their invaluable contributions, without which you wouldn't have been able to lift a hammer.

A simple summary

✓ Digital images can easily be shared with friends and family around the world using either e-mail or the Internet.

✓ It is best to inform people before inundating their e-mail with lots of images. Better still, you could place the images on a website and send a link instead.

✓ It takes just a few minutes to set up a basic website on which you can display your images.

✓ Many photographers fear that images can be stolen from the Internet, but there are ways to reduce the instances of theft.

✓ Once you feel ready to mount a show, you should begin planning.

✓ Any space can be used as a gallery, so use your imagination.

✓ You may be able to secure sponsorship or financing from local businesses.

Digital photography on the Web

THERE IS A HUGE AMOUNT of information about digital photography on the Internet. The following list contains some of the sites that I think are useful. Please note that due to the fast-changing nature of the Net, some of the below may have disappeared before you have a chance to check them out…

Information on digital photography

www.allthingsphoto.com
This is a search engine specifically for everything photographic – galleries, reviews, books, websites, retailers: a useful starting point for your research.

www.apple.com, www.fotango.co.uk, www.kodak.com, www.photobox.co.uk
These sites all offer some sort of online printing service for the digital photographer.

www.bjphoto.co.uk
The website of the *British Journal of Photography* is arguably one of the best photography sites there is – and it is certainly superior to the magazine. Worth bookmarking for its extensive links and resources.

www.datarescue.com
To retrieve data from damaged memory cards, try PhotoRescue, available from this website.

www.digitaltruth.com
This wide-ranging resource site covers all kinds of photography and is strong on film processing. It also has file downloads and useful links to other sites.

www.ephotozine.com
This is a rich site providing much instruction – for both digital and film-based photography – together with the usual mix of reviews, news, and galleries.

www.imaging-resource.com
This site combines how-to features with product news (cameras, scanners, and printers) and reviews.

www.megapixel.net
This site offers good-quality information with the usual mix of news, reviews, retailer links, and so on.

www.photo.net
With reviews not only of equipment but also books and suppliers, this is a large, varied, and lively site. There is also news and some travel stories and guides.

www.photodo.com
This is an eccentric site notable for its wide range of detailed lens tests – a useful basis for shopping once you learn how to read the charts. It also offers a range of links and some highly technical articles.

www.photographersindex.com
This free-of-charge site links databases and directories on photography for buying, selling, or conversing with others in the photographers' forum.

www.photography.za.com
This attractive, lively site has largely South African material on products, online portfolios, links, and a useful listing of creative professionals.

www.vectortrust.com/articles/welcome.html
Here you will find helpful content and features on photography, picture galleries, and a few links.

www.webcam.com
This site will tell you all you need to know about webcams – what they are, how to use them, and where to buy them.

www.zonezero.com
This lively site is dedicated to "photography's journey from the analog to digital world" by a leading practitioner. The content is also available in Spanish.

Specialist information

www.dewilewispublishing.com
Dewi Lewis is a publisher of an exceptionally challenging and interesting range of photography by outstanding photographers of the generation.

www.hardware-one.com
This site collects a vast range of information on all sorts of computer and digital hardware.

www.inkjetmall.com
Resources, techniques, and services relating to ink-jet products are featured at this primarily retail site.

www.panoguide.com
Here is an excellent specialist site devoted to the creation of panoramas, covering equipment, techniques, and software, and featuring a gallery.

www.photogybooks.com
Effectively a department of amazon.com, this is a very good online source for photography books.

www.scantips.com
Check out this site for information on all aspects of scanning as well as reviews of scanners.

www.wilhelm-research.com
This is the premier site for data on the longevity of photographic and digital images.

Picture sources and sharing

Taken together, and they are only a small selection, these sites offer a huge range of images. Some of them are free of charge for personal use, others are only for viewing. Before you download any images, ensure that you check the conditions of use.

www.fonts.com, www.1001freefonts.com
These sites offer free fonts for Mac and PC users.

www.fotki.com
You can use this rich and lively site for checking on what other photographers are up to; check out its useful "most-visited members" list. You can join and add your own photo album for others to view, too.

www.google.com
Click on the Images tab on Google's home page and type in what you are looking for.

http://images.jsc.nasa.gov
NASA's Johnson Space Center Digital Image Collection website houses an astonishing collection of images. This is a "must-see" site.

www.kodak.com
Generous not only with information and instruction but also images, this vast site is worth frequent visits.

http://landsat.gsfc.nasa.gov/main/images.html
This NASA site contains a collection of images of the earth taken with remote sensing technology.

www.reuters.com/pictures
Here you will find a selection of Reuters images that can be bought online to be printed and sent to you.

Equipment manufacturers

Agfa
Digital cameras, scanners, film
www.agfa.com

Apple
Computers, displays
www.apple.com

Canon
Cameras and lenses and accessory system, digital cameras, printers, scanners
www.canon.com

Casio
Digital cameras and accessories
www.casio.com

Epson
Printers, digital cameras, scanners, as well as helpful guides for troubleshooting your printer and getting the best results
www.epson.com

Fuji
Cameras: digital, film, and medium format
www.fujifilm.com

Heidelberg
Scanners, fonts, color software
www.heidelberg.com

Hewlett-Packard
Printers, papers, scanners, digital cameras, computers
www.hp.com

Jenoptik
Digital cameras, card readers, and accessories
www.jenoptik-camera.com

Kodak
Digital cameras, film cameras, film, printers
www.kodak.com

Konica
Digital cameras, film cameras, film
www.konica.com

LaCie
Storage drives and media, displays
www.lacie.com

Leica
Cameras and lenses, digital cameras
www.leica.com

Lexar
Memory cards and readers for digital cameras
www.digitalfilm.com

Lexmark
Printers
www.lexmark.com

Microtek
Scanners
www.microtek.com

Minolta
Cameras, lenses, digital cameras, film scanners
www.minolta.com

Nikon
Cameras, lenses, digital cameras, film scanners
www.nikon.com

Nixvue
Digital album for computerless storage of files
www.nixvue.com

Olympus
Cameras, lenses, digital cameras, printers, media
www.olympus.com

Pentax
Cameras (of all types) and lenses
www.pentax.com

Ricoh
Digital and conventional cameras
www.ricoh.com

Umax
Scanners
www.umax.com

Further reading

Easy

Digital Photographer's Handbook
Tom Ang
DK Publishing; New York; 0789489074
This book offers comprehensive coverage of all
aspects of photography, including film-based work,
with sections on camera techniques, working on
projects, image manipulation, and output.

Digital Photography
Tom Ang
Mitchell Beazley; London; 184000 178 X
This general introduction is intended as a bridge
between traditional and digital photography, with
numerous photographs and workshop examples.

Silver Pixels
Tom Ang
Argentum; London; 1902538 04 8
An introduction to the digital darkroom, showing
how digital techniques can mimic darkroom
techniques, with several useful technical sections.

The Cyberspace Lexicon:
An Illustrated Dictionary of Terms
Bob Cotton & Richard Oliver
Phaidon; London; 0714832677
Numerous illustrations and a hyperactive layout
make for a restless read, but this is a veritable visual
source in itself. Well worth dipping into, and it's
hard not to learn something new.

Creative Computer Tools for Artists
JL Pollard & JJ Little
Watson-Guptill; New York; 0823010392
An attractive and likeable guide to using image
manipulation as a fine-art tool, with lots of step-
by-step detail and inviting examples. Highly
recommended.

Digital Printmaking
George Whale & Naren Barfield
A & C Black; London; 0713650354
This modest but highly inspirational book has
many lovely images from artists. Short on detail,
but it will give you many ideas.

Intermediate

Dictionary of Digital Photography & Digital Imaging
Tom Ang

Argentum; London; 1902538137

Here you'll find a comprehensive listing of technical terms used in conventional and digital photography, with terms from imaging sciences, the Internet, publishing, and computing of use to the digital photographer, with easy-to-understand explanations.

Photoshop Restoration and Retouching
Karin Eismann

QUE; Indianapolis; 0789723182

This is a first-rate, thorough, and well-illustrated guide to a specialist topic, but you'll learn lots along the way. Highly recommended.

Glossary of Graphic Communications
Pamela Groff

Prentice Hall; New Jersey; 0130964107

An excellent example of the thorough specialist glossary: definitions are brief but sound.

The Illustrated Digital Imaging Dictionary
Sally Wiener Grotta & Daniel Grotta

McGraw-Hill; New York; 0070250693

Many indulgently long-winded entries spoil what could be a useful work. Good on explanations of menu items and tools, but dominated by Photoshop.

Digital Image Creation
Hisaka Kojima

Peachpit; Berkeley; 020188660X

Inspirational if rather glossy, this book is full of professional work, but it shows you what can be done with expertise and experience.

Dictionary of Contemporary Photography
Leslie Stroebel & Hollis N Todd

Morgan & Morgan, Inc; New York; 08710000652

Safe, sound, and solid as ever from these authors: clear definitions, excellent coverage, but rather hampered by its lack of depth on digital matters.

Avoiding the Scanning Blues
Taz Tally

Prentice Hall, New Jersey; 0130873225

Subtitled "A desktop scanning primer," this book goes much further than that, offering good advice on scanning for pre-press preparation. However, coverage is patchy.

Advanced

Advanced Digital Photography
Tom Ang

Mitchell Beazley; London; 0817432736

This book takes the techniques and background a little further into the fundamental principles, less-explored ideas, and some advanced tricks.

Adobe Photoshop 7 for Photographers
Martin Evening

Focal Press; Oxford; 0240516338

This production-oriented approach to Photoshop benefits photographers. Well illustrated with screen shots and useful techniques hard to find elsewhere, with some basics well covered, but not a lively read.

The Dictionary of Multimedia Terms & Acronyms
Brad Hansen

Fitzroy Dearborn; London; 157958084X

Up to date on Internet and multimedia, this is aimed slightly high at the more knowledgeable reader. It has extensive appendices, listing Java instructions and HTML code, for example.

Essentials of Digital Photography
Akira Kasai & Russell Sparkman

New Riders; Indianapolis; 1562057626

A thorough and careful treatment, this book is suitable for the experienced and advanced worker. It comes with a CD-ROM containing image files.

Photoshop for Color Correction
Michael Kieran

Peachpit; Berkeley; 0321124014

Thorough, authoritative, and not sparing in detail, this is everything you're likely to need on color. Essential for anyone with aspirations to serious digital photography.

Photographic Imaging and Electronic Photography
Sidney F Ray

Focal Press; Oxford, 0240513894

More encyclopedia than dictionary, this book is strong where entries can be more leisurely, but the shorter definitions are often illuminating only to technophiles.

A simple glossary

Additive color Combining or blending two or more colored lights in order to simulate or give the sensation of another color.

Alpha channels Selections stored as masks in the form of grayscale images. Fully selected areas appear white, non-selected areas as black, and partially selected areas as shades of gray.

Analog An effect, representation, or record that is proportionate to a physical property or change.

Anti-aliasing Smoothing away the stair-stepping in an image or computer typesetting.

Application A computer program designed to do a certain job.

Archive To store a permanent copy of something you don't need to access very often.

Artifacts Features in an image, introduced during capture or processing, that were not originally present.

Attachment A file that is sent along with an e-mail, such as an image or other complicated or large item.

Background The bottom layer of an image; the base.

Back up To make and store second or further copies of computer files.

Bicubic interpolation A type of interpolation in which the value of a new pixel is calculated from the values of its eight near neighbors.

Bilinear interpolation A type of interpolation in which the value of a new pixel is calculated from the values of four of its near neighbors – left, right, top, and bottom.

Black An area that has no color or hue due to absorption of most or all light.

Bleed (1) A photograph or line that runs off the page when printed. (2) The spread of ink into fibers of support material; the effect causes dot gain.

Brightness The quality of visual perception that varies with the amount or intensity of light.

Brush An image-editing tool used to apply effects such as color, blurring, burn, dodge, and so on.

Burning-in The alteration of the local contrast and density of an image by making certain parts darker, while masking off the rest of the picture.

Byte A word or unit of digital information.

Calibrate To adjust a device, like a monitor, so that it meets certain standards.

Camera exposure A quantity-of-light sensor. It depends on effective aperture of lens and duration of exposure to light.

Channel A set of data used by image-manipulation software to define a color or mask.

Click-drag To place the mouse pointer over the item you want to move, press the mouse button down and hold it down as you move the mouse pointer to where you want to place the item. Don't carry the mouse; roll it over the desk.

Cloning The process of copying, repeating, or duplicating pixels from one part of an image or another image on to another.

Colorize To add color to a grayscale image without changing the original lightness values.

CMYK Cyan Magenta Yellow Key. The colors of inks used to create a sense of color.

ColorSync Proprietary color-management software system that helps ensure that colors seen on screen match those to be reproduced.

Color cast A hint of color evenly covering an image.

Color gamut The range of colors that can be handled or output by a device such as a printer or screen.

Color management The process of controlling the output of all devices in a production chain.

Color saturation This measures how rich or pure color is: highly saturated colors are very pure, and appear strong.

Color space An abstract way of showing how different colors relate to each other. The most common color space is that created by RGB.

Compositing The putting together of parts of different images to create a new one. Its similarity to sticking bits of pictures and other things together gives it the alternative name of collage.

Compression The process of reducing the size of digital files by changing the way the data is coded.

Contrast This measures the differences between the lights and darks in an image.

Crash The sudden, unexpected, and unwelcome non-functioning of a computer.

Crop (1) To use part of an image for the purpose of, for example, improving composition; fitting an image to available space or format; squaring up an image to correct the horizon. (2) To scan the required part of an image.

Default settings The settings that a camera or software offers you in the absence of other instructions.

Definition A measure of how much detail is recorded. Low definition equates with not much fine detail being visible; high definition shows fine detail clearly.

Delete To remove the name of a file from the computer records. The file itself may still be present, so it may be possible to retrieve it.

Depth of field The space in front of, and behind, the plane of best focus within which objects appear acceptably sharp.

Digital image Any picture or graphic in digital form. It could be created directly by drawing, but could also be caught in a camera or scanner.

Digital photography A type of photography in which any stage involves or uses a digital image.

Digitize To turn an analog record, such as a print, into a digital file – either using a scanner or a digital camera.

Direct-vision finder A type of viewfinder in which the subject is observed directly – that is, through a hole or optical device.

Display A device that provides the temporary visual representation of data. Examples: monitor screen, LCD projector, information panel on camera.

Dodging The selective lightening of parts of the image that would otherwise appear too dark. Compare Burning-in.

dpi Dots per inch. The measure of the resolution of an output device as a number of dots or points that can be addressed or printed by the device.

Driver The software used by a computer to control or drive a peripheral device, such as a scanner, printer, or removable-media drive.

Drop shadow A graphic effect in which an object appears to float above a surface, leaving a fuzzy shadow below it and offset to one side.

Duotone (1) A photomechanical printing process using two inks to increase tonal range. (2) A mode of working in image-manipulation software that simulates the printing of an image with two inks.

Electronic viewfinder An LCD screen, viewed under the eyepiece, that shows the view through the camera lens.

Exposure The process of allowing light to reach light-sensitive material to create an image.

f/number A lens-diaphragm setting that determines the amount of light transmitted by the lens.

Feathering Blurring a border or bounding line by reducing the sharpness or suddenness of the change.

Field of view (of a lens) This measures the angle of what can be seen at the viewer's position, from one corner to the opposite corner of the image.

Fill-in (1) To illuminate shadows cast by the main light by using another light source or reflector to bounce light from the main source into the shadows. (2) To cover an area with color, as achieved by the Bucket tool.

Filter Software that converts one file format to another or applies effects to the image.

FireWire The standard for rapid communication between computers and devices. Also called i.Link and IEEE 1394.

Flare The light that is present in the image but that does not actually help show detail or colors – it is just an unwanted nuisance. It's caused by stray light bouncing around inside the lens.

Flash (1) A very brief burst – less than $\frac{1}{1,000}$ of a second in duration – of intense light. This light is added to that from the available, or ambient, light. (2) The equipment used to provide a brief burst or flash of light. (3) A type of electronic memory used in digital cameras.

Flatten To combine multiple layers and other elements into a background layer.

Focal length For a simple lens, the distance between the center of the lens and the sharp image of an object at infinity projected by it.

Font A computer file describing a set of letter forms for display on screen or to be printed.

Format The shape (or proportion of the length to the width) and the orientation (upright or horizontal) of a picture. Applied to film, it means the size of image.

Gamma A combined measure of how bright and contrasty the screen image appears.

GIF Graphic Interchange Format. A compressed file format designed for use on the Internet.

Grayscale A measure of the number of distinct steps between black and white in a record.

gsm Grammes per square metre. This measure tells you how much substance paper has, which is roughly proportional to how thick it is.

Hard copy A visible form of a computer file printed more or less permanently on to a support such as paper or film.

Histogram A graphical representation showing the relative numbers of something over a range of values.

Hot-pluggable A connector that can be disconnected or connected while the computer and machine are powered. Examples are FireWire and USB.

Ink-jet Printing based on the squirting of extremely tiny drops of ink on to a receiving substrate.

Interpolation *See* Pixel interpolation.

Jaggies The appearance of stair-stepping artifacts.

JPEG Joint Photographic Expert Group. A data-compression technique that reduces file sizes with loss of information.

K (1) Binary thousand – that is, 1,024. For example, 1,024 bytes is abbreviated KB, or K. (2) The Key ink in the CMYK process. (3) Degrees Kelvin, which measure color temperature.

Keyboard shortcut A keystroke to execute a command.

Key tone The principal or most important tone in an image, usually the mid-tone between white and black.

Layer mode A picture-processing or image-manipulation technique that determines the way in which a layer in a multilayer image combines or interacts with the layer below.

LCD Liquid crystal display. A type of display using materials that can block light.

Lossless compression A computing routine that reduces the size of a digital file without reducing the information in the file – for example, LZW.

Lossy compression A computing routine that reduces the size of a digital file but also loses information or data – for example, JPEG.

lpi Lines per inch. A measure of resolution or fineness of photomechanical reproduction.

Luminance range A term given to the difference between the brightest and darkest parts of the image.

LZW compression A way of reducing file size that does not damage image quality.

Marquee A selection tool used in image-manipulation and graphics software.

Mask To obscure selectively or hold back parts of an image while allowing other parts to show.

Megapixel One million pixels; used to describe a digital camera in terms of sensor resolutions.

Memory card An electronic chip encased in a slim plastic casing; it stores information such as image data. Memory cards are often nicknamed "digital film." There are many kinds and standards.

Menu A list of options offered by the camera. You must select one to set the camera to that option.

Moiré A pattern of alternating light and dark bands or colors caused by interference between two or more superimposed arrays or patterns that differ in phase, orientation, or frequency.

Monochrome A photograph or image made of black, white, and grays, which may or may not be tinted.

Morphs Digital distortions that can be highly and precisely localized.

Navigate To move through menus until you find and select the control option you are looking for.

Nearest neighbor A type of interpolation in which the value of the new pixel is copied from the nearest pixel to it.

Noise Irregularities in an image that reduce the information content.

Opacity A measure of how much can be "seen" through a layer.

Operating system A special type of software that controls the computer itself and the way it interacts with you. It does things like organizing files, managing connected devices, and putting the display on to the monitor.

Optical viewfinder A type of viewfinder that shows a subject through an optical system, rather than via a monitor screen.

Out-of-gamut Colors from one color system that cannot be seen or reproduced in another.

Output A hard-copy printout of a digital file – for example, an ink-jet print.

Paint To apply color, texture, or effect with a digital "brush."

Palette (1) A set of tools, colors, or shapes. (2) A range or selection of colors.

Peripheral Any device connected to a computer – for example, printer, monitor, scanner, or modem.

Photomontage A photographic image made from the combination of several other photographic images.

PICT A graphic file format used on Mac OS.

Pixel Short for picture element. Pixels are the building blocks of the image. Usually square in shape, they are virtual, having no size until they are printed or displayed.

Pixel interpolation A mathematical process for working out new intermediate values between known ones. It is used to interpose new pixels between existing pixels.

Pixelated Describes images in which the individual picture elements – square blocks of color – can be easily seen.

Plug-in An application software that works in conjunction with a host program into which it is "plugged" so that it operates as if part of the program itself.

Posterization The representation of an image that results in a banded appearance and flat areas of color.

ppi Points per inch. The number of points that are seen or resolved by a scanning device per linear inch.

Pre-scan In image acquisition, a quick view of the object to be scanned, taken at a low resolution for cropping, for example.

Prosumer A term applied to cameras designed for amateur or hobbyist photographers but capable of making professional-quality images.

RAM Random Access Memory. The component of the computer in which information can be stored or rapidly accessed.

Raster The grid-like arrangement of pixels or dots of ink, like that of a chessboard.

Read To access or remove information from a storage device such as a hard disk or CD-ROM.

Resizing Changing resolution or file size of an image.

RGB Red Green Blue. A color model that defines colors in terms of relative amounts of red, green, and blue components.

Rubylith A red paint applied to negative film that prevents painted areas from being printed out.

Saturation A measure of intensity; a highly saturated color is said to be pure.

Scan To use a machine to make a digital copy of your original photograph.

Scrolling The process of moving to a different portion of a file that is too large for the whole to fit on to a monitor screen.

Selection A defined area of the image that you can work on and to which you apply effects.

Sharpness A subjective judgment of how clearly details can be seen in an image.

SLR Single-lens reflex. This type of camera uses the same lens for viewing as for taking the picture. For focusing and framing, you view the image on a focusing screen; the image you see on the screen is how your photo will turn out.

Softening An effect that surrounds sharp outlines with blur, often with more blur at high-contrast edges than at low-contrast ones.

Soft proofing The use of a monitor screen to proof or confirm the quality of an image.

Stair-stepping The jagged, rough, or step-like reproduction of a line or boundary that is intended to be smooth.

Suffix The dot and a few letters added after the file name. It is used by some operating systems.

Telephoto An optical construction that enables the physical length of the lens to be less than the focal length.

Thumbnail The representation of an image as a small, low-resolution version.

TIFF A widely used file format.

Tint (1) A color that can be reproduced with process colors; a process color. (2) An overall, usually light, coloring that tends to affect areas with density but not clear areas.

Tolerance setting This determines how different a pixel can be before it is ignored. A low tolerance selects very similar pixels; a high tolerance selects a wide range of pixels.

Tone reproduction In photography, this describes the way in which a record represents the changes of light and dark. When you get it right, it looks convincing and part of the effect of the image.

Transfer functions These define the way one measure changes as a result of applying an effect – for example, dark tones are made less dark, while light tones become darker. A curve represents these changes through the shape of its line.

Transparency adapter An accessory light source that enables a scanner to scan transparencies.

TWAIN A standardized software "bridge" used by computers to control scanners via scanner drivers.

Undo To reverse an editing or similar action within application software.

Upload The transfer of data between computers or from network to computer.

USB Universal Serial Bus – a standard port design for connecting peripheral devices – for example, a digital camera, telecommunications equipment, or a printer – to a computer.

USM Unsharp Mask. An image-processing technique that has the effect of improving the apparent sharpness of an image.

Veiling flare Light – like an overall mist – in the image that does not form the image. It lowers contrast.

Warm colors Hues such as reds, through oranges, to yellows.

Write To commit data on to a storage medium – for example, a CD-R.

Zip The proprietary name for a data-storage system.

Index

Acknowledgments

Author's acknowledgments

This project would not have been possible without the support of many people from all parts of the industry. Many thanks to Jenny Hodge of FujiFilm and Hayley Buery of Canon UK for their untiring helpfulness. A big help in keeping me up to date (and the bank balance less red) have been many commissions and assistance from my editors at *Total Digital Photography* (Simon Joinson), *MacUser* (Kenny Hemphill), *MacFormat* (Rachel Spooner), and *Digital Camera Shopper* (Dan Slingsby): many thanks to you all. Technical assistance from software manufacturers has been invaluable: my thanks are due to Adobe, FotoWare, Extensis, LizardTech, ShortCut, Alien Skin, Equilibrium, Binuscan, and TypeMaker.

Cameras used in this book include the Canon D30, D60, 10D, and 1D; Fuji 602, Sony F717, and Nikon 990. Film cameras that contributed include the Canon EOS-1n and EOS-500, Leica M6, and Rollei 6008. Scanners used were the Minolta DiMage Scan Multi Pro and Heidelberg Saphir Ultra.

And most of all, my thanks go to Wendy, indefatigable provider of hot meals, tea, and boundless support as ever, and throughout.

Tom Ang
London 2003

Packager's acknowledgments

Sands Publishing Solutions would like to thank the following people for their assistance in this project: Martin Apps at Jessops, Maidstone; Hilary Bird for compiling the index; Barry Robson for his artworks; and, of course, Tom Ang.

Picture credits

The publisher would like to thank the following for their permission to reproduce photographs of their products: Adobe, Apple, Aquapac International Ltd, Canon UK, Fujifilm UK, IBM, Iomega, Kodak, LaCie, Lexmark, Microsoft, Minolta, Nikon, Olympus, Pentax, Philips, Smartdisk.